13 Most Wanted Men
Andy Warhol and the 1964 World's Fair

"The thing I most of all remember about the World's Fair was sitting in a car with the sound coming from speakers behind me. As I sat there hearing the words rush past me from behind, I got the same sensation I always got when I have interviews—that the words weren't coming out of me, that they were coming from someplace else, someplace behind me."

Andy Warhol

Acknowledgements

The exhibition organizers would like to thank individual and institutional lenders to this exhibition: Städisches Museum Abteiberg, Mönchengladbach; Bob Adelman; Anthology Film Archives; The Eli and Edythe L. Broad Collection, Los Angeles; the Leo Castelli Gallery Records at the Archives of American Art, Smithsonian Institution; Paula Cooper Gallery; Bill Cotter; Bruce Davidson/Howard Greenberg Gallery; Electronic Arts Intermix; the Doris and Donald Fisher Collection; the Henry Geldzahler Papers at the Beinecke Library, Yale University; the Hopper Art Trust; Herbert F. Johnson Museum of Art, Cornell University; Chris Kellberg; William John Kennedy/KIWI Arts Group; Mark Lancaster/David Bolger; Museum Ludwig, Cologne; David McCabe/Susan Cipolla McCabe; the Fred McDarrah Estate at Steven Kasher Gallery; Jonas Mekas; the Mugrabi Collection; Ugo Mulas Archive at Galleria Lia Rumma, Milano/Napoli; the Ugo Mulas Estate at MiCucci Gallery; Museum für Moderne Kunst, Frankfurt; Billy Name and Dagon James; Jay Reeg; the Larry Rivers Papers at the Fales Library, New York University; and two private collections.

It is with the risk of repeating a phrase found in every Warhol-related book since the mid-nineties that we thank Matt Wrbican, Chief Archivist at The Andy Warhol Museum, whose deep and generous input was crucial to the telling of the core story. We would also like to extend our gratitude to the following individuals for their invaluable assistance in the process of organizing this exhibition and publication: Ammiel Alcalay, Elaine Angelopoulos, Matthew Buckingham, George Chauncey, Beatriz Colomina, David Dalton, Anita Fröhlich, Yvonne Garcia, Helen Harrison, Barbara Haskell, Dagon James, Sam Markham, Julie Martin, Jack Masey and Beverly Payeff-Masey, Sebastian Mekas, Mark Michaelson, Marc Miller, Sohrab Mohebbi, Dennis Mohr, Barbara Moore, Franz Schulze, Mariana Silva, Robert A.M. Stern, Joseph Tirella, Lorraine Two, Jay Reeg, Ali Rosenbaum, Philippe Segalot, Annie Tummino, Kristen Utter Fedders, Steven Watson, and Reva Wolf. We are also grateful for the assistance of Claudia Defendi and Scott Ferguson at The Andy Warhol Foundation, Maria Murguia at the Artists Rights Society, Janet Parks of the Avery Architectural & Fine Arts Library at Columbia University, Esme Watanabe at the Jack Smith Archive, Barbara Gladstone Gallery, Allison Brant and Zoe Larson at the Brant Foundation, Thomas Bolze at the Beineke Library at Yale University, Amanda Gaspari at Corbis Images, Marianne Aebersold at the Daros Collection, Tihana Ilic at Getty Images, Katie Trainor at the Museum of Modern Art New York, Tal Nadan and Weatherly Stephan at the New York Public Library, Brian DeShazor and Holly Larson at Pacifica Radio Archives, Irene Shum Allen and Henry Urbach at the Philip Johnson Glass House, Kelly Baum at the Princeton University Art Museum, David White at the Rauschenberg Foundation, Monica Blank at the Rockefeller Archives Center, Alison Smith at VAGA, Gary Comenas of Warhol Stars, and Claire Henry at the Whitney Museum of American Art.

Larissa Harris, Curator, Queens Museum
Nicholas Chambers, The Milton Fine Curator of Art, The Andy Warhol Museum
Anastasia Rygle, Project Assistant Curator
Timothy Mennel, Curatorial Adviser
Media Farzin, Publication Coeditor

Foreword

Fifty years ago, Flushing Meadows Corona Park was the site of the 1964 World's Fair, and witness to a collision between Andy Warhol, Robert Moses, Nelson Rockefeller, Philip Johnson, and the emerging downtown art scene. Warhol, who had been invited by Johnson to produce a mural for the New York State Pavilion alongside nine other up-and-coming artists, installed a work made up of the mug shots of the NYPD's Thirteen Most Wanted Men of 1962. Within days of its installation, before the fair had even opened to the public, Warhol's work was censored, covered over with silver paint.

This exhibition is both an examination of a moment in time for a great American artist, and a detective story about exactly what went wrong when the organizers of the fair felt obliged to require Warhol to paint over this twenty-by-twenty-foot work. It's also a confluence of circumstances that has brought together two museums: the Queens Museum, which is a stone's throw away from the site of the ruin of the New York State Pavilion, and The Andy Warhol Museum, which is the center for discussion of all matters regarding Warhol.

A half century has passed since those days in 1964, and a lot has changed. The idea of the NYPD raiding a film screening to confiscate unsuitable work (as they did at many downtown venues in 1964) seems out of the question today. But the idea of an artwork inflaming a controversy on the basis of its content is not at all a thing of the past—whenever an artwork disappears from public view or is rejected by an institution, there is much speculation about the causes and implications. Herein is the story of one occasion, and we are thrilled to have the chance to share it with you on its fiftieth anniversary.

This exhibition and publication have involved the collaboration of numerous individuals at our respective institutions. We would particularly like to acknowledge Queens Museum curator Larissa Harris and The Andy Warhol Museum Milton Fine Curator of Art, Nicholas Chambers; The Andy Warhol Museum Chief Archivist, Matt Wrbican; assistant curator for the project, Anastasia Rygle; curatorial advisor Timothy Mennel; coeditor of this publication, Media Farzin; the lenders to the exhibition; and all of the photographers, photojournalists, filmmakers, archivists, and others who contributed their expertise to this project. The Andy Warhol Museum registrar Heather Kowalski has handled bringing nine of the *Thirteen Most Wanted Men* canvases together from all corners of the world, while Louise Weinberg and Manjari Sihare at the Queens Museum have gathered over 150 documents of the period from archives, artists, and photojournalists.

Finally, we are grateful to our funders, without whom none of this would be possible: The Henry Luce Foundation, The National Endowment for the Arts, and Delta Airlines, as well as the New York City Department of Cultural Affairs and the New York State Council on the Arts with the support of Governor Andrew Cuomo and the New York State Legislature.

Tom Finkelpearl, Commissioner of the Department of Cultural Affairs, New York City; President and Executive Director, Queens Museum (2002–2014)
Eric Shiner, Director, The Andy Warhol Museum

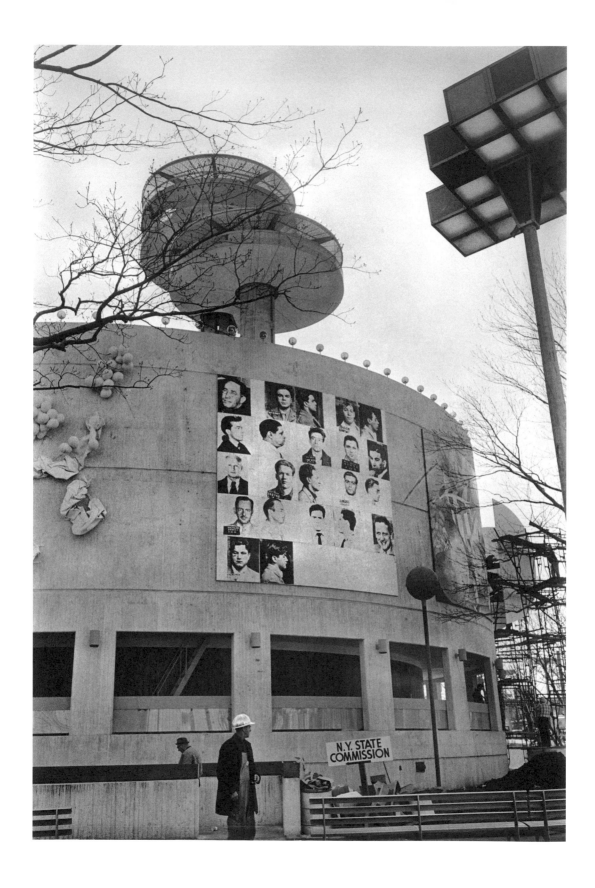

"It just had something to do with New York."

Our story begins in 1961, with billionaire art collector and New York State Governor Nelson Rockefeller, and peripatetic critic and architect Philip Johnson. The two men were connected through the Museum of Modern Art: Rockefeller's mother had co-founded the institution and Johnson was the first director of its architecture department. When Rockefeller asked Johnson to design the New York State Pavilion for the 1964 New York World's Fair, his only instructions were to make the host state's structure the tallest at the global expo. The resulting pavilion—which still exists, partially dilapidated and partially as a working theater—was a multipart complex whose main structure was somewhere between a classical ruin and a circus tent. It featured the world's largest terrazzo map of New York State sheltered by the "Tent of Tomorrow," an oval roof of brightly colored translucent plastic panels suspended many feet above. Three yellow disc-shaped observation decks, each higher than the last, supported by concrete columns, towered over the tent. Finally, there was the circular "Theaterama," built to contain a panoramic film of New York State.

Johnson invited ten up-and-coming artists, some of whom he collected personally, to produce new work for the Theaterama's featureless gray exterior. These artists were Peter Agostini, John Chamberlain, Robert Indiana, Ellsworth Kelly, Roy Lichtenstein, Alexander Liberman, Robert Mallary, Robert Rauschenberg, James Rosenquist, and Andy Warhol, who had opened his first New York exhibition of Pop paintings in November 1962, just a month before the New York State Pavilion work was commissioned. (Johnson had purchased Warhol's 1962 *Gold Marilyn* out of this exhibition, probably on the advice of his life partner, David Whitney, who, thirty years his junior, was what we would now call an "independent curator" and major tastemaker in his own right. Johnson would donate it to the Museum of Modern Art very soon after.)

In planning the exterior of the Theaterama, Johnson had invited each artist to produce a new work for a twenty-by-twenty-foot slot, to be spaced all around at regular intervals on the exterior wall. For his contribution, Warhol chose to enlarge the mug shots of the New York Police Department's thirteen most wanted criminals of 1962, silk-screen them on square Masonite panels, and tile them together into an animated black-and-white rogue's gallery which, along with the other works, would overlook one of the fair's central byways. All of the works were installed by April 15, 1964. But after triggering objections at the highest level, *Thirteen Most Wanted Men* was painted over with silver paint a few days later. When the fair opened to the public on April 22, all that was visible was a twenty-by-twenty-foot silver square, mounted on the concrete structure between a fragile-looking white sculpture by Agostini and a colorful combination of advertising imagery by Rosenquist.

That July, Warhol reused the mural's silkscreens to make a set of paintings, each featuring one of the *Thirteen Most Wanted Men*. He abandoned the square format of the fair tiles in favor of forty-eight-by-forty-inch canvases that emphasized their presence as portraits. In titling these new, individual works—twenty of which were made altogether[1]—he also returned to the source material for the first names, initials of last names, and "numbers" of the criminals themselves. Before moving on to other work, Warhol produced a replacement for the New York State Pavilion piece: twenty-five Masonite panels each depicting the smiling face of New York City planning master-

1. Some *Men* were made in triplicate; some doubled; and others are unique.

2. Philip Johnson, quoted in Rainer Crone, *Andy Warhol* (New York: Praeger, 1970), 30.

3. Kit Kincade, "Silver Square 'So Nothing' at Fair it Satisfies Warhol," *New York World-Telegram*, July 6, 1965, 6. New York World's Fair 1964–65 Corporation Records, Manuscripts and Archives Division, New York Public Library.

4. Andy Warhol, *America* (New York, Harper & Row, 1985).

5. "Avant-Garde Art Going to the Fair," *New York Times*, October 5, 1963, 1. New York World's Fair 1964–65 Corporation Records, Manuscripts, and Archives Division, New York Public Library.

mind and World's Fair president Robert Moses. This was rejected immediately by Johnson—who said he didn't think they should "thumb [their] noses"[2]—and, though consigned to Castelli Gallery at the end of that summer, these works were subsequently lost. Although there is no evidence that Moses had anything to do with the commission or the covering-over of the mural, Warhol appeared to be identifying him as the mural's censor. (The seventy-five-year-old Moses's conservative cultural attitudes, his destructive urban renewal policies, and, specifically at the fair, his refusal to remind the building trades of the desegregation laws that were on the books, generated much anger among New Yorkers from Greenwich Village to Harlem. The fair presidency was a kind of "consolation prize" for Moses's loss of other public offices—losses orchestrated by Nelson Rockefeller, the only man powerful enough to do so. After forty years of reigning over New York's public realm he had become for many a kind of Public Enemy #1.)

The fair was open from April to October of both 1964 and 1965, and the square silvery blank that had been *Thirteen Most Wanted Men* stayed up for both of those seasons. In a *New York World-Telegram* article from summer 1965 headlined "Silver Square 'So Nothing' It Satisfies Warhol," the artist is described standing before the mural at the World's Fair with members of his entourage, saying that the silvered-over version is "more me now."[3] Through typical, jesting Warholian attitudinal alchemy, *Thirteen Most Wanted Men* had become a new work in the form of a silver monochrome. (Indeed, the "blank" appears frequently in his work and words. He added identically sized, single-color panels without imagery to a selection of the "Disaster" paintings; and in many other works of that period, he left areas of the canvas untouched, including a section of *Thirteen Most Wanted Men*. [The number of individual images [twenty-two] did not match the number of panels that would make up a grid [twenty-five], so he simply left three squares at the bottom edge empty.] Not just comfortable with the void but personally identified with it, Warhol also wished later that his gravestone be left blank—then adjusted this statement to say that it should, rather, say the word "figment.")[4]

The works on the New York State Pavilion were commissioned in December 1962 and announced (with one-line descriptions for each, and no illustrations) in the *New York Times* on October 6, 1963.[5] It was during precisely this period that Warhol was repurposing imagery of suicides, car crashes, an electric chair, and protestors clashing with police which he found in the newsmedia as subjects for paintings now known as the "Death and Disaster" series. The first "Disasters" serially repeat dreadful scenes of dismemberment—a body impaled on a telephone pole, a foot next to a car tire, bodies hanging out of car windows amidst crumpled steel. Others repeat an image of an empty electric chair in 1963, the same year that New York State, after banning capital punishment, performed its last two executions. The *Race Riots*, also considered part of this body of work, reproduce a series of photographs of a police dog tearing off a civil rights protestor's trouser leg—three frames of humiliation unfolding as the civil rights movement was gaining strength, assisted by media exposure of exactly this type of violence.

According to poet John Giorno, it was at a dinner party in April 1963 (just weeks before the photograph of the Birmingham protests that Warhol used for *Race Riot*

would be published in *Life* magazine) that painter Wynn Chamberlain suggested the most wanted men as subject matter for Warhol's World's Fair commission. Chamberlain reportedly offered to ask his boyfriend, a policeman with the NYPD, to bring Warhol a stash of police department printed matter for inspiration.[6] Indeed, a handy, pocket-sized, police-department-printed booklet containing the mug shots, aliases, crimes, fingerprints, and other identifying information for the NYPD's Thirteen Most Wanted of 1962 was found in Warhol's *Time Capsules*,[7] along with examples of the kind of FBI wanted posters that were apparently on view in post offices at that time. *Thirteen Most Wanted Men* is frequently mistakenly thought to be based on the FBI's most wanted, but Warhol's usual deadly precision is in evidence in his choice of the NYPD booklet. In line with his interest in seriality and repetition, Warhol chose the ready-made "collection" of men over the single criminal, and, better to represent his city and state, focused on local, rather than national, fugitives from justice, with the possible result that New York City visitors to the fair might have recognized a family member or neighbor in the dubious group. When quizzed about the piece by a reporter for a *New York Journal-American* article from April 15, 1964, the day the mural went up, Warhol said, "It just had something to do with New York."[8]

Warhol's New York gallerist, Eleanor Ward of the Stable Gallery, did not show or sell the works in the "Disaster" series. Ileana Sonnabend showed them in Paris in January 1964, in an exhibition Warhol had wanted to title "Death in America." Too hot for New York, the *Men* canvases themselves were also shown for the first time together at Sonnabend's Paris gallery three years after the incident at the fair. In the exhibition booklet for this 1967 exhibition, the *Thirteen Most Wanted Men* are dated to 1963, emphasizing their connection to the "Disaster" series and other work that year, and deemphasizing their connection to the World's Fair. (Inside is an essay by art critic Otto Hahn, with an epigraph by Robert Delaunay: "La photo est un art criminel.") *Thirteen Most Wanted Men*'s unusually long gestation—only a year or so less than the time required to plan the World's Fair itself—meant that a work generated during Warhol's most provocative period, whose results had not been seen by New Yorkers even within the protected confines of an art gallery, would have ended up, had the mural remained, in the most visible venue of its day. Its covering-over in silver effectively brought it up to date in his own work and life: silver was the color with which Billy Name was covering every possible corner of Warhol's new studio, which would become known as "the Factory," into which he had moved in January 1964. Although absent from the fair, the images of the *Thirteen Most Wanted Men* in the form of acetates hanging on walls and over windows served as a backdrop to activity at the Factory at least through 1965.

But as much as these works—with their black-and-white palette and their disturbingly seductive imagery of violence as captured by a cruel camera—are "Disasters," they are also portraits. During the same period, Warhol produced his first portrait commission, 1963's *Ethel Scull Thirty-Six Times*, based on a session with the socialite in a Times Square photo booth. The final product was a wall of shots of his subject's head and shoulders, reordered into a multicolored grid of animated poses. Like the mug shot, a photo-booth picture is an industrial or workaday (as opposed to fine-art) photographic format whose multiple frames resemble a segment of film—a medium

6. John Giorno, "Andy Warhol's Movie *Sleep*," in *You Got to Burn to Shine: New and Selected Writings* (London and New York: High Risk Books/ Serpent's Tale, 1994), 127–129.

7. Warhol's *Time Capsules* consist of approximately six hundred boxes of life-related ephemera accumulated by the artist since the mid-1960s, whose cataloguing over the past twenty years by The Andy Warhol Museum has allowed much insight into his work.

8. Richard Barr and Cyril Egan, Jr, "Some Not-So-Fair Faces: Mural Is Something Yegg-Stra", *New York Journal-American*, April 15, 1964, 1.

9. Callie Angell, *Andy Warhol Screen Tests: The Films of Andy Warhol, Catalogue Raisonné, Volume 1* (New York: H.H. Abrams, 2006)

10. Billy Name, Adrian Marin, and Debra Miller, interview with Mirra Bank Brockman at The Andy Warhol Foundation, New York, December 17, 1991.

11. Richard Meyer, "Most Wanted Men: Homoeroticism and the Secret of Censorship in Early Warhol," in *Outlaw Representation: Censorship and Homosexuality in Twentieth-Century American Art* (Oxford and New York: Oxford University Press), 95–158.

12. But like his punning elder Marcel Duchamp, Warhol did also make explicit works, as early as 1964's *Couch.*

13. Billy Name, Letter to Andy Warhol, ca 1965, Collection of the Andy Warhol Museum, Pittsburgh; Founding Collection, Contribution The Andy Warhol Foundation for Visual Arts, Inc. *Time Capsule* 5.60

14. Protesting this and other shutdowns, on April 22, 1964—the opening date of the World's Fair—a group of artists and poets including Taylor Mead, Alan Marlowe, Diane di Prima, Julian Beck, Allen Ginsburg, and others—marched from Bryant Park to the newly constructed Lincoln Center where they dumped a coffin marked "Will Free Expression be Buried?" next to the fountains adjacent to the New York State Theater, another Philip Johnson building that would open officially the following day.

into which Warhol had recently plunged.

Also in January 1964, Warhol began shooting the *Screen Tests*, three-minute-long portraits in 16 mm film. The very first series of these—which could be said to be the inspiration for all of the *Tests*, which eventually numbered 472—were titled *Thirteen Most Beautiful Boys*. As identified by Callie Angell, this "conceptual series,"[9] which continued into 1966 but was concentrated in 1964, eventually comprised forty-two portraits of thirty-five young men, ranging from underground film star and poet Taylor Mead to dancer Freddie Herko to poet and artist John Giorno to Factory photographer Billy Name to actor Dennis Hopper to someone noted only as "Boy." In an unpublished interview conducted for Angell's *Andy Warhol Screen Tests*, Billy Name says that the work *was* the title—a perpetually open-ended group that could always be added to, like any other collection.[10] The *Boys* and *Men* share more than the first part of their title: in the *Tests'* very process, in which a subject is placed under bright lights and requested to stay as still as possible for three minutes, we also find a hint of law enforcement's punishing constraints.

Warhol's identification with criminals and other transgressors as well as his artistic deployment of the state structures that discipline and punish them can be read in the context of his own sexuality and that of his peers. At a time when the expression of gay sexuality, either between people or in media, was illegal, all references to it had to be in code. *Thirteen Most Wanted Men* has, in fact, been persuasively decoded by art historian Richard Meyer and others, and now we can read the double meaning in its punning reference to wanted men. We can also see the active glances going on amongst those men in their mural configuration, and pick up the work's reference to "rough trade" or desirably threatening forms of masculinity.[11] Warhol coded his early films as well: from *Eat* to *Empire* to the *Screen Tests*, he generally preferred visual and verbal puns on sex acts to showing forbidden body parts.[12] In a letter to a traveling Warhol, probably from spring of 1965, Billy Name informs him about a police department visit to the Factory in search of "13 Most" (a likely reference to either *Thirteen Most Beautiful Boys* or *Thirteen Most Beautiful Women*, a companion group of *Screen Tests*).[13] But had law enforcement viewed what they were after, they would have seen only an anonymous series of quiet faces. This contrasts strongly with the explicit *Flaming Creatures* (1963), whose far less politic author, underground filmmaker Jack Smith, was one of Warhol's main inspirations as he took up filmmaking. *Flaming Creatures* was a lightning rod for police enforcement of obscenity laws, especially in the run-up to the New York World's Fair in spring 1964. During the summer of 1963, Warhol had made what may have been his first film on the set of Smith's second film, *Normal Love*. On March 3, 1964, a Jonas Mekas-organized screening of *Flaming Creatures*, which had Warhol's three-minute "newsreel" of *Normal Love* on the bill as well, was raided and all films and equipment confiscated and never returned.[14]

In one of the comparatively few newspaper articles that reported the covering-up at the time, Philip Johnson claimed that it had been Warhol's decision to paint over the mural, and that official objections were not, and would never have been, the deciding factor.[15] In another, he claimed that due to the length of time that had elapsed, one of the criminals had been pardoned, and they wanted to avoid lawsuits.[16] Here it's

worth quoting at length—despite the inaccuracies—an unpublished interview that the prominent curator and close Warhol friend Henry Geldzahler conducted with Johnson in 1982:

Henry Geldzahler

Philip, we're going to end this with a story that perhaps hasn't been printed before. In 1964, for the New York World's Fair, you did the New York State Building. And you commissioned Andy Warhol to do 10 paintings—enormous ones—20 × 20 feet, for the exterior of this building. A very daring commission, because Andy was not the enormous Pop figure in '64 that he has become. And yet somehow those paintings disappeared overnight. What happened?

Philip Johnson

It was a very sad story. He chose, unbeknownst to me, but I don't care. I gave each artist a chance to pick his own subject, and he picked—impishly—the ten most wanted men, their heads would be about 15 feet. And I thought, "That would be an absolutely delicious idea." Why not? He used the FBI list we used to see in Post Offices—we don't anymore—of the ten most wanted names. And I thought nothing of it until I got a call from Rene d'Harnoncourt that the Governor wished to have it removed, just before the show opened.

HG

Did it have anything to do with the high number of a certain ethnic group that was in the top ten?

PJ

It had all to do with the fact that 9 out of 10 names that were all from . . .

HG

A certain part of the world.

PJ

Yes. Well, the Governor wanted to be elected (in the worst [way]), and this never crossed my mind, so I didn't check with him. The Governor, by the way, helped us pay for that, personally.

HG

The first part or the second part?

PJ

Well, he didn't help pay for Andy, no. But there were lots of other artists. And the Governor was most, most helpful. But they weren't painted over—they were removed. Eventually all the canvases were removed; they don't still hang there. The Rauschenberg is in the Dallas museum.[17]

Rene d'Harnoncourt was the director of the Museum of Modern Art. As a trustee of that museum, Rockefeller was d'Harnoncourt's boss; Johnson was probably MoMA's most influential ex-employee, the designer that same year of the renovation of its signature garden, and a major donor. His mention of the FBI (rather than NYPD) might be Johnson misremembering, or it might have been his real understanding of Warhol's intentions at the time. But the phrase "absolutely delicious" calls up both Johnson's

15. Mel Juffe, "Fair's 'Most Wanted' Mural Becomes 'Least Desirable'", *New York Journal American*, April 18, 1964, 4.

16. Grace Glueck, "In Britain, What's a Government Budget Without Art?," *New York Times*, July 19, 1964, 12.

17. Henry Geldzahler, "Interview of Philip Johnson" (unpublished), 1982. Henry Geldzahler Papers, Yale Collection of American Literature, Beinecke Rare Book and Manuscript Library.

18. "Andy's was the one the governor turned down. He was a *méchant* boy that time." In Philip Johnson, interview with Billy Klüver and Julie Martin, 1990, audio recording.

19. The murder of Kitty Genovese, in which the young woman was killed reportedly within earshot of thirty-eight neighbors, had taken place that March in Kew Gardens, a Queens neighborhood which bordered on the Fairgrounds.

20. Kincade, "Silver Square 'So Nothing' at Fair it Satisfies Warhol," 6.

deep attitudinal alignment with Warhol (in another unpublished interview, he calls him "*méchant*" [naughty][18], echoing the indulgent tone of this interview's "impish") and his surprising political naïveté, which had had incalculably worse results thirty years earlier, before and during World War II.

The ethnicity that dared not speak its name was Italian-American (seven out of thirteen of the *Men* had Italian names). But Warhol's elevation of career criminals—with all their bruises and booking numbers—to the facade of a building which existed explicitly to promote a positive image of New York State to a predicted forty million visitors would seem to be reason enough to have the mural removed, especially for a Northeastern moderate running for the Republican nomination for US president against a much more conservative opponent at a moment when New York City was experiencing a well-publicized rise in its crime rate.[19] And it may be that Rockefeller's extraordinary role as a supporter of art and artists as well as his liberal views generally—not to mention his involvement in the destruction of Diego Rivera's mural at Rockefeller Center in 1934—prevented him from saying openly that it was outrageous and had to go. Indeed, the *World-Telegram* article in which Warhol is quoted affirming the silvered-over work as a more accurate reflection of himself begins with a reference to *Thirteen Most Wanted Men* as having been "deemed inappropriate for a Fair."[20] Here the reporter seems to be taking for granted that the various explanations provided in the press the year before were specious, and leaps to the most obvious conclusion—and the one that may be, viscerally, the truest.

Everyone remained friends. Nelson Rockefeller was New York State governor until 1973, and though he was the one who gave the order that the mural must go, in 1967 he commissioned Warhol to do his own portrait and, in 1968, one of his wife, Happy. Johnson, occupied at the time not only by the New York State Pavilion but by the New York State Theater at Lincoln Center—funded in part by Rockefeller's office and made possible by Robert Moses's urban renewal policies—and the new garden at the Museum of Modern Art, almost certainly worked with Warhol to select silver as the color to paint over *Thirteen Most Wanted Men*. Johnson remained an important ally of the artist and a collector of his work, commissioning his own portrait in 1972 for which Warhol used a photograph taken in the summer of 1964 as source material.

The interviews that follow were conducted over the course of about ten months in 2013 and 2014, while the exhibition was being prepared. Together, they represent aspects of the forces at work on an artist famous for refusing to describe his own motivations, as well as glimpses of the social and political currents uppermost at the time in the lives of the major players. We hope to have opened a space for the essence of the story, as Virgina Woolf might have phrased it, to "rise up in a fume," without taking the place of an artwork that is, above all, a gesture—a powerful act that supersedes words.

Larissa Harris

Warhol's *Time Capsules* are a collection of approximately 600 boxes of odds and ends created as the artist swept the contents of his desk into a box and sealed them up. Much of the material reproduced in this publication, including the NYPD's *Thirteen Most Wanted* booklet, was found as the *Time Capsules* were catalogued by The Andy Warhol Museum over the last twenty years.

Though he received the commission in December 1962, it took five months for Warhol to find an idea for his slot on the New York State Pavilion. According to poet John Giorno, Warhol's lover at the time, it was at a dinner party in April 1963 that painter Wynn Chamberlain suggested that the Most Wanted Men would be a wonderful choice for the World's Fair—and that Chamberlain's boyfriend, a policeman with the NYPD, could bring Warhol a stash of police department-related materials. Indeed, this pocket-sized police department booklet, used as source material for the mural, was found in a *Time Capsule* decades later.

THE

THIRTEEN

MOST WANTED

POLICE DEPARTMENT

City of New York

1

INVESTIGATION OF HOMICIDE

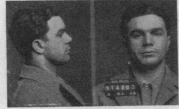

JOHN MAZZIOTTA

ALIAS

Chappie, Mazzotta, Massa, Mazza, Marlow, Marlo, Squinty.

DESCRIPTION

Age 42 (1957); ht. 5'5''; 160 lbs. (stocky); straight nose; brown eyes; black, wavy hair; medium ears. A slow talker with deep gruff voice. There is a three-inch scar in center of forehead and 10-inch scar over left hip. There is a tattoo on upper left arm—head and bust of sailor girl with "JM 1931"—and on right forearm—airplane with "JM."

FINGERPRINT CLASSIFICATION

4	0	9	U	100	17
	L	17	T	00	

P.D. No. B 114,803 66th Squad

Issued September, 1955

CIRCUMSTANCES OF CRIME

Sought for questioning in murder of Arnold Schuster, who supplied the information which led to the arrest of Willie Sutton. Schuster, 24, was shot while walking near his home on March 8, 1952, at the entrance to an alley at 913 45th Street, Brooklyn.

BACKGROUND INFORMATION

Mazziotta has a record of 38 arrests, the last 33 for bookmaking, two for robbery, one each for petit larceny, unlawful entry and vagrancy. He has been indicted by the Kings County Grand Jury for Criminally Receiving in connection with the revolver found near the scene of the crime which was stolen with seven others from a shipment on Pier 22, Brooklyn. Two others implicated in the theft were apprehended and convicted. Rewards of $25,000 put up by the City of New York and $1,000 by the Patrolmen's Benevolent Association are outstanding.

3

2

HOMICIDE

JOHN VICTOR GUISTO

DESCRIPTION

Age 38 (1957); ht. 5'8''; weight 170 lbs.; blue eyes and brown hair. Previous occupations were laborer, helper, chauffeur. Last known address, 37 Cornelia Street, New York City. He is known to frequent dice and other gambling games and spends freely on female entertainment and liquor.

REWARD

A reward of $25,000 for the arrest and conviction of the killers of William Lurye is posted by the International Ladies Garment Workers Union.

FINGERPRINT CLASSIFICATION

18	0	29	W	10M	
	I	24	W	101	19

P.D. No. B 136,592 14th Squad

Issued September, 1955

CIRCUMSTANCES OF CRIME

On May 19, 1949, William Lurye, an organizer for Local 60 of the International Ladies Garment Workers Union was stabbed while in a telephone booth in the hallway of 224 West 35th Street, Manhattan. He died the following day.

BACKGROUND INFORMATION

Guisto was on parole from Wallkill Prison at the time of occurrence, having received a sentence of five to ten years on a charge of assault and robbery in 1940. He was paroled April 10, 1944. Previously, he was arrested as a disorderly person in Jersey City and for grand larceny and possession of a dangerous weapon in New York City. A second man, Benedict Macri, was tried for the murder of Lurye in 1951 and was acquitted.

4

3
HOMICIDE (KNIFE AND HAMMER)

ELLIS RUIZ BAEZ

ALIAS

The Professor, Ellis Baei, Ellia Ruiz Baez.

DESCRIPTION

Male, white (PR), 55 yrs. (1957); 5'6"; 155 lbs., brown eyes, black hair mixed with gray, scar on upper side of the forehead, upper teeth missing, hernia scar on the abdomen, wears glasses. (Pedigree in 1943).

FINGERPRINT CLASSIFICATION

17 O 27 W III 11
　　L 28 W OII

P.D. No. E-13,245 18th Squad

Issued September 10, 1956

CIRCUMSTANCES OF CRIME

On January 20, 1943, Martha Punt, female, white, 14 years, was found stabbed and beaten to death in bedroom of apartment 16, 513 West 59th Street, Manhattan, occupied by Ellis Ruiz Baez. (Residence).

BACKGROUND INFORMATION

Born in Bayoman, Puerto Rico, came to United States in 1917. Had been employed at the Hotel Plaza from 1927 to 1943 as a waiter and dishwasher. Registered in draft at Local Board #23, 1860 Broadway, New York City. Seeks employment in hotels as dishwasher or waiter. Social Security No. 085-07-6578. Indicted by the New York County Grand Jury on January 5, 1945. Proceedings have been instituted by the Federal Bureau of Investigation for Flight to Avoid Prosecution.

5

4
INVESTIGATION OF MURDER AND ROBBERY

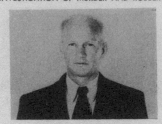

REDMOND CRIBBEN

ALIAS

James Daniels, R. Gribben, Mike Malloy, Frank Ryan, Frank Dooley, Frank Carney, "Minnie" and "Ninny."

DESCRIPTION

Age, 44 (1957); ht., 5'8"; wt., 190 lbs.; blue-gray eyes; brown hair turning gray and balding; stockily built. There is a large oval birthmark covering the back of the left hand, a small scar over the right eye, a scar on the right side of the nose, a small dark brown oval birthmark on the right shoulder and an appendectomy scar. He has worked as a tile setter and laborer.

FINGERPRINT CLASSIFICATION

16 M 1 U 101 6
　　M 1 U 101

P.D. No. B 95,097 16th Squad

Issued September, 1955

CIRCUMSTANCES OF CRIME

Wanted for questioning in holdup of Chase Manhattan Bank, Woodside branch, on April 6, 1955, and in murder of John McQueeney in a bar and grill at 52nd Street and 9th Avenue on November 23, 1954. He is sought by the FBI for unlawful flight to avoid prosecution since January 1, 1955.

BACKGROUND INFORMATION

After two arrests for grand larceny, both dismissed, Cribben was convicted for murder in the second degree in 1931 and sentenced to 25 years to life. He was paroled from Wallkill Prison on June 28, 1948 after serving 17 years. Thomas "Duke" Connelly, also on this wanted list, is believed to be an associate in the holdup of the Chase Manhattan Bank .

6

5
BURGLARY

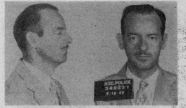

ARTHUR ALVIN MILLS

ALIAS

Skin, Samuel A. Mills

DESCRIPTION

Age, 41 (1961); height, 5' 10"; weight, 155 lbs., slim build, brown hair, blue eyes, small nose, fair complexion. Address, 12 West 184th Street, Bronx; Occupation, welder. Likes to fly small private airplanes.

FINGERPRINT CLASSIFICATION

15 M 31 W 100 17
　　I 27 W 010

P.D. No. B348,231

Safe, Loft & Truck Squad

Issued May 29th, 1961

CIRCUMSTANCES OF CRIME

Mills pleaded guilty to attempted grand larceny, 2nd degree and jumped bail of $5,000; bench warrant issued January 31st. With associate, Frederick Reiner, arrested by detectives as they emerged from 855 Sixth Avenue, on August 15th, 1960, with proceeds of safe cracking in building. On March 16th, Reiner sentenced to 1½ to 2½ years in State Prison.

BACKGROUND INFORMATION

Mills is a known safe burglar and lock picker. Possesses nine arrests. Convicted of federal charges in Pennsylvania in 1944 for forgery and in Ohio in 1949 for theft of interstate shipment, and in 1958 by the State of Georgia for safe burglary. When last seen was driving a 1956 pink Cadillac with black top, registered to him at 94 22nd Street, Barbetto, Ohio, license D946N, Ohio.

7

6
INVESTIGATION OF ROBBERY

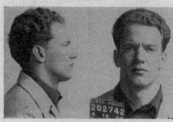

THOMAS FRANCIS CONNELLY

ALIAS

"Duke," "Tommy."

DESCRIPTION

Age, 32 (1957); ht., 5'9"; wt., 175 lbs.; blond hair; blue eyes; medium build; fair complexion. There is a two inch scar on the outer left wrist. A steam fitter by trade, his last known address is 315 West 15th Street, Manhattan.

FINGERPRINT CLASSIFICATION

20 M 1 U II0 6
　　L 1 U 0II

P.D. No. B 202,742 110th Squad

Issued September, 1955

CIRCUMSTANCES OF CRIME

With Redmond Cribben and at least one other, Connelly is wanted as a prime suspect in the holdup of the Woodside branch of the Chase Manhattan Bank on April 6, 1955. Eleven persons were held at bay by machine guns as the bandits made away with $305,243.17 prior to the opening of the office for business.

BACKGROUND INFORMATION

Traces of Connelly's flight turned up on July 27 when his two children were found abandoned in Baltimore. A car belonging to Connelly was found on August 29 in a parking lot at Folly Beach, South Carolina, near the house in which Elmer Burke was captured the day before. Connelly's wife, Ann, is believed to have accompanied him. His record shows six arrests, four for burglary, one for dangerous weapons and one for petit larceny. Strong and well built, Connelly likes to show off his acrobatic ability in bars.

8

7
GRAND LARCENY

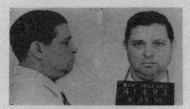

SALVATORE VITALE

ALIAS

Sal Vitale.

DESCRIPTION

Age, 54 (1957); ht., 5'3"; wt., 200 lbs.; straight black hair, slightly gray on sides; olive complexion; blue eyes; round chubby face; irregularly cut scar below left nostril; cut scar top of forehead at hairline; short and stocky build. Last known address, 9 Prince Street, Manhattan; born in Cinic, Italy.

FINGERPRINT CLASSIFICATION

16	O	21 W	M	0 0	17
	0	28 W	M	0 I	

P.D. No. B 107,032
 Special Frauds Squad

Issued July 20, 1957

CIRCUMSTANCES OF CRIME

Vitale was indicted by the New York County Grand Jury on January 3, 1957, on six counts of grand larceny in aspirin switch confidence game. Poses as possessor of $50,000 seeking to return to Italy with it. Accosts victim on street, supposedly seeking a 'builder" who was to help him. Victim, induced to perform this service by accomplice who flashes bundle of cash, withdraws money from a bank to show good faith. He is sent for aspirin to help illness feigned by perpetrator. Victim leaves money with the perpetrators and when he returns with drugs, they are gone.

BACKGROUND INFORMATION

Vitale has a history of thirteen arrests, among them two for violation of Harrison Act; one each for suspicion of murder and violation of immigration laws; larceny by fraud and trickery, four times. Moves from city to city; arrested for aspirin switch in Pennsylvania and Louisiana.

9

8
MURDER

ANDREW FERRAIOLA

ALIAS

Andy Ferraiolo, Allen Gerviatz, Allen Gauiatz.

DESCRIPTION

Age, 39 (1957); height, 5'6"; weight, 130 lbs.; black hair; thin face; sharp features. Dresses neatly and makes a good appearance. Occupation was longshoreman and auto electrician. Frequented dice games and race tracks. Resided with wife and son at 45 Bay 28th Street, Brooklyn. Previous address, 2238 86th Street, Brooklyn.

FINGERPRINT CLASSIFICATION

7	I	9	R	t	17
	M	17	U	t	

P.D. No. E37,376 62nd Squad

Issued February, 1956

CIRCUMSTANCES OF CRIME

Ferraiola is accused of the murder of Andrew Guagente, 51, of 1011 Neck Road, Brooklyn. On January 14th, 1945, as Guagente and two others left a garage at 133 Bay 38th Street, Brooklyn, where Guagente operated a dice game, the three were accosted by Ferraiola. In Guagente's car, Ferraiola fired three shots, two of which took effect, killing Guagente. Ferraiola fled with $1,700 from Guagente's pockets.

BACKGROUND INFORMATION

Ferraiola is under indictment for murder by the Kings County Grand Jury and is wanted by the F.B.I. for unlawful flight to avoid prosecution. He disappeared the same day after threatening the two witnesses. Was seen in Missoula, Mont., soon after and, on October 28, 1945, registered at a hotel in Spokane, Wash., using the name of Allen Gerviatz or Allen Gauiatz. No previous criminal record.

10

9
GRAND LARCENY

JOHN STRZELECKI

ALIAS

John Steck.

DESCRIPTION

Age, 50 (9/6/11); height, 5'8"; weight 180 lbs.; stocky build, brown hair, blue eyes, fair complexion. Occupation, cashier. Deformity, left leg shorter than right leg, walks with noticeable limp, wears built up shoe. Resided with wife at 488 Oakland Avenue, Cedarhurst, L. I.

FINGERPRINT CLASSIFICATION

None

 109th Squad

Issued, October 19, 1961

CIRCUMSTANCES OF CRIME

On Oct. 12, 1958, Strzelecki, a cashier for United Parcel Service at garage, 133-35 37th Ave., Flushing, failed to deposit receipts of $13,013 in office safe. He called his wife and stated he was "fed up and leaving." When he did not report for work on Oct. 15, officials of company notified police. Employed by company sixteen years.

BACKGROUND INFORMATION

Not criminally known to department. High school education. Frequents race tracks, possibly in Florida, California. Indicted by Queens County Grand Jury, district attorney will extradite. Wanted by F.B.I. for unlawful flight to avoid prosecution.

11

10
FELONIOUS ASSAULT — BAIL JUMPING

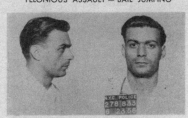

LOUIS JOSEPH MUSTO

ALIAS

Louie, Tony

DESCRIPTION

Age, 29 (1959); ht., 5'8"; wt., 145 lbs.; medium build, brown hair, brown eyes, small straight nose, dark complexion. Occupation, bartender, chauffeur, laborer, ship scaler, truck driver. Last address, 196 Mott Street. Tattoos: two hearts and "True Love to Mother 1946" upper right arm, cross and "Memory Dad, April 11, 1935" lower right arm, cross and "Pals Tommy Monk House" (or Mouse) upper left arm, 6" dragon lower left arm.

FINGERPRINT CLASSIFICATION

23	L	6	U	000
	I	8	W	101

P.D. No. B 278,833 7th Squad

Issued, October, 1959

CIRCUMSTANCES OF CRIME

On June 23, 1956, at 2:45 a.m., in bar at 60 Clinton Street with two others, Musto is accused of beating Norman Mais, a U.S. Navy seaman, with a baseball bat, the victim suffering fractured ribs and shoulder. Vincent Potenza, 57 Spring Street, pleaded guilty to assault, third degree, in this case, sentenced to six months, suspended sentence. Grand Jury failed to indict third man.

BACKGROUND INFORMATION

Released in $5,000 bail, Musto did not appear for trial. Bench warrant issued for bail jumping, felony, Dec. 21, 1956, by General Sessions Court. Nine previous arrests, including felonious assault. Convicted, 1952, attempting to take prisoner from police officer. Musto is wanted by F.B.I. for conspiracy and theft from interstate shipment, and by the 114th squad as a robbery suspect.

12

11
ROBBERY

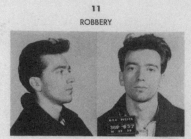

JOHN JOSEPH HENEHAN, JR.

ALIAS

John Hennessy

DESCRIPTION

Age, 22 (1960); height, 5' 10"; weight, 150 lbs., slim build, brown wavy hair, brown eyes, fair complexion. A laborer and storm window installer, his last address was 24-64 28th Street, Astoria. Tattoo marks: on left arm a panther and a rose with Eileen and John; on right arm, a heart.

FINGERPRINT CLASSIFICATION

22	I	31	W	110	20
	O	27	W	010	19

P.D. No. B 369,857 107 Sqd.

Issued June 27, 1960

CIRCUMSTANCES OF CRIME

On February 28, 1959, with three others, entered a liquor store at 153-07 Horace Harding Boulevard and, at gun point, removed $350 from register, $70 from owner, $450, watch and ring from unlocked safe. The others, James J. Donovan, 21, 19-05 22nd Road, Salvatore Puliafica, 19, 29-14 25th Avenue, and Frank Palmieri, 22, 22-90 26th Street, all convicted, Donovan, in whose home the gun was recovered and Palmieri sentenced to Sing Sing, Puliafica to Elmira.

BACKGROUND INFORMATION

Arrested February 3, 1956 for possession of gun, he was adjudged a youthful offender, and was paroled from Great Meadows November 19, 1957. Arrested October 26, 1958 for possession of heroin and needle, acquitted. Indicted for robbery by Queens County Grand Jury, also wanted for unlawful flight by F.B.I.

13

12
MURDER

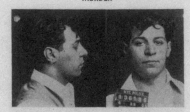

FRANK BELLONE

ALIAS

James Bellone, "Tanky."

DESCRIPTION

Bellone is 44 years old (1957); height, 5'7"; weight, 170 lbs.;; brown eyes, black hair. A restaurant worker, he was known to frequent cafeterias in the vicinity of 14th Street, Manhattan. Last known address (1935), 237 East 16th Street, Manhattan. Indicted for murder, August 28, 1935, by the New York County Grand Jury.

FINGERPRINT CLASSIFICATION

5	O	29	W	110	16
	I	18	R	011	

P.D. No. B 136,196 9th Squad

Issued September 17, 1956

CIRCUMSTANCES OF CRIME

Bellone is sought for the murder of Michael Macagnone of 1013 Willoughby Street, Brooklyn, on July 19, 1935. The victim left a female friend at 415 East 13th Street at 8:30 P.M. and was walking east when he was shot down by two men in a passing sedan who fired a volley of shots at him. He suffered three gunshot wounds and died two hours later in Bellevue Hospital.

BACKGROUND INFORMATION

The victim, 22 years old, refused to give information. He had been in the fruit business and had been shot in 1934. He had one arrest for robbery. On August 27, 1935, Joseph "Piney" Armore, 441 East 16th Street, was arrested for acting in concert with Bellone. Armore was sentenced to 2½ to 5 years. Bellone is a fugitive wanted for unlawful flight to avoid prosecution. He is also sought for draft evasion.

14

13
ASSAULT AND ROBBERY

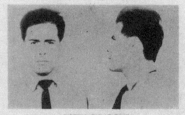

JOSEPH FUNGONE

ALIAS

Harry Lyson, John Hayes, Harry Boland, John E. Dunn, John Williamson

DESCRIPTION

Age, 27 (12/7/34), 5'7", 140 lbs., brown eyes, black hair, dark complexion, small nose, crescent shaped scars under each breast. Good dresser, neat appearance, well-spoken. Previous occupation, seaman. Addresses: 132 E. 34th St., 120 E. 34th St., 225 E. 17th St., Manhattan.

FINGERPRINT CLASSIFICATION

15	M	I	R	III	6
	S	I	T	II	

P.D. No. 301,371 83rd Squad

Issued, November 26, 1961

CIRCUMSTANCES OF CRIME

Armed with an automatic, on June 6th, robbed Airmarine Travel Agency, 1432 Myrtle Ave., Brooklyn, of $10,000 in American Express and First National City Bank traveller's checks and $300 in cash. Wanted by other squads for twenty additional robberies, all but most recent committed alone.

BACKGROUND INFORMATION

Indicted by Kings County Grand Jury Sept. 22nd. Arrested 1951 for burglary in 120th Pct. Released from Federal penitentiary, Lewisburg, Pa., in 1957, interstate transportation of stolen property, parole expired December, 1960. Specializes in holdups of travel agencies, telegraph offices, and other establishments where traveller's checks may be obtained. Aliases accumulated in passing traveller's checks in better night clubs, hotels, clothing stores, etc. and banks.

15

BUREAU OF PRINTING
POLICE DEPARTMENT
CITY OF NEW YORK

In early 1963, Warhol was repurposing imagery of suicides, car crashes, an electric chair, and civil rights protestors clashing with police from newsmagazines and other sources into paintings now known as the "Death and Disaster" series. At the same time, he had received his first portrait commission, in which he tiled multiple photo-booth shots of his subject, socialite Ethel Scull, into a multi-colored grid of animated poses. *Thirteen Most Wanted Men* can be seen as part portrait, part "Disaster."

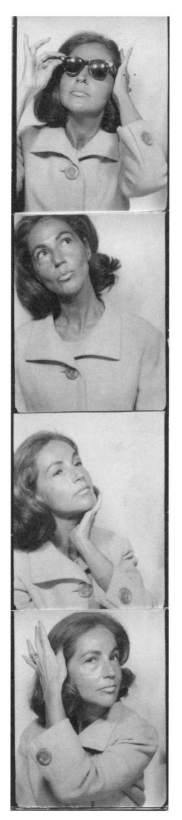

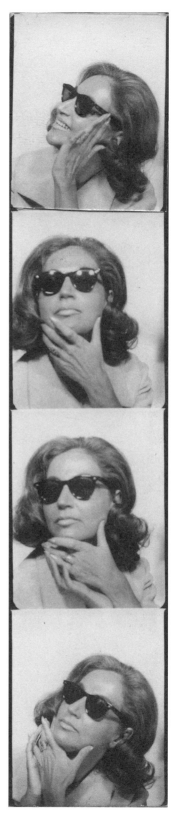

Part of Warhol's "Disaster" series, the first paintings featuring an electric chair were made in early 1963. Most of these repeated a single image of an electric chair over a large canvas. In 1963, Governor Rockefeller ended the death penalty in York State. Warhol began the *Little Electric Chairs*—in which a single image is centered on a canvas sized to the screen, as pictured here—in the winter of 1964–65.

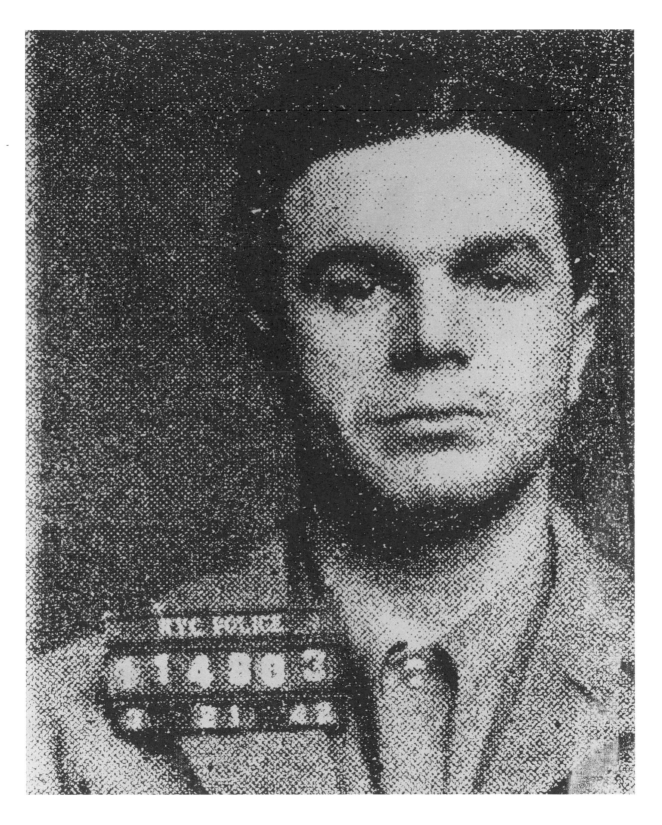

"He was a commercial artist. It was the kiss of death."

The "star" of Andy Warhol's film *Sleep* in 1963, the initiator of *Dial-a-Poem* in 1968, and the subject of an upcoming one-man exhibition at the Palais de Tokyo in 2015, artist and poet **John Giorno** has been an inspired and influential catalyst and connector for generations of New York visual artists, writers, and performance-makers. Here he recalls, in conversation with curators **Nicholas Chambers** and **Larissa Harris**, an ambitious Warhol working in unfriendly conditions in the first half of the sixties, the intimacy of an art scene "before everyone had a retinue," and a postwar generation hitting its stride.

John Giorno
I'm not a part of the modernist New York School of poets. I'm not a part of the lyrical Beat Generation. I'm not a part of any of those things, although I've used some of everything to invent myself as a poet. It started in 1961 and '62—meeting Andy Warhol, you can imagine, set me off on another trajectory. I said, "If he can do it, why can't I do it?" Andy was unknown, but his brilliance was obvious.

Larissa Harris
How old were you then?

JG
In my early twenties. Twenty-four?

Nicholas Chambers
Andy was born in '28, so he would have been thirty-two. Do you remember some of the first times you encountered each other?

JG
Yes. I saw him first in 1962. That year there were a thousand openings. Everyone was having their first show. Frank Stella was having his second show. They were all really unknown, and there were about eighty of them, and they all knew and loved each other and nobody was paranoid. I had seen Andy at a couple of openings, like "The New Realists" at Sidney Janis on October 31. I was introduced to him at his solo show, which opened at Eleanor Ward's gallery on November 3. That was my first moment with Andy.

LH
In a way, even though he was older than you, he was also starting out. When he started making paintings, he'd already had a career as an illustrator, right?

JG
Yes, but he was hated by everyone in the beginning. This small group of people—Henry Geldzahler, Frank Stella, and Barbara Rose—loved him, but it was an insular group. All those stories of him being rejected by those abstract painters and the Twelfth Street Gallery are all true.

But he had such a great success in '62. I remember that Wynn Chamberlain gave a dinner before we went to see Yvonne Rainer do a new piece at the Judson Dance Theater. Andy and I and another friend rendezvoused at Wynn's dinner, then we went together to the Judson. The very next night was the opening of Jack Smith's *Flaming Creatures*, which each of us had seen at least twelve times in the two years before because Jack had endless loft showings. We would go on to see it another fifty times in the two years following because Jonas Mekas always included *Flaming Creatures* at the beginning of an evening, and if you wanted to see somebody's new film—

NC
You had to see *Flaming Creatures* again! [*All laugh.*]

JG
But that's another story. So we went together to Jack's opening, and that began this thing of seeing each other every night or every other night.

NC
One of the interesting things about this early period of Warhol's practice, say '62 to '64, is his incredibly rapid rise to prominence in the art world. Something that Larissa and I often return to, in this context, is just how audacious the *Thirteen Most Wanted Men* project seems. For such an up-and-coming artist to put that particular work in such a public space—the World's Fair, at the New York State Pavilion—seems like an incredibly bold and even politically motivated move.

JG
Andy was on speed in those years. It was his drug of choice. I did speed in those years, too, and I have a very positive view of drugs. Speed kills, as they say, and yes, it's true, all drugs can be a problem. But drugs can be very important to a person at a certain moment in their life, because it lets them realize something that maybe they wouldn't have.

So Andy . . . well, let's go back a little bit. You said he had a

career. He had a career as a *commercial artist*. And *that* was ter-rible. That was a curse. That was the thing that he couldn't get rid of. People who disliked him, like Allen Ginsberg, would say, "Oh, it's nothing but commercial art." He was a commercial artist. It was the kiss of death.

So, he reinvented himself. The paintings from '61 that he hadn't quite formed but that he formed in '62, they were heroic. When you take the right drugs—LSD or any kind of drug—at the right moment in your life, when you've developed all your skills. . . well, he had all his skills, and that's when he created the beginning of his body of work.

Speed makes you fearless. One of its good qualities is that it gives you a lot of infinite, positive adrenaline. If you give speed to a stupid person, you get a lot of dumb ideas, and if you give speed to Andy Warhol, you get a lot of great ideas. And that's what compelled him to do *Sleep* and all of the early films and all of the paintings.

That was until he got shot. He was told by his doctor, "If you take one more pill, you're dead." And, as you know, this always frightened him. So everything he did after that was highly calcu-lated. It was Andy, so everything was brilliant, but that risk-taking was gone.

But *Thirteen Most Wanted Men* was something else. And then he went on to the "Death" pictures, and those were so great. But then he knew enough not to do those for long, be-cause nobody wanted to buy them.

LH

Did you and the other friends involved know he was going to be doing *Thirteen Most Wanted Men* before it went up? What did you think about it?

JG

It was just another one of Andy's great ideas. Seeing Andy every day, or every other day, you saw what he did the day before, or what he took down from the firehouse, where he silk-screened it, and carried it on his shoulder—as you know from photos, he used to staple painting on top of painting—and every day you saw something different. He would put it up because somebody was coming to look at things. It just seemed like another great idea, and one appreciated that fearlessness.

It had all the qualities of Pop because wanted posters were in every post office in America. Wherever you walked in, it was just right in front of your face. And it was sort of sexual. Not gay, but gay and straight; incredibly sexual.

LH

Did you guys feel like it was very pointed, very related to the particular context of the World's Fair?

JG

Well, I think that it was one of those things that spontaneously arose. He had no idea what to do. He didn't want to do any of the things that he had already done. He had a small body of work, but he was obviously not going to do Marilyns. And it sort of fell into place.

Andy was always apolitical. I think that even when he did the painting of Robert Moses later [after *Thirteen Most Wanted Men* was rejected], he thought, "Well, that's a beautiful portrait!" Be-cause the image is the standard press photo of Robert Moses [*all laugh*]. Obviously this was the way that Robert Moses saw himself. So I think Andy probably naively thought, "Oh, well, he might like that!" [*Laughs.*] While also knowing that it was a car-toon—but hoping to get away with it. If he wasn't on speed, he maybe wouldn't have ventured such a thing.

NC

Indeed, and now, looking at the event in retrospect, it seems clear that the *Thirteen Most Wanted Men* proposal *had* to be censored. It couldn't *not* be censored.

JG

Well, that was my first intuitive feeling, but what the fuck? It's not my problem.

NC

Richard Meyer, in his book *Outlaw Representation*, discusses what was happening in New York in the lead-up to the fair—there was a sense of the city being "cleaned up," with the crackdown on gay bars.[1]

JG

I'm sure it was true.

NC

And to what extent do you think we can see Warhol's World's Fair mural as a response to this situation?

JG

That was all true. But like all great ideas, it wasn't conceptual; it was spontaneous. Ideas that are not so logical or intellectual are sometimes the best. Robert Moses had ruined the city by building the parkways all the way around the edge of Manhattan on both the Hudson River and the East River. He took down the gorgeous tenements and built all those tunnels and bridges and housing projects. It's a natural thing, of course. You have to clean up the city for the city's great triumph.

I'm sure Andy saw this, but he would never have ventured it as a political statement. But once it was there, I'm sure he was thrilled that it was a statement.

LH

Did you know Philip Johnson much?

JG

A little, over the years, but not so much. Later, I would run into him more at dinners uptown and at MoMA. But I knew David Whitney really early. Maybe even in '60, or '61 for sure, because we just hung around this small group of people. David Whitney worked installing shows as a job, helping Jasper and various others. And, of course, his lover was Philip Johnson and he lived in the Glass House.

My partner, Ugo Rondinone, is reading the John Cage biography right now and they talk about that—the worlds of David downtown and Philip in the Glass House. Philip kept it a bit separate, even though they were perfect lovers for all those years.

Then again, Philip was there. For instance, he bought the *Gold Marilyn* from the 1962 show. But he gave it to the Museum of Modern Art only six months later. He was a sort of formal, old-fashioned guy. He appreciated the *Gold Marilyn*, and I think he understood that it was one of those seminal things, but he didn't want to have it. David got him to buy it. That was really early, to dump it at the MoMA! But it was thrilling because it got there. It didn't have to go through ten auctions.

So that was Andy's world. He was there, and he was hugely successful. But there was always that edge of everyone loathing him, or not liking him, or liking him for the wrong reasons or whatever.

NC

Another thing we've been talking about is the *Thirteen Most Wanted Men* mural as a rare instance of censorship in relation to Warhol's work. Of course, there was another, not long before this. . . .

LH

While Jack Smith was filming *Normal Love* up in Connecticut, Andy had made a newsreel of it, which was then confiscated in a police raid of a screening of *Flaming Creatures*. So two Warhol works were censored in one year.

JG

I think that was the time Diane di Prima and others were dancing naked on the birthday cake. She was pregnant, I seem to remember. Naked and pregnant!

LH

Yes, and asked to jump off that cake about a hundred times [*laughs*]. So, what happened with you and Andy in '64? It was a fantastic affair—and then it was over?

JG

Andy sort of got rid of me at the end of '64. I totally adored him and loved him. I didn't realize that I was the first superstar he was getting rid of—because later he dumped all of the superstars one by one, they either died or he got rid of them—so I took it personally.

But then again, I'm also very thickheaded. When I get rejected, it's not my problem. I still saw him, at the opening of the Plexiglas of *Sleep* at Sidney Janis in the fall of '65, when *Sleep* was screened. I was still asked to these occasional parties, and went to them. But, at the end of '64 or beginning of '65, I met William Burroughs and Brion Gysin, and we became best friends, as you know, for the rest of our lives.

So that started, and that world was completely different from Andy's. I mean parallel but completely unconnected. We lived in the Hotel Chelsea when he was filming *Chelsea Girls*, but it was like another part of the city. We never ran into them in the halls or lobby while they were filming. And of course I got endless phone calls asking if I could try to get William to be in *Chelsea Girls*. And I said, "I'll see. I'll see. I'll ask."

And I would say to myself, "Fuck you, Andy Warhol! If I'm not in *Chelsea Girls*, William Burroughs is not going to be in *Chelsea Girls*!" [*All laugh.*]

But my life went on and evolved for another fifty years.

NC

John, did you go to the fair?

JG

I went out once before it opened. And then I never went again, because it was that world of Robert Moses.

LH

It's funny to read about the high-cultural crowd's attitudes towards the fair. Of course, it's the ultimate mainstream event. In a letter from Frank O'Hara to Larry Rivers, O'Hara talks about how every day Robert Moses would get in his helicopter and fly out to the World's Fair to inspect progress and then fly back to Manhattan. They are laughing at that excess, and really feeling separate.[2]

JG

As you know, in the early 1960s there was a vitality in the air. We were all young, but it was also that kind of magical moment where no one quite understands what's happening, except that it's unusual and exceptional.

I have a feeling that what happened was that, for the first time in the history of the world, there were several generations of educated people, all the children of immigrants. There was compulsory education from the late nineteenth century, so,

democratically, everybody more or less fulfilled his or her potential by going off to high school and on to college easily. This was the first time in history, because they were all children of immigrants.

And secondly, there was this vast wealth produced by World War II. There were always millionaires, but the middle class became hugely rich for the first time. After the Depression they had an abundance, which made them sort of fearless and naive.

And then the third thing was drugs—whether it was speed and grass in the late fifties with Jack Kerouac, or LSD and the psychedelic scene in the early sixties. So that was in the air at every moment of those years and decades, and one felt it. I was young and thought it was natural, but one didn't realize it was a rare moment.

LH

It was also a pretty small scene where, as you said, everybody knew everybody else. There is a sense that there was a single conversation going on, rather than it being so big and balkanized.

JG

Well, yes. In December of 1963, Wynn gave me a birthday party on the top floor of 222 Bowery, and he invited eighty or eighty-five people to come. The seven Pop artists were there, of course—Roy and his girlfriend, Claes and Patty, Jim and the others. Jasper Johns came and left a half an hour before Bob Rauschenberg came with his new boyfriend, Steve Paxton. Jasper and Bob had broken up the year before because of Steve. John Cage and Merce Cunningham came. Frank O'Hara and John Ashbery came, accompanied by the second generation of New York poets. Jonas Mekas and Ruth Kligman and George Segal, Yvonne Rainer and Bob Morris, Lucinda Childs and Jill Johnston and all those other artists came.

Not that they talked a lot together. You would see them standing together, never talking about much important, just being together—they weren't yet superstars, and everyone loved each other. Nobody knew who I was. I was this young poet who was in *Sleep*. But they didn't care. They came to this party because they wanted to be together, as they came to many parties in those years.

This was in '63. By '65, nobody went to any parties because they were all hugely rich superstars. Each had retinues, and each had a reason to dislike the other person's retinue. And then there was the polar rift between Bob and Jasper on one side, and the Pop artists and the Minimal and the Conceptual artists coming shortly after. So that was a rare time.

LH

Do you feel like it was a predominantly gay milieu? Or not?

JG

No. The world was basically straight, except for a number of us who were gay—Jasper and Bob, Merce and John. The Pop artists were straight. Andy was the only one who was gay.

But Andy was always at a disadvantage because people disliked him. And when you start out life in that position and it never changes, to my mind—and I have a bit of the same problem—it becomes like cancer. Whatever the problems were from '62 into '63, they were worse by '64 into '65. By '66 into '67, when Bob Rauschenberg was being called the "Grandfather of Pop Art," you can just imagine what was going on. So Andy was constantly rejected.

Then he got shot, and there was sympathy, and then he went on to make those other things, like the *Mao*. Skip to the end: In 1989—the year of the Andy Warhol retrospective—I was talking to Kynaston [McShine], who is an old friend from '61. He came here for dinner, and I talked about how Andy was always sort of hated, and he said, "John, when Andy Warhol died, he was more hated by the art world than at any other time in his life."

And I thought to myself, "Can you imagine how that felt?" Because it wasn't only '89, or when he died, it was every year before that. He was rich and famous, but when everybody who *you* like hates you, that's incredibly depressing. So I'm sure that when he died, at the moment of death, if anything flashed before him, it was this life of failure. Nobody ever thinks this of Andy, because of that myth of Andy. But this was his life.

I'm sure in the eighties he was so successful and he was a little looser about life and he was happier. But even though he was happier, this current from the late fifties never ended.

LH

And did that flow from a prejudice against his commercial aspects, or from the way that he treated people? Or from a combination?

JG

No, it's just karmic. I'm sure it started in Pittsburgh when he was a Czechoslovakian immigrant with that family and that mother. I've never quite gotten past this: that he was living with his mother in those years in the house. But even before, he was living in an apartment with her and she was cooking. I couldn't bear that!

So he has the disadvantage of being an immigrant still in a time when nobody's an immigrant anymore. And then there is the discrimination that comes from being so ruthlessly great at art. All of his art was so perfect, and it stood for him and he stood behind it. He would have loved everyone to love it, just as we all would like for people to like our work.

NC

Going back to the mural, within the milieu that we're talking about in the early sixties, was the homosexual reference embedded in *Thirteen Most Wanted Men* instantly recognizable?

JG

Oh, yes. But then again, it was straight and gay. Have you seen photographs of Frank Stella from 1963? He was skinny with a two-days-grown beard. He looked like one of the *Thirteen Most Wanted Men!* Everybody looked like that. Even George Segal with his beard! Everybody was very ordinary looking. So the thirteen were "most wanted" for everyone.

LH

There's also that famous Duchamp wanted poster, where he has himself photographed in profile and facing forward. That was one of the posters for the Pasadena show in 1963 that Andy visited.

JG

Yes, he went out to that in September or whenever it was.

LH

And that is understood as Duchamp posing the avant-garde as criminal. The rule-breakers. That's what they do—they break laws.

JG

It's true. Andy was so in love with Duchamp. Maybe he even recognized that as a mug shot. Or when he saw the mug shots, without even conceptually thinking, the two came together in his head to say "Yes." That's when everything is so perfectly connected and spontaneously arising as something great.

NC

Of course, a work that is closely related to the mural is *Thirteen Most Beautiful Boys*, of which you are one. What was that like?

JG

It was just one more thing that was happening!

I had an experience a couple of months ago. I went to the Museum of Modern Art because the Whitney was showing Andy's '63 movies and they asked me to be on a panel with Bruce Jenkins. It was just me and Jenkins, and I didn't know this, but he found in the Andy archive a movie of me washing dishes naked for twenty minutes! [*All laugh.*]

My apartment at 255 East Seventy-Fourth Street was where we shot *Sleep*. There was the sink, and I was standing there with my back and my ass to the camera, and I go like this [*gestures as if washing dishes*]. I had a hangover, and every dish was soaked and rinsed and put on the drainboard.

It was really Andy at his best because it's in black and white. Slowed so it's so nonsexual and so sexual.

LH

Also romantic.

JG

I couldn't believe my eyes! I don't even remember him doing that. I'd given a dinner party the night before, which I think he'd probably come to. When he called the next morning, he said, "What are you doing?"

I said, "I have to wash the dishes."

He said, "Can I come over?" That's how that happened, to be standing there naked. Life was like that.

Like with the Forty-Second Street photo-booth strip photos. We just did it. Ethel Scull was the first to do it, then three or four other people, and then me; I think we did it twice. It was just part of the day. I loved everything that Andy did in the world. Because I was a kid, I was happy to be a part of it.

NC

But *Sleep* was different, right? Because *Sleep* was the first and Andy truly didn't know what he was doing at that time with film, and had to shoot you numerous times to complete that piece.

JG

I've worked with many artists and many artist-filmmakers, and I know that you just do what they ask and you don't ask any questions. He obviously had bitten off more than he could chew and had to make something out of it, which he eventually did, with much suffering.

NC

There was a lot of attention paid to *Sleep* before he had even completed the film.

JG

Because Andy had this other career earlier, he knew all the fashion editors, like Bea Feitler, this incredibly great woman, who was co–art director of *Harper's Bazaar*. She slipped Andy into all their issues. *Sleep* with the photo was in the September '63 issue, and there was no film. Andy got enormous publicity, and *Sleep* was already in the *Village Voice* almost weekly.

NC

Another work that connects to the mural is Warhol's portrait of Watson Powell, *The American Man*.

LH

A commissioned portrait of the CEO of the American Republic Insurance Company.

JG

See, he liked what he did for Robert Moses! [*Laughs.*] Eleanor Ward couldn't sell the "Disasters," you know.

LH

Yes, he shifts from Eleanor Ward to Castelli at the end of that summer. An interesting move, to join that team.

JG

You know, I knew Eleanor. He had to do it. She was an elderly lady. She was a modest dealer and was modestly successful and represented all the abstract sculptors and abstract painters and in-between people, like Marisol and Bob Indiana. Everything was problematic. And even though he liked her . . .

I was going to say something, but I'm not going to say it now! I think he was relieved. And again, lucky to get into that world of Leo's.

1. Richard Meyer, *Outlaw Representation: Censorship and Homosexuality in Twentieth-Century American Art* (Oxford and New York: Oxford University Press, 2002).
2. Frank O'Hara, letter to Larry Rivers, April 18, 1964. Larry Rivers Papers, MSS293, Fales Library and Special Collections, New York University Libraries.

On January 28, 1964, Andy Warhol's datebook notes "New Studio, 231 East 47th." With a hand-operated elevator and no electricity, this workspace was where, in 1964, Warhol made the *Thirteen Most Wanted Men* Masonite panels and the canvases that followed them; the 3-minute film portraits known as the *Screen Tests*; the box sculptures including *Brillo Boxes*; and almost-innumerable *Jackies* and *Flowers*. The production of box sculptures started in February 1964 for his second Stable Gallery exhibition which would open April 21, 1964, the day before the World's Fair. It may have been the assembly-line-style labor required of Warhol and one or two assistants that gave the studio its name: the Factory. By the end of 1964 it had been almost completely covered in silver by Billy Name.

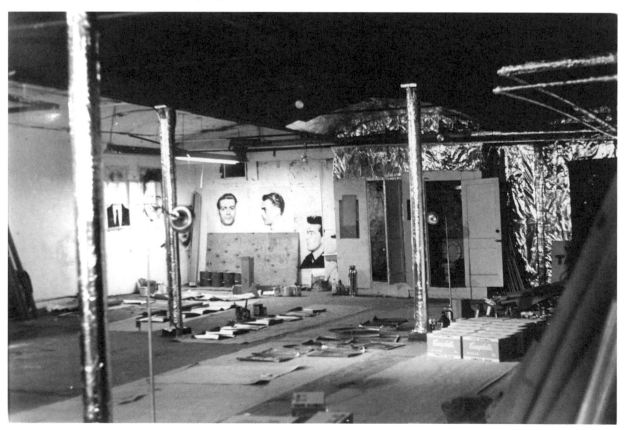

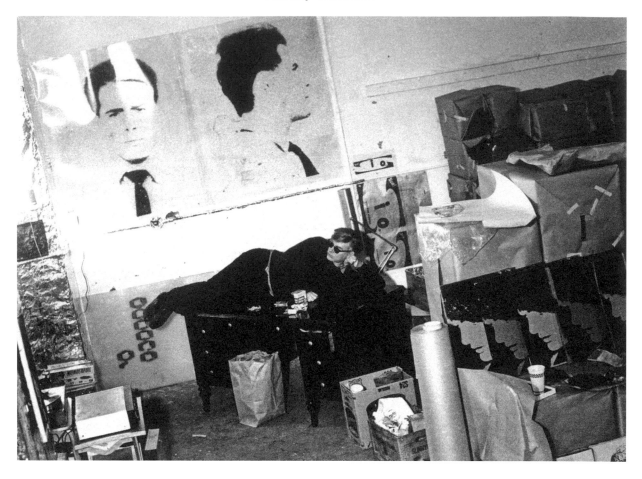

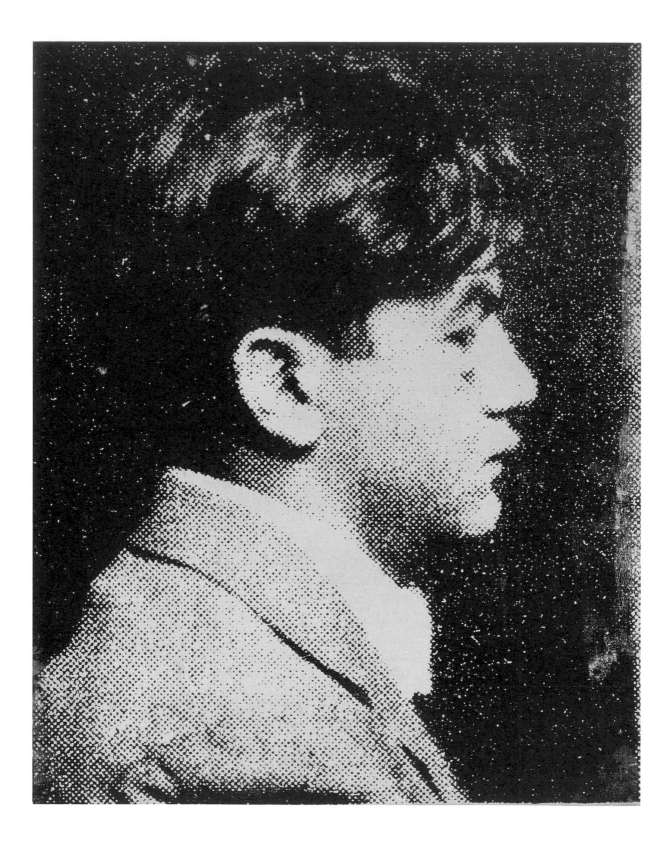

"He once had a two-ton Henry Moore delivered by helicopter."

Nelson Rockefeller (1908–1979) was the son of Abby Aldrich Rockefeller, one of the cofounders of the Museum of Modern Art, of which he was also a trustee; and grandson of Standard Oil founder John D. Rockefeller. He chose a career in public service, and at the time of the opening of the 1964 New York World's Fair, was the moderate Republican governor of New York State and in the midst of an unsuccessful run for the Republican presidential nomination, which the conservative Barry Goldwater would eventually win. According to Philip Johnson, architect of the New York State Pavilion, it was Rockefeller who ordered that *Thirteen Most Wanted Men* be painted over for fear of offending potential voters of Italian descent. (Seven of the criminals depicted in *Thirteen Most Wanted Men* were ethnically Italian.) Curatorial adviser **Timothy Mennel** talks with historian **Richard Norton Smith**, whose biography of Rockefeller was recently published by Random House, about Rockefeller's relationship to World's Fair President Robert Moses, to the Republican Party at a key moment in its history, and to art and collecting.

Timothy Mennel
Richard, you feel that Nelson Rockefeller was deeply an art lover and that this informed a lot of what he did politically.

Richard Norton Smith
I think so. In fact, I would define him in many ways by his love of art. He was dyslexic, but he had been raised to believe that he had a deficient IQ—his mother in particular told him, "Always surround yourself with people who are smarter than you," which in some ways is a tradition in the Rockefeller family. Both Senior (Nelson's grandfather) and Junior (his father) had built their reputations by collecting first-rate talent. But in Nelson's case, I think the dyslexia also contributed to a kind of visual intelligence backed by strong instincts about his immediate environment. These were great assets for a politician, certainly for a campaigner, sampling the endless diversity of New York. And then, of course, there was the enormous impact of his mother, Abby, herself a great art collector and one of the cofounders of MoMA. In their town house on Fifty-Fourth Street, she installed an art gallery, with changing exhibits reflecting the breadth of her taste and curiosity. Nelson grew up in this atmosphere. His father collected fifteenth-century tapestries as well as porcelains from the Far East. His mother began with Japanese prints and branched out to the Impressionists and more radical schools of nonrepresentational art. It was a very catholic approach to human creativity, and it surrounded Nelson Rockefeller from the cradle.

TM
And he was famously involved with modern art, both at MoMA and in his personal collecting.

RNS
Absolutely. His press secretary Bob McManus observed in the early sixties that he didn't know if the American people were ready to elect a president who collected modern art, but Nelson went right on collecting. Mark Hatfield, the governor of Oregon, was once given the grand tour of Nelson's Fifth Avenue apartment, which at that point had expanded to about thirty-five rooms, a museum itself, crammed full of world-class artworks. (Nelson had five homes, and he complained, "I'm out of walls. I've been out of walls for years.") After seeing this extraordinary collection of collections, Hatfield couldn't resist asking Nelson, "Of all your collections, what gives you the greatest pleasure?" And Rockefeller, without hesitation, said, "Oh, Mark, it's my china. Sometimes I get up in the middle of the night just to set the table."

TM
By 1964, what modern artists was he collecting, or which did he feel the most affinity with?

RNS
Well, he was not a big fan of Andy Warhol, nor of Pop art generally. He said as much. But he also made it very clear that he was not particularly interested in art that purportedly had a message to impart. Cubism had interested him from the beginning. He had Léger paint the staircase in his apartment. And Matisse did the mantel over the fireplace in the living room. As governor, he filled the executive mansion in Albany with the works of contemporary artists like Pollock, Motherwell, and de Kooning. He loved to conduct tours, to the head-scratching bafflement of state legislators, one of whom proclaimed that it reminded him of stuff they had referred to the Committee on Pornography. Nelson kind of laughed it off. He once said to a reporter—and remember, this is a dyslexic talking—"You know the problem with you guys is you're word people. You're all trained to think in terms of what it says, what it means, and to put it into words." His view was that it means, in effect, whatever you want it to mean, at any given time and circumstance. In other words, it isn't the artist who defines the work; it's the *owner*. Which is a truly radical notion.

Joe Canzeri, who was the manager of the Rockefeller estate

at Pocantico, remembered having delivered a large outdoor sculpture—Nelson littered the grounds there with dozens of pieces; he once had a two-ton Henry Moore delivered by helicopter while his brother David and a group of international bankers were playing golf on their grandfather's course. Canzeri told me that, having bought this other large work, he immediately had it repainted from red to black. The artist, not surprisingly, registered a stiff protest. And Rockefeller was genuinely surprised. He said, "Well, why did he sell it to me?" Now, that sense of entitlement is almost frightening. But it tells you a lot about Nelson's approach, not only to art but to most things.

TM

And so that sense of control was critical. It sounds like he was very attracted to large art, spectacular art, to Abstract Expressionism, modernism, interestingly, and not Pop.

RNS

No, not Pop. Remember, in Albany he built the Empire State Plaza, the state-government complex, otherwise known as the Mall, which is itself, in some ways, an outdoor series of sculptures playing off of the proximity to the Hudson and the surrounding hills. The shape of the Egg, famously, is one that had never been built before. Whatever you think of the Mall, it was designed as a showcase—some people would say one wasted on the New York State government workforce—of the New York School of Abstract Expressionist art.

TM

It's Storm King Art Center with a government attached.

RNS

But he *bought* all of that art. There are about eighty pieces, bought well in advance of the completion of the Mall, lest he find himself out of office and his political and cultural opponents decide to either cancel or significantly cut back on the project.

He once said that the more you think about art, the more you intellectualize art—I suppose the more you try to impart a message of any sort through art—the less aesthetic the experience. For him art was spiritual, it was an escape, a release, not something to be verbalized.

TM

Does this in your mind explain some of what happened with the Diego Rivera mural?[1]

RNS

Well, it's very clear that Nelson's father, John D. Rockefeller Jr., was ultimately responsible for the orders to remove the Rivera.

And what we know now is that the image of Lenin was a factor but probably not the determining factor. It was the presence of syphilitic microbes, symbolic of diseased capitalism. The old man thought the picture was obscene. That's the word he used. Which is different from politically offensive.

TM

Whereas Nelson would have been attracted to the *scale* of the mural.

RNS

Well, subsequent to that event, there was a municipal art exhibition at Rockefeller Center curated by Holger Cahill. And Cahill was nervous because the show included politically charged submissions. In particular, there was a painting called *The Smiling Face of Fascism*, which was a picture of Franklin Delano Roosevelt, and then there was another that had all the subtlety of a *New Masses* editorial: a distinguished lady serving tea while someone with an ax cut a picture off the wall—seemingly alluding to the Rockefellers destroying the Rivera mural. Cahill says to Nelson, "You know who that is?" And Nelson says, "Sure, I know." And then he said, "I don't care."

I think if Nelson had been left to his own devices—and you can certainly question his judgment—I'm not at all convinced that the Rivera mural would have come down. Nelson and his generation, including Philip Johnson and others associated with the Museum of Modern Art, wanted it to be a showcase for the avant-garde—for the politically incorrect, if you will. Which is an interesting forerunner of the controversy surrounding the New York State Pavilion at the World's Fair thirty years later.

TM

Let's turn to that. In some ways, you describe the Mall in Albany as this great fusion of artistic expression serving a governmental role as well. On a smaller scale, the pavilion is kind of that, too, right? It's something that's a monument to the state, but Johnson's design involves art in a very integral fashion. Do you think that Rockefeller played much of a role in influencing Johnson's design?

RNS

I doubt he influenced his design, though he picked Johnson for the job. The one instruction that I'm aware of was that he told Johnson that he wanted to make sure that it was the tallest pavilion at the fair. So you've got the vertical quality with the three towers, and then you have the circular theater, and of course the great map and the outdoor Tent of Tomorrow. It's an interesting smorgasbord of styles and attractions, and I'm sure there was never for a moment any doubt that it would incorporate the latest from the New York art world.

Nelson was not only about collecting art but about sharing it with and explaining it to a mass audience. In some ways he was a populist. He could be perfectly at home in a SoHo art gallery and in the refined precincts of MoMA, but he was equally comfortable in a union hall in Queens. And I'm sure if you'd asked him, he would have told you there was no reason why the folks in the union hall couldn't appreciate the art as much as the people at the MoMA cocktail party.

TM

But you would say it's probably not likely that Rockefeller took a detailed interest in what was actually going on with the Pop art at the theater. He would have endorsed the aim of putting the newest and the latest up there—

RNS

I don't know, to be perfectly honest with you. Given his interest in the fair, given his interest in the subject, it's hard for me to believe that he wasn't consulted or that he didn't express opinions. Now, given the controversy that arose—and this is speculation on my part—and based on the pattern going back to the Diego Rivera incident, other people could have called to his attention the political or cultural consequences of going ahead with Warhol's original artwork. It's not something that I think necessarily would have occurred spontaneously to him. But he's in a different position than in the early thirties, since in the early sixties he is governor of the largest state in the union and had been a leading contender for the 1964 presidential nomination.

TM

Let's talk about that, because certainly in the spring of 1964 Rockefeller is extremely busy, crisscrossing the country, spending a lot of time on the West Coast, campaigning. Can you sketch a little bit what else he was doing at the time?

RNS

Well, by this point most people have written off his chances for the presidency, in part because of his divorce from his first wife, Mary Todhunter Clark, and much more because of his subsequent remarriage to Happy Murphy, who was portrayed in the popular press as having in effect walked away from her four children in order to marry Nelson. He was seen as something of a corpse politically by the end of 1963.

TM

And yet he's persisting in the campaign.

RNS

He not only persisted, I would argue that the real relevance of that '64 campaign is its foreshadowing of the rift in the Republican Party ever since. Nelson Rockefeller came from a tradition, for example, that was very strongly committed to civil rights. Nelson quietly paid Martin Luther King Jr.'s hospital bills when Dr. King was stabbed in Harlem in '58. He was a generous supporter of the Student Nonviolent Coordinating Committee. More importantly, New York State under Rockefeller passed a series of pioneering pieces of legislation that were designed to end the obvious impact of segregation and to give the state the power to overrule local zoning authorities, so as to build public housing in places where the predominantly white population opposed the idea. These were ideas that would not be attempted in today's political climate.

Then project this to the national scene. He's running against Barry Goldwater, who is in many ways a forerunner of the Tea Party. Goldwater could by no means be described as personally a racist, but he was of the rugged-individualist wing of the party that genuinely believed there was no constitutional right to force integration. For example, he was one of only six Republicans who voted against the '64 civil rights bill.

This conflict comes to a head at the famous scene at the '64 convention—in many ways Rockefeller's finest hour—where he is on the podium, speaking on behalf of a platform amendment denouncing extremism and mentioning specifically the Ku Klux Klan, the American Communist Party, and the John Birch Society. It was a national embarrassment for the party, because of the booing from delegates and those in the galleries, who themselves represented the future of the Republican Party. That night the Republican Party changed, permanently, and Nelson Rockefeller was the catalyst.

Rockefeller in his '64 campaign was not simply a man driven by ambition—although there is certainly that—or even a man who refused to believe what all the polls and the pundits said in terms of his own chances. He thought he was fighting for the soul of his party. And in April 1964, when the campaign had not been going well, Nelson had to make a decision. Does he go on? If he does, he has to commit everything to the Oregon primary, where he was in fourth place in the polls going in. And he did, and he came from behind, and he won. But of course it didn't do him any good when he lost the California primary a few weeks later.

TM

And so the Oregon primary is happening just as the run-up to the fair is happening, so he's out there, not in New York.

RNS

Absolutely, the Oregon primary is in May, but Nelson spent something like twenty-one days campaigning in Oregon. So while this is going on, he's also got the opening of the New York State Theater at Lincoln Center—

TM

—also designed by Philip Johnson—

RNS

—and made possible by a Nelsonian sleight of hand that got $15 million for it out of the state legislature, ostensibly because of the World's Fair, notwithstanding that it was nowhere near the World's Fair. Lord knows what they traded for that. And then, of course, he had the aftermath of the state liquor board scandal, which was the one significant scandal to mar his governorship—

TM

Before we get too much into that, there is an interesting resonance between the race issue and the crime issue. These are the two things, especially crime, that are very vivid in Warhol's mural.

RNS

In the early sixties, crime is beginning to be an issue. What you see in the early sixties is the first early signs of cultural issues, including crime, including prayer in the schools, including a whole host of issues that foreshadow what often dominates our modern political discourse.

To show you how at odds Nelson was with later Republican orthodoxy, there was the famous case of the "Capeman," which was fodder for the tabloid press. This was the case of a sixteen-year-old named Salvador Agrón, who had been sentenced to death for the murder of two other teens in a gang fight. There was an enormous swirl of controversy around this case, and no one disputed the facts, but Agrón's upbringing, his family background, even his mental status all factored into the debate. Eleanor Roosevelt petitioned for leniency, as did one of the parents of one of the victims, and it fell to the governor to address the matter in a public hearing. Rockefeller was not a spellbinding orator—partly because of the dyslexia, he couldn't read a script. But he was very good extemporaneously. He had obviously studied the brief, and he raised a series of questions. He asked those who were pleading for leniency, "When this boy was growing up, where were you then? When this boy's family was coming apart, where were you then?" These questions in effect answered themselves. And then he commuted the sentence. I don't think a politician today, given those circumstances, would have acted in that way. Remember, it was under Nelson Rockefeller that New York State for all intents and purposes eliminated the death penalty. It was under Nelson Rockefeller that New York State advanced the most liberal abortion law in the nation before *Roe v. Wade*, and *Roe v. Wade* drew significantly upon New York State's action. And when the legislature changed its mind and voted to repeal what it had done, he vetoed that. This is someone who represents what once was a vigorous stream of Republican thought: fiscally conservative,

socially liberal. That, in a nutshell, is Rockefeller Republicanism. And for the last thirty-plus years, its opponents have run against it. Which is the bridge to where we are today, with the Tea Party.

TM

Going back to the crime question: given his general liberality and his approach to these subjects, it's interesting that early 1964 sees him pushing for laws allowing no-knock police searches and expanding the scope of cops' ability to stop and frisk people on the streets.

RNS

Absolutely, that attitude coexisted with his liberalism, even before the 1973 "Rockefeller drug laws," which have become a metaphor for what many people believe is an overly harsh, unrealistically punitive government stance against even relatively minor usage or sale of drugs. Certainly they contributed to a surge in the prison population in New York State. Understanding how he could hold both perspectives goes to, I think, not only the public man but in many ways the private man.

Nelson Rockefeller believed there was no such thing as a problem that couldn't be solved. Every problem had a solution, if you brought together the right combination of talent, resources, goodwill, and expertise. It goes back to surrounding yourself with people smarter than you are. Every problem could be solved. And when intractable problems, like drugs, appeared in front of him, he refused to believe otherwise. In '63–64, a lot of what he was proposing—the no-knock laws and the like—were seen as innovations, and that grows out of his attitude: "What we're doing isn't working. Therefore, let's try this."

TM

"Let's try something else."

RNS

Exactly. And that, in turn, is the attitude of someone who basically did not have an ideology. When people call him a liberal, certainly by comparison with others in the Republican Party then and now, that's logical. But he was, much like the hero of his youth, FDR, really defined by a pragmatic approach to solving problems.

TM

To return to the liquor board scandal, this was really trouble for him because it was not pragmatic at all. It's exactly what everyone fears about government. One of Rockefeller's closest aides was tied to corruption at the State Liquor Authority, prompting Rockefeller to try to reform the liquor laws, to the point of calling the state legislature back into special session on April 15—just as

Thirteen Most Wanted Men was being installed, coincidentally—in order to press his case.

RNS

Not only that, but Rockefeller appealed to the "good government" instinct. People felt that obviously he was incorruptible because no one could buy him.

TM

No one could corrupt him.

RNS

Exactly, there was not a price. But obviously, there were prices. When he ran for governor, it was the first time he had ever run for office. It was kind of a hostile takeover of the state-party structure in New York. And he made some promises along the way. He let the organization impose this guy Martin Epstein, who became the State Liquor Authority chairman. He learned a painful lesson: first of all, that that board—along with, for example, horse racing—has traditionally been prone to corruption.

TM

No! [*Laughter.*]

RNS

Yeah, believe it or not. What Epstein was doing was extortion, simple if not pure. Liquor licenses in New York, in the early sixties, were part of a billion-dollar-a-year business—satisfying the thirst of New Yorkers. And there were all sorts of arcane rules that could be manipulated and exploited for financial gain. And, frankly, Epstein had absolute power; he could charge twice as much for a liquor license in Harlem as he did on the Lower East Side. And the lack of oversight was a very legitimate complaint—and it fit into this narrative that Nelson was so busy running for president, keeping his eye on national developments, that he wasn't minding the store.

So when Nelson suddenly pushed for reform of the liquor board in the midst of his presidential campaign, it was perfectly understandable that members of the legislature and the press interpreted it as a quasi-desperate effort to change the subject at a time of maximum political vulnerability. But he also saw it as the ultimate challenge. Rockefeller prided himself on getting his way with the legislature, almost all of the time.

TM

Speaking of political power, Rockefeller obviously had a long and complicated relationship with World's Fair president Robert Moses. He'd asked him to work on the Mall in Albany early in 1962, and Moses refused. And he was involved in Moses's losses of

power in the city in 1960 and statewide in 1962.

RNS

He fired him. He was the first governor to have—to use Moses's phrase—the balls to fire him and to keep him fired.

TM

Right. So at the time of the fair, how would you characterize their relationship?

RNS

They went through the motions. Nelson was a master at publicly lavishing praise, which for all I know he actually meant at the time. Nelson would not be the first politician who could compartmentalize, and the fact of the matter is, he had known Moses for a very long time. His brother Laurance had been involved in the parks since the late 1930s, when Moses had controlled New York State and City parks. The fact is that once Moses stalked out of Rockefeller's town house—this was after a meeting with him on November 27, 1962—having announced his decision to resign all his positions, before he got back to his office he was already thinking of how he could rescind it. And in fact he sent an emissary to speak to Rockefeller's aide William Ronan, who made it very clear that there was no going back. And so Moses, realizing that he was about to be publicly fired, rushed out a statement denouncing the governor for nepotism, since Laurance Rockefeller was to assume one of Moses's state posts. Which of course was the worst thing he could have done. Nelson and Laurance were joined at the hip all their lives. Nelson's closest friend, maybe his only true friend, was Laurance.

Nelson used the perfectly credible explanation that Moses was still heading the World's Fair. He was also building the Verrazano-Narrows Bridge, and still ran the Triborough Bridge and Tunnel Authority. It wasn't as if Moses was lacking for things to do. It's only in the context of this unique and never-to-be-repeated situation where Moses had all of these positions, all of these titles—

TM

—all of these different governments in and around the city—

RNS

—that it looked like he was being in any way demoted. And Rockefeller put out a temperate statement, full of praise for Moses's brilliant career, which goaded Moses into a very intemperate public display. Moses expected, to the end, that the journalistic cavalry would come to his rescue, demanding that he be reinstated. He kept waiting for the *Daily News* editorial, and it didn't happen.

TM

He sent out Christmas cards that year that said things like, "You won't believe what's happened in the last few weeks. It's more extraordinary than most fiction." He just could not relate to the fact of what had happened at all.

So in 1964, then, there is no reason to think that there was any sort of collusion or even extensive conversation between them on the subject of the pavilion and Warhol's mural and all that.

RNS

I want to be careful, but logic would suggest that that is the case. On the other hand, Nelson was perfectly capable of, as I say, compartmentalizing enmities and postponing revenge [laughter]. He was very good at taking apart situations and determining what was the greatest danger and what was the most immediate reward. I hesitate even to speculate, except to say that logic suggests they were not communicating. But the fact is, there were communications. And in public, they behaved impeccably. In 1978, near the end of his life, when the Empire State Plaza was renamed the Nelson A. Rockefeller Empire State Plaza, whom do you think he flew up to Albany that day to see his handiwork? Robert Moses.

TM

Don't you think he just wanted to rub his face in it a little bit?

RNS

Well, that theory is as good as any other. But it does suggest that even "enmities for life," at least as defined by other politicians, were not necessarily applicable in Nelson's case.

TM

I see. I really appreciate your time here—this has been incredibly informative.

RNS

Well, I have very fond memories of visiting the fair as a ten-year-old.

TM

What do you remember most fondly?

RNS

Oh, I became a World's Fair buff. I've visited eight fairs since then. I remember everything from *Great Moments with Mr. Lincoln* to the Bell Telephone pavilion vividly. I remember the wonderful ride through American history in the Federal Pavilion. Of course, I saw the *Pietà*, which I thought was a little hokey—not the *Pietà* itself but the stage design. But fairs are all meant to be in some ways snapshots—time capsules, if you will—of a particular culture. New York's is certainly more than most; it really is as much about the fifties as it is about the sixties, I always thought, for all that it celebrated innovation and possibility. But if you look at Futurama in '64, it wasn't all that different from Futurama in '39. And you wondered if this is the pace of progress. It's a very un-utopian theme, which I think makes the '64 fair kind of an anomaly. I think there are millions of people out there who have personal memories of eating their first Belgian waffle, and they had a wonderful time. Yet it's never gotten the respect that it deserves. Certainly, it lives in the shadow of the '39 fair.

1. In 1933 and 1934, as part of the management team at Rockefeller Center, Nelson Rockefeller was involved in the destruction of Diego Rivera's controversial mural *Man at the Crossroads*, which included an image of Vladimir Lenin and explicit biological critiques of capitalism.

Andy –

2 plainclothes policemen visited friday night. They looked around casually but pretty thoroughly. They were very interested in the films and looked at about 3 small reels (from "13 most") and asked if there was a projector here. I said no projector

When they left they said I'd be seeing them again.

Who should I inform of this action? Henry knows about it. I will call Leo & tell him. Should I inform Jonas? Do you have a regular lawyer? I don't want to let them look around again, but I also don't want to offer resistance unless I have

someone who knows what course of action is best, to advise me – and definite legal resources.

Please write to me & tell me what you think about it all & whom I should contact. I have placed the factory in a state of "TEMPORARILY CLOSED" and am trying to have it appear that no one is in at all times.

I miss you. Please get in touch.

Hello Edie Chuck Gerry.

to love
Billy

Emmanuel
4 rue St.
Paris

Many (though not all) of Warhol's silent films coded their homoeroticism. In this letter, long-time assistant and collaborator Billy Name expresses concern about a police visit to the Factory in search of the "13 Most" which likely refers to the *Thirteen Most Beautiful Boys*. This apparently sounded like pornography to the police.

Made between early 1964 and 1966, Warhol's *Screen Tests* are 100-foot reels used to make 3-minute film portraits of people who came through the Factory. Early on, Warhol selected individual *Screen Tests* for inclusion in various open-ended conceptual series, which included "Thirteen Most Beautiful Boys" and "Thirteen Most Beautiful Women." The very first *Screen Tests* were part of the "Thirteen Most Beautiful Boys": a grouping of 42 individual *Screen Tests* of 35 different men. The earliest documented mention of these films is found in Kelly Edey's diary entry for January 17, 1964, in which he noted, "This afternoon Andy Warhol made a movie here, a series of portraits of a number of beautiful boys, including Harold Talbot and Denis Deegan and also me."

An identification key is available on p 142.

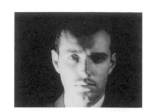

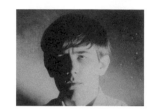

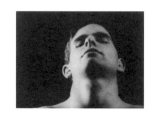

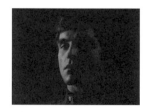

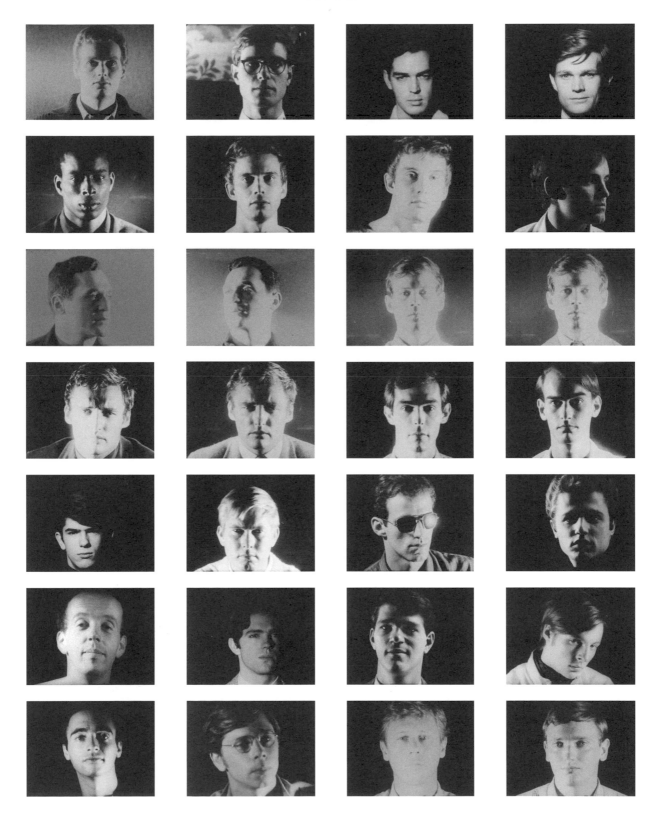

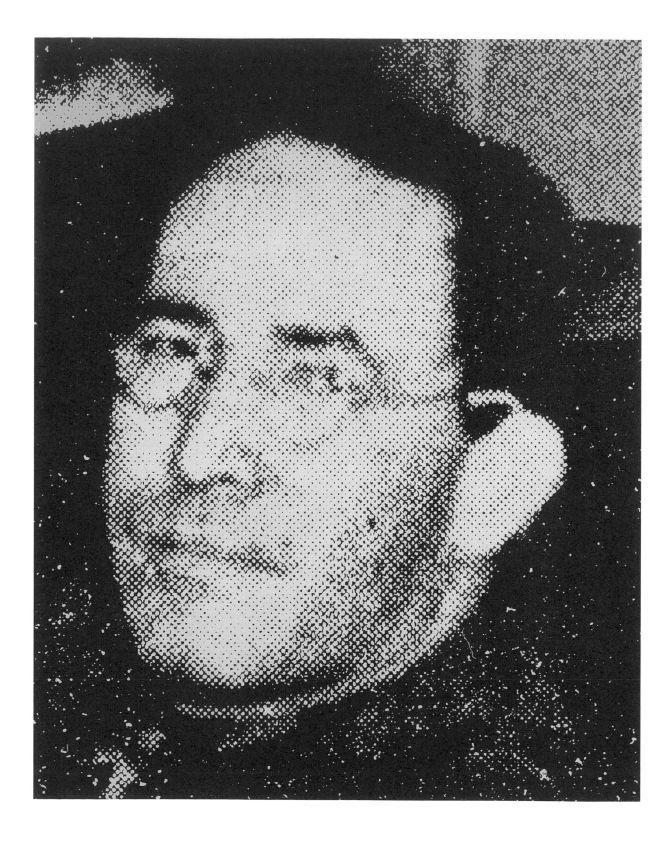

Poet **Gerard Malanga** was Warhol's chief assistant from 1963 to 1970, helping the artist produce many of his early silkscreened paintings and box sculptures, as well as films, several of which Malanga appeared in. Here he speaks with project assistant curator **Anastasia Rygle**.

Anastasia Rygle
It was in January 1964 that you helped Andy move his studio out of the firehouse on East Eighty-Seventh Street and into the space at 231 East Forty-Seventh that would become known as the Factory. Can you describe this period of time and what you were up to?

Gerard Malanga
I think I helped myself move into the Forty-Seventh Street Factory more than I helped Andy—he had things pretty much under control. At this point in my life I was juggling schedules, attending morning classes at Wagner College out in Staten Island three times a week, and arriving at the Factory around one in the afternoon; but within a couple of months it became quite obvious that I wasn't able to keep up this pace and so I dropped out of school for the College of the Factory.

By June of '65, the tenement I lived in was condemned by the city, and I found myself out on the street. From this point on, I was technically homeless; when not going to my mom's flat up in the Bronx for short respites, I'd be crashing on friends' sofas, and sometimes at the Factory as well, because there was a YMCA literally across the street where I could wash up.

In spite of everything that was going on, I was writing poetry at a clip and finding outlets for it, such as *Poetry*, the *New Yorker*, and *Art & Literature*, whose editor, John Ashbery, admired my work. So I kept myself creatively busy every step of the way, with my own work as well as with all the daily chores and responsibilities I had working with Andy.

AR
As a poet, what was it like to work in the medium of film? Were filmmaking and poetry compatible or complimentary practices for you?

GM
Jean Cocteau was a hero of mine early on, because he was as much a poet as he was a filmmaker—he was known for the "Cocteau touch." His movies exuded poetry. Whenever I made

a movie of my own, it was with the understanding that I, a poet, was making it.

AR
Your poem "Rollerskate" was written to accompany Andy Warhol's film *Dance Movie* at a 1963 memorial for the dancer Freddie Herko. Were you close to Freddie?

GM
Freddie and I were quite close. Once, after I'd given a poetry reading at St. Mark's Church, Joe Brainard hosted a party for me in the apartment he was house-sitting for Frank O'Hara, and after a while the scene got a bit boisterous, so Freddie offered his loft over on Bond Street where we continued our festivities well into the night. Freddie was always generous and had a heart of gold.

AR
You were working with Warhol when he received the commission to produce a mural for the facade of the New York State Pavilion. Do you remember how this came about?

GM
I have no inkling of how Andy got the commission to produce panels on the New York State Pavilion, but I think it was quite obvious that Philip Johnson had a hand in this. He was in a very tight, influential position with Governor Rockefeller, who was officially his employer.

AR
Why did Warhol decide to use the "most wanted men" as the subject for the World's Fair mural?

GM
I think Andy perceived that Rockefeller was tough on crime and the "most wanted men" would have reflected the governor's sensibility. It was almost a backhanded compliment. Andy seemed to be pandering from time to time to those who might be interested in buying his work.

AR
Can you tell me what you remember about making the paintings? Why was a second set made on canvas after the mural was painted over?

GM

I think we made the transition from Masonite to canvas because it was easier to install in a gallery setting, and Andy may have been hoping that Ileana Sonnabend would exhibit them in their entirety at her gallery in Paris.

AR

Can you tell me about the Robert Moses portrait that Andy made as a suggested replacement for the *Thirteen Most Wanted Men* mural?

GM

I'm not sure why we silk-screened the Robert Moses canvases, but I think they were made sometime later; and then I didn't know what happened to them.

AR

In your opinion, what were the *Thirteen Most Wanted Men* paintings all about?

GM

The *Thirteen Most Wanted Men* seemed like a logical extension of the "Death and Disaster" series, and Andy may have even voiced this idea to me, though I can't exactly recall his words or how it all came about—as if crime equals death equals disaster. Maybe this is just my idea after all, now that I come to think of it. Also, the *Thirteen Most Wanted Men* carried over the black-and-white imagery of the "Car Crash" canvases.

AR

Did Warhol ever talk about them after the incident at the fair?

GM

Andy, to my recollection, never spoke about them, so that was the end of that.

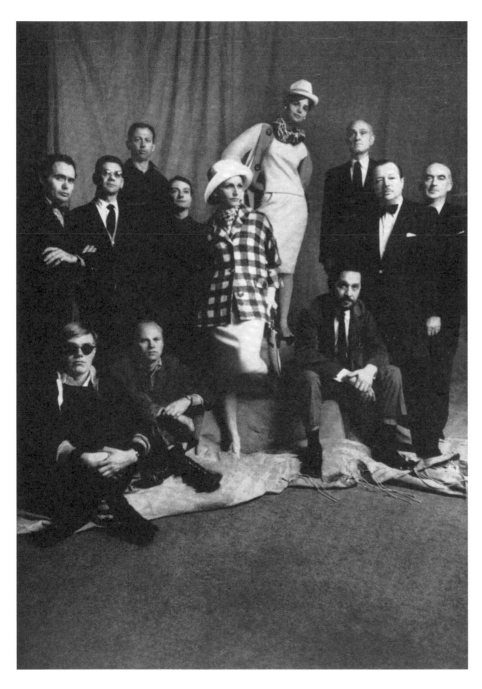

Philip Johnson posed with the artists featured on the New York State Pavilion in the February 1964 issue of *Harper's Bazaar*, which was devoted to the New York World's Fair opening that April.

Seated, from left to right: Andy Warhol, James Rosenquist, and Peter Agostini. Standing, from left to right: Bob Indiana, Francisco C.J. Ferrer (not a New York State Pavilion artist), Ellsworth Kelly, Roy Lichtenstein, Philip Johnson, Joe Mistizer (not a New York State Pavilion artist), and Alexander Liberman.

In the fall of 1962, WBAI 99.5, a social-justice oriented public radio station based in New York City, hosted a groundbreaking interview with **seven gay men**, residents of New York frankly reflecting on their lives. Moderated by WBAI's public affairs director, the novelist **Richard Elman,** this conversation included and was apparently initiated by Randy Wicker, an important early advocate of gay rights. A transcript was published in Berkeley's *Annual Annual* in 1965 and is reprinted here. The *Annual Annual* itself was found in one of Warhol's *Time Capsules.* The original introduction reads:

> The following is a transcript of an informal conversation with a group of practicing and therefore anonymous homosexuals, recorded by WBAI in New York City. WBAI's heterosexual moderator, Dick Elman, is distinguished by italics.

Do homosexuals, as homosexuals, feel that they are a distinct grouping in this society? How do you feel about that? Why don't we just answer that, all of you.

You say in society as a whole, or I assume that's what you mean by this. No. This depends upon the particular case, of course. Some people have a need, psychologically, to form a separate identity. Perhaps others, for economic or social reasons—I should say economic, primarily—don't choose to have this identity as an entity. It's part of the fact that you have a society set up where there is large prejudice against a particular group, and very few people are willing to associate themselves with this minority where it's not necessary, because of the—well, because, of course, the obvious repercussions. On the other hand, society is—some people recognize that society, as it's set up—we owe a debt to society, I should say, and, therefore, are not willing to renounce society as such, or, I should say, society as a whole, or sever themselves from it.

So it's a two-way process, in effect. You feel that society regards you in a peculiar way, and as a result, there is an interaction where there is a separate kind of recognition of society. Is this what you'd say—I mean kind of a feeling that one is in a sense somewhat divorced—lives in a separate world, not altogether—

Well, let's say some people can, for example, mix their social and their business lives together in various professions—

specifically entertainment, publishing—whereas other people cannot afford this.

[. . .]

Do you find when you move in the heterosexual realm—world, if you will—society—milieu—I'd hate to make too much of this; I'm just curious—do you find that you have to hide the fact that you are homosexual necessarily, or do you find that this is ever an acceptable thing? I mean does this ruin the relationship in the heterosexual world?

There has only been, in my experience, one heterosexual that I have told I was homosexual. Generally, it's—I participate, you know, as just myself, as a friend.

Do you think this makes a difference?

Generally, I think it does make a tremendous difference.

I mean, if you were—if you felt—do you feel, in a sense, that you are constricted to reveal this kind of thing, or that—

Oh, I feel that it's not necessary for my sex life—you know—to be an element of my character because if somebody is going to accept me as a friend, they needn't—my sex life has nothing to do with it, if they like my personality or if they like me.

In general, though, there's a whole system of lies and a face put up, which in general would tend to make a person more difficult to communicate with. In other words, you're not on a cordial— you're not on a candid relationship with these people because you have no—well, you're putting up certain lies when you hide certain features of your life, in certain areas and certain activities, and you don't discuss as freely with them certain things, and this, naturally, would lead to a colder relationship because of the fact that you would hate to reveal a stigma which would prejudice their opinion toward you.

I find that there's less problem among heterosexual friends than there is among business associates and people that one is forced into a relationship with. In that case, you sort of are forced to hide any homosexual tendencies and the fact that you are homosexual, because these people are prejudiced against you,

particularly in a business situation, with the exception of the theater and some of the others where there's more liberality and more understanding.

Could you—or would you mind telling us what you do—all of you—I mean, what you do in a business sense. Could we just go around and each one of you tell us what you do to make a living?

I'm a salesman.

I'm an electronics technician.

I'm engaged in technical professions.

I work in a nursery in New Jersey.

I'm a corresponding secretary.

I'm a sportswear designer.

And I'm an artist and designer.

We have a fairly representative group of the professions that the heterosexual world espouses, in a sense, don't we? So this is where the problem arises—that, in a sense, your interests in the commercial world—in the world of business—are not demonstrably different from anybody else's interests. Is this correct?

Right.

I would say, generally so, but there are, when you get into this idea of those people that need to associate with other homosexuals, you find that there are people who tend to go, I feel, into things such as hairdressing and interior decorating because, either through social conditioning they're effeminate and they don't fit in any group except a totally homosexual group, and to that extent they do tend to collect in one profession, but you'll find homosexuals in every walk of life.

Perhaps you'll answer a kind of bigotry of my own. I've always assumed that a large portion of the life of the homosexual was concerned with seduction and, therefore, that his business activities were somewhat directed by this as well. [Amused chuckling in background.] Is this at all—

I disagree. [*More chuckling.*] I think we'd all rather be seduced than seduce. [*Giggles and laughter.*] And, strange as it may seem, I would say, generally, the homosexual has a very strong moral fiber and a very definite set of rules, from which he rarely breaks and won't digress.

Do any of you feel—I mean, perhaps I am mistaken, but there are certain industries in New York which seem to have a larger percentage of homosexuals than others, and perhaps the reason for that is because—well, you say it's—these industries regard this as a more social—the members of them regard this as a more socially acceptable thing?

Well, wait. What industries are you speaking of?

You're speaking of film industries, or acting, perhaps.

Well—I don't—yeah, I suppose so. . . .

They're creative fields.

Yeah, the creative fields.

Now, what you're saying is that this is used, perhaps, as a means to—

—make contacts?

—further one's career. Yes.

There are several reasons why homosexuals, I've found, go into creative fields, and one of the major ones is that a homosexual usually doesn't have a family—there are exceptions, of course, but he usually doesn't—and therefore he doesn't have the responsibility—the down-to-earth—I-have-to-bring-home-so-much-money-every-week-in-order-to-feed-a-wife-and-whatever-children. Therefore, I can go into a more creative industry which does not, maybe, pay as much money at first and where there are more hardships, such as being an artist or writer, designer, all these things—an actor—and I can afford to live in a garret because there's no one dependent on me totally.

I'd like to elaborate on that point. He sort of started off in a vein that I wanted to develop, being that since the homosexual doesn't have a family and he doesn't necessarily need to be a breadwinner, you need some sort of sustaining force. For example, a homosexual existence—from my point of view, love affairs are very destructive and I don't think they really and truly work out. Some people do manage it. So, aside from that—and if your social life isn't working out, too, the way you would like it to—you need something to sustain you; hence the creative arts where you can feel that you are expressing yourself and, most important of all, enjoying your occupation.

[. . .]

Let me ask you a question, to return for a second to what you said, which I found interesting, and I sort of wanted to pursue it a little further. You said that homosexuals are—you used the word "moral"—they have as strong a moral code as anybody else. I would like to develop this a little further. Is promiscuity more prevalent among homosexuals than in heterosexual society?

Yes.

Yes.

Yes.

But the why is also very important, I feel.

How would you explain the why?

Well, because I said the inability to sustain a relationship—you know, two males living together with this, well you know, this romantic aspect that really doesn't exist in a heterosexual relationship, but inevitably all relationships go—even, you know, the ones that are based on something which is sort of what they consider solid at the outset. So promiscuity has to come in, you know, in the window.

I think this would be interesting to know—before we get into too much of a self-incriminating discussion of promiscuity—what has been the longest—generally, the age of each of us here, and what's been their longest relationship if they've ever had any type of relationship with someone.

Yeah, could we go around and see—

Why don't we do that? I've always avoided marriage—women or male.

Well, I'm twenty-five and my longest out of two was six months.

I'm twenty-seven and—uh—no.

I'm twenty-one—four and a half months.

I'm twenty-one, and I made seven months.

I'm twenty-seven and my longest affair was a year.

I'm twenty-six and it was about seven and a half years.

Let me ask you this. Seven and a half years is a fairly long time. Is that one still in existence?

No, it isn't.

Well, presumably, the standard kind of cliché about this—not about homosexuals, but about all love—is that if this is perfectly agreeable, that everything else is perfectly agreeable; you know, if the sex is going well, then everything else is going well. This is the kind of ultimate of the Freudian view of human nature. I was just wondering whether this was really the truth. I mean, have any of you found that, for example, you were perfectly mated from a sexual point of view, but the person might have been an absolute boor, or vulgar, or any of the other reasons why somebody might find a relationship wasn't possible.

I usually find that love affairs are really not based on sex too much. It does play an important role, but it seems to be very much the person—what they have to offer.

I'd say along those lines, too, that you don't really—and I think this is true of heterosexuals or homosexuals—until you live with somebody, just one—I have a friend who's an older person that's been going with someone quite a long time, and he has a very low opinion of heterosexual marriage, because he says, "Just think if you find the perfect girl and then there's one thing wrong with her—she turns out to be a social climber. . . ." And this is so true. One little thing, when you live with someone—and you notice this among a nonsexual roommate relationship, whether it be homosexual or heterosexual—a person's habit of playing a hi-fi a little bit too loud, or burning the toast in the morning. All these little things cause terrific complications when you're living in a very close, intimate relationship.

Well, I disagree with both opinions. My experience has been that, generally, you know, homosexuals are promiscuous and that sex is the most important element in a relationship. Because it seems that if, no matter how many sterling qualities you have—you might have a wonderful intellectual capacity, you're very sensitive, and you're just a wonderful companion—but if you don't have a virtuoso performance in the boudoir, it doesn't work.

I know people that have been together three, four, five years. Everything is going very well with them, but they're absolutely not suited for each other for sex. And they do not have sex with each other, but yet, their relationship is the best possible.

Yes, but that's not a relationship. That's a friendship.

No, it's—in a certain way, I guess it is, but it's a little bit more with them than a friendship.

[. . .]

Well, how do you feel about the casual homosexual?

What do you mean by "casual"?

The experimenter, the—one-night stand, the fellow who thinks he wants to try this—how do all of you feel about this?

I would say that he probably is someone who, by some sort of luck or some other reason, is slowly becoming able to realize himself and that this is one of the urges which he has, and I think everyone has them. I don't think that there are any exceptions among the entire human race, including—not only the human race but the animal kingdom, and, of course, animals are totally free about it. They do what they please because they don't think about it—

Well, I would be inclined to feel, because I feel very strongly about this bisexual thing, and I would think if you would take a poll among the few people here that—Peter is the dark horse, because generally homosexuals are homosexual because—well, in the Freudian concept there are many reasons why—usually the absence of the father, or, you know, being overprotected by the mother, and all this kind of jazz—but generally a homosexual seeks, actively and constantly, only male companionship and does try to have a workable relationship, even though he knows it's going to be destructive. It may last an hour, a week, ten years—but Peter is the only one whom I have ever spoken to who has had these convictions.

I do think, to this extent, though, that a bisexual runs into a great deal of hostility in the homosexual society because he doesn't really believe in any group, and I'd like to turn this back over to Peter with one question I've always been curious about. Most bisexuals, it's a very corny relationship—the ones I know—they have girlfriends that don't know about their homosexual life, and I know of cases where, with their boyfriends, they don't tell about their girlfriends. Now, you tell me you're pretty open with the girls you go with, that you make no bones about being bisexual, and I'd like to know their general reactions and the kind of things that happen and what they say.

It's been rather odd. I, incidentally, am from Vermont, and in Vermont, which is a very puritanical state, although in some ways far freer than New York—New York tends to have its own puritanism—I found up there, though, that the girls up there were very shocked. I found that the boys were far less shocked and it didn't bother them. I have many heterosexual friends in Vermont, because of course that's where I was raised, I went to school there, and it didn't bother them particularly. The type of homosexual that bothers a fairly well-oriented heterosexual boy is the type who will drive around in a car or walk around and make very, very sneaky passes—who will not be open and honest—and of course this is very frightening. These people bother me. I don't particularly like to be hitchhiking on a road and be picked up by a man who will, you know, say, "Hello, how are ya? Blah blah blah. Come on in, let's go for a ride—" And as soon as you get going down a highway, here comes a hand sneaking across the seat. This sort of thing is repulsive to me. I think he should come out and say what he wants to do and be free about it.

He'd get slugged anyway.

He certainly wouldn't be slugged by me and most of the boys that I know.

I rather maintain that you want somebody to walk up to you on the street and say, well, you know, "Let's go up to my place—"

This is something very—no, I'm not saying that you should walk down the street and as soon as you see someone who's attractive, whether it be a male or female, go right up and say, "Let's go to bed." But there is also a way to be subtle and not sneaky.

But if you are a practicing homosexual, you will know that there is a ritual. And really, it's truly magnificent, you know, in the art of cruising, because I've discussed this. And also the bit—you might be very tired, you've had a very pleasant evening, you might have been to the theater, you might have been to the movies, you might have been walking. And you are going home. You're not interested in sex. You don't want a sexual partner. But you pass somebody. You know it's definitely wrong, but once this chain of events has been put into play, you've got to go through with it, and it's very elaborate and it's very humorous sometimes, too, and it's marvelous.

You know—I had an interesting experience. Now, most of the homosexuals here—I'm not sure about this; I know a few very well—are very dishonest in their heterosexual relationships. Peter is an exception insofar as he has heterosexual friends that know that he is bisexual. Now, since I've become active in this work [homosexual public relations], I've told a few of my heterosexual friends, and through my life there have been heterosexual friends who knew nothing of my sexual nature, and there were those that

I told. And I've noticed that there was a great enriching of the relationship, a great deal of honesty coming to the relationship. There have been some relationships that have almost soured, people that—you think this guy is a hipster; you know, he has ideas. Someone gets up and talks about liberalism, and they're way out on every type of social and political idea, and they find out that you're homosexual, and all their own personal complexes—

They become a puritan, you mean?

They become a puritan.

I want to ask you something along these lines. Do you all observe the same kinds of taboos that heterosexual society does in this sense, let's say along social lines? Is it common, for example, that homosexuals cross interracial lines? Do they cross religious lines? I suppose religious lines are much less stronger taboos than racial lines at this stage. What about economic lines? And all the various taboos. Anybody have anything to say about that?

Well, I think most homosexuals are snobs economically, except in bed. I think we'll go to bed with anyone who attracts us, no matter what they do. But socially, I think we're all snobs. I don't know why that is, but I think most of us are, unless we meet someone who is of a lower economic group, but who is quite intelligent. That's different. But, as a rule, I think, we're snobs. As far as the race thing goes, my relationship was with a Negro—the seven-and-a-half-year one—and we got along beautifully.

Throughout history it has been proven that—you know—in a homosexual relationship there are no social strata which aren't crossed. It's the only kind of relationship where you will find—you know—a prince with a commoner or a millionaire with a lackey.

Is this true in all cases?

It's true in all cases.

Generally, they don't mix socially. They mix sexually.

They don't always mix sexually. I know a lot of homosexuals in this town that will turn around—you live in a certain type of homosexual community. I have friends who will say about somebody, "He's a dinge queen." Dinge meaning Negro, meaning he goes to bed with Negroes, and he's not acceptable—

And they'll also say, "He's a Puerto Rican—"

Randy, but of course. That's only natural. That's hypocrisy. He's

saying this to you. You know, under the stark light of day, or you're sitting down and you're dining, of course. I would say the same thing. But two o'clock in the morning, when you're walking home where there's nobody to see you—it's been proven.

These same people are so phony and so concerned with their social strata that they'll go to bed with a mess at forty-five years old if he has a nice apartment and a Cadillac and he's a successful man—and they'll pass up someone twice as good-looking at twenty-five who is in a lower economic position. And that is a pattern they never deviate from.

Granted. But generally—if a homosexual is going home at two o'clock in the morning and he knows his smart East Side friends aren't going to see him, you would be shocked at what he drags home.

In answer to an earlier question—what about the casual relationships? What's the term—"rough trade"?

No. Rough trade is something which, I think, most intelligent homosexuals avoid. And rough trade being, of course, the straight, so-called normal boy who is on the street and the homosexual approaches him and either gives him money; or because he's been sexually frustrated for a while he's willing to go anyway—

To submit to one act.

To submit to something so that he can feel a relief from his frustration. This is a very dangerous thing, for one thing, because of the social pressures—the psychological pressures coming from the social problem—and most intelligent homosexuals don't bother with this type of a boy.

It's very sick and very dull. And when I say that, that's an opinion, and I think it would be agreed with by almost all homosexual people—

This type of a boy will, in the first place, if he is a latent homosexual, which is usually the case, he will still be very rigid—

Vicious, vicious.

Sometimes very vicious, and the reason for his being vicious, of course, is because he doubts his own masculinity, and therefore this creates all kinds of torment inside him—emotional problems—so that he, even if he's not vicious, will be dull. He will not respond while in the sexual act; regardless of whether he's being masculine or feminine in the act, he will not respond. He will be a dull, boring person.

And filled with guilt—

Filled with guilt, which he will, as a rule, take out on the person by punching him in the nose—on the homosexual that has picked him up.

Or even killing him.

Or even killing him. This has happened, of course.

Is this, then, among homosexuals, largely an upper-class vice?

It is a vice which goes from the lowest working class—or non-working at all, no-money class—right to the top.

I'm talking about homosexuals who indulge in so-called rough trade—if this isn't an upper-class vice. I'm thinking of the fact, for example, that in Manhattan there is a large incidence of felonious assault resulting from the fact that, whichever way the relationship begins, casual pickups develop into where the boy, to expiate his guilt out of a kind of revulsion, beats up his partner or robs him, or—

I'd like to say something about that. This is a—it could be a lower-class person or upper-class homosexual. It's strictly psychological—like the Don Juan in heterosexual society, who has to seduce every woman—there is a type of homosexual who gets hung up on the idea that, boy, the more masculine, the more attractive. And he starts out chasing masculine homosexuals and then he gets completely fixated on this idea of what you call rough trade.

Well, of course, there's two types of homosexuals: the one who carries on a rather normal homosexual relationship with various people, and the type who gets very bored with what they've been doing and they're always seeking something new and exciting because actually they're bored with themselves, and eventually they'll try just about anything, and I think the older they get, the more strange their desires are.

[. . .]

Let me ask you this, because I find this very interesting. Is it possible that there are in homosexual society, itself, certain kinds of actions, homosexual actions, which are regarded as perversions? In other words, do the homosexuals make distinctions between normal sexual practice among homosexuals and homosexual practice which they consider to be abnormal among themselves?

I'd like to—there's two dimensions to that. One thing is someone that has a fetish. In other words, maybe that likes to—well, you get into the classical—someone that likes to make love to hair or something. This is as much looked down upon in homosexual society as in heterosexual society. But there's another type of narrowness here. For instance, we were talking earlier about the homosexual who likes this rough trade—likes to go up to the young heterosexual or semi-homosexual who thinks he's a man and wants to find a queer to take him for money and then beat him up. This is considered a social perversion among the homosexual group by and large. There are all types of patterns—people that go to the Village—there are some people that look down on homosexuals who go to homosexual bars, and the people who go to homosexual bars look down on those people that follow devious practices of walking along the waterfront and knocking on truck-driver cabs and climbing in with the truck driver. And the East Side parties, they look down on everybody. And the point I'm making is there are a thousand different little patterns of living.

What you're saying, too, is that homosexuals resent difference as much as heterosexuals do.

Yes.

If I may break in and just say one thing. It's to clarify a point. I don't think we should talk about homosexuals or heterosexuals. I think we should talk about people who happen to be homosexual; when you say homosexuals do this, you're making a vast mistake. There are homosexuals who do this and there are homosexuals who do absolutely the opposite.

Well, we can just speak about the symptoms of the—

When you're trying to be general, you make terrible mistakes and I think we should avoid it as much as possible.

But, you have to be general—

You can be general to a degree, but as soon as we say that homosexuals have the same puritanism that heterosexuals have, we're making a double mistake because we're saying that homosexuals all, or heterosexuals all, have the same puritanism.

This is valid except I find that you'll find homosexuals that never go to bars, that live in very quiet little what-you-call sewing circles in Queens and Brooklyn, and I'll say to them, "You know, most homosexuals really go to bars and enjoy dancing together." And they'll rise up and say to me, "Dancing—with another man?" Because my social thing has been a certain pattern—

You're talking about, now, individuals who are in a sewing circle—

That's right, and they disagree violently with people who have different frames of reference, and this goes along with your idea that all homosexuals don't do this, and all heterosexuals don't do that.

But there is a general pattern.

There is a majority pattern, or majority patterns. In other words, there's large groups that do this and large groups that do that—

Then a certain percent dissent. Is that what it is? Let's say that the whole world—as we're trying to formulate it out of this thing—they resent any kind of threat to the status quo. Isn't this what it amounts to? There is a homosexual status quo more or less.

Individuals in the society are opposed to any dent in the status quo, but you cannot say that homosexuals are pro–status quo and anti-change—nor vice versa, that heterosexuals are. This doesn't follow.

So homosexuals represent a kind of anarchy, now?

No.

No!

That's the whole point.

Well, to the heterosexual world—

To the heterosexual world. In the mind of the average heterosexual, the homosexual is some kind of libertine. This is true. This is almost invariably true. It's not 100 percent true, but it works out to a large percentage of being true.

Jim, what do you think about this?

Well, I would like to pick up a point that he mentioned earlier, and that is the fact that the homosexual world has taken over quite a lot of the heterosexual patterns of behavior. This bit about gay marriage—I don't know if that's been discussed at all—it's really a farce to see how they carry it along to the point where they must be complete high fidelity toward each other, and at the same time, it does break up, just as in the hetero world, and the pattern keeps repeating itself.

I want to talk about harassment, which I think is practiced—

Yeah, but let's talk about anarchy so we can settle this. The heterosexual sees homosexuality as anarchy, but they really see it as a competing system, and this is not true. It's not trying to compete. We're not trying to overthrow heterosexual society—

Not as a group. No.

Not as a group. We're only trying to live with it, whether it's bisexuals or homosexuals.

As a group, homosexuals are not of any particular political mind. This I have found out much to my horror, but they are not. I feel they all should be—every blooming homosexual in the world should be antistate—antiestablishment, antigovernment, because every government—with the exception of Napoleon's, of course—has put down homosexuals.

I think we can fairly say that all societies, more or less all heterosexual societies, since most societies, contemporary societies, are heterosexual—or let's say, they own up to whether they're Communist or, let us say—what do we call the fact—they put themselves forth as heterosexual societies, ourselves?—democratic—or neutral—you know, that they recognize that—the thing I'm saying—now here's the simple statement: officially they regard the homosexual as a kind of anarchistic threat. A threat to the existing order. And as a result of this, there is a certain amount of harassment. Now, I'd like to talk about the harassment for a moment, because I don't think that people are really fully aware of what this is concerned with, what happens in this sense, what kinds of particular corruption are involved in this, and really what's at stake here—who is involved in it. Perhaps we ought to begin with this: most of you probably lead fairly commendable private lives; most of you have talked against cruising, for example, I assume, but I use the subject of harassment other than the harassment you find in employment, and have you witnessed this kind of harassment, and how does it operate—in what subtle ways?

I've seen harassment when you get into employment. You get into situations in the armed services where such things as associations with known homosexuals, or being accused of being homosexual, is grounds for discharge. Sometimes this is done to very naive, slightly effeminate boys who fall in with a group of homosexuals, and they just think Joe is really funny because he's so effeminate and he's really not queer but he's a lot of fun because—he doesn't fit with the other boys either for some reason. And then you swing over into other types of harassment when it comes to such things as personal. I call it harassment when a child can't talk to the family or when you can't be honest in your relationship with people. Legal harassment usually only falls to those

people that ask for it—the person who is asking for trouble going into men's restrooms or out on the street approaching minors, things like that. These are the people that get in legal trouble.

Well, you don't call that harassment, do you? They're asking for it.

No, that's what I'm saying. They're asking for it.

[. . .]

Well, do the police use any kind of covert methods? For example, would they, in a public place, in an undercover way approach somebody whom they assume to be homosexual and try to make a pickup, and then—I've heard they do use these procedures—and then, once a man responds, then they—

Yes.

Yes. I've never had this happen personally to me, but I've had friends who have had the problem. It occurs more often in Chicago than in New York, and it's a very bad thing in Chicago.

San Francisco, supposedly, is the most liberal town, and if you read the homosexual publications from San Francisco, when they heard that I was active here, they said they didn't know there were any homosexuals left in New York 'cause they thought they'd all moved out there. But once in LA I was doing this thing. I was walking down the street. I'd come from a friend's house and I was going home, I was tired, and the policeman roared up, jumped out of the car, grabbed me, and started giving me this big thing about what are you doing here, you know there are a lot of queers around this neighborhood. And the mentality is very similar; he said, "You know, there's only one thing worse than a queer, and that's a nigger." And there's this just general reactive type of personality that runs all the way through. You can guarantee the guy's a conservative Republican on top of all this.

Has anyone ever met a homosexual policeman?

Yes.

Yes, I have.

New York?

New York City.

I won't ask for badge numbers.

Central Park beat, and I've witnessed him traipsing off in the bushes with people, but I've never witnessed if anything occurred after they got there.

There was only one case in New York City that I would say was a really flagrant violation of civil liberties, and that came when there was a killing—there was a raid on. Juvenile delinquency became a big issue about two years ago, and if you watched the newscasts closely, they said, "Today 392 young juvenile delinquents were picked up in the west 70s," and it would go on to list that 212 of these were "procurers"—beginners in the solicitation of men. And all they had done to make the numbers big and to build their own political careers was to go around through the 70s and every time they saw a slightly obvious homosexual—and the ones up there generally speaking are of a rather poor background—they picked them up and put them in the wagon and the numbers grew. These people weren't the ones that were robbing stores and killing people, but they were the ones that were scapegoated.

Yeah, but not only in the sense of the scapegoat—we've sort of talked about the scapegoat—what actually happens? There are gay bars in New York. The law says you can't have this kind of activity—you can't acknowledge this kind of activity—yet they function with liquor licenses and so on and so forth—

This is an irony. In California, the Supreme Court ruled that homosexuals had the right to go to a bar or restaurant as anyone else, under the right of assembly, and they ruled that you couldn't revoke a liquor license because it was a homosexual bar, saying the two reasons: right of assembly and that the bartender could not be expected to tell who was and was not homosexual. Now, you can revoke a license on the grounds of immoral, obscene behavior, and I would imagine where you had a homosexual bar where dancing went on, this was true. And generally speaking it's never been tested to the United States Supreme Court, but it's something on a lower level, the liquor licensing agencies set up their own rules and they shut up a bar. Right now you can go down to the Village and there are two or three with "Raided Premises" signs, and the bar owners don't fight it to the court because generally they're underworld elements, they don't want to bother. They'd rather take their marbles, and go over to a quieter area of town and reopen. Because the homosexuals don't own their own bars, and no one—the homosexuals are not willing to stand up and fight these things legally, and the underworld certainly isn't interested in it.

You mean when a homosexual goes for a liquor license, the liquor board would say that they wouldn't grant him a license because

he's homosexual—aren't there homosexuals who could afford to have a liquor license if they wanted to?

Well, as a matter of fact, I know of an owner of a number of gay bars, some of which—over a period of the last four years when I've known him, he's owned a number of them—some of which have been closed. This man is in what is commonly called "The Mafia" or the underworld. However, he also happens to be homosexual. And so there you have a mating of the two things, and the money does go to the organized underworld, and at the same time this man is homosexual.

So there is a kind of a—you know—just like any other kind of puritanical society, you cover up and therefore the corruption comes from within. Is this what happens here?

Yeah, well, I think this is especially evident in the Village now.

[. . .]

I'd like to ask one final question, and I wish you would all give an answer to this if you would. If you could address, let's say, a corporate straight world or, that is to say, the straight world, in as frank terms as possible—that is, leaving out obscenity—how would you—what would you say to them regarding the homosexual? What attitude would you like them to adopt toward homosexual society?

Well, I'd sum it up in a phrase. I'd say, just: "Live and let live."

I'd spell it out. I'd say, "T-H-I-N-K"—and this program has been a breakthrough in this regard. I think the fact that WBAI is here tonight taping this program is the first "T." I want to look forward to seeing the "H-I-N-K" in all phases of society and especially among the thinking community in this generation and maybe in the whole community in a generation or two.

Peter, what will you say?

Well, I'd say I'm not willing to be accepted. Or tolerated. I wanted to be recognized as what I am and then accepted for that. But not tolerated.

Harry?

I won't put it as strong as that, not being of the same political leanings as Peter is. I would accept tolerance gladly.

Marty?

I'd say that my personal life is my own business and it's not the right of society or any other individual to tell me what I should do as long as I act within the realm of my own rights.

Jack?

Well, I would say in regard to the homosexual that society could do us a justice by simply being more compassionate and more understanding.

Bill?

Yes, I agree. I think we all have skeletons in our closets, and the less stones thrown the better.

CLASS OF SERVICE
This is a fast message unless its deferred character is indicated by the proper symbol.

WESTERN UNION
TELEGRAM
W. P. MARSHALL, PRESIDENT SF-1201 (4-60)

SYMBOLS
DL = Day Letter
NL = Night Letter
LT = International Letter Telegram

The filing time shown in the date line on domestic telegrams is LOCAL TIME at point of origin. Time of receipt is LOCAL TIME at point of destination

NHC099 BE171
 1964 MAR 4 PM 2 27
B PFA079 RX PD PF NEW YORK NY 4 142P EST

ANDREW WARHOL

1342 LEXINGTON AVE NYK

PLEASE DON'T TALK WITH REPORTERS OR GIVE OUT ANY PUBLIC STATEMENTS
ON YOUR WORK FOR THE NEW YORK STATE EXHIBIT. THIS WILL BE HANDLED
BY THE PUBLICITY DEPARTMENT OF THE NEW YORK STATE COMMISSION
 PHILIP JOHNSON
(47).

This March 4 telegram from Johnson to Warhol suggests the possibility for potential problems has dawned on the architect, although we don't know what might have triggered him to communicate it so urgently.

The only article written about *Thirteen Most Wanted Men* before it was painted over appeared in the *New York Journal-American*, an evening newspaper with a high circulation especially on Long Island and Queens, the New York City borough hosting the fair. Amidst reportage of a sensational murder, police preparation for a civil-rights protest at the fair, and controversy surrounding Rockefeller's legislation to eliminate fixed prices for liquor, the newspaper refers to *Thirteen Most Wanted Men* using the word "yegg"—underworld slang for thief or safecracker. On the second page (not pictured here), the reporter identifies the *Men* with their names and crimes, which the mural itself had not done.

The full article text is available on p 144.

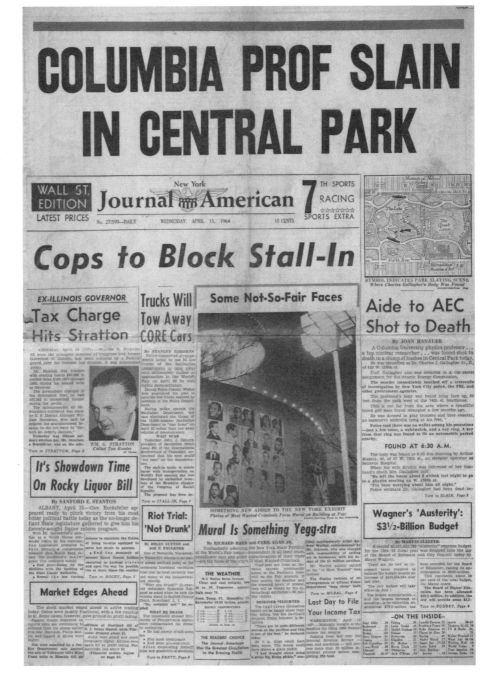

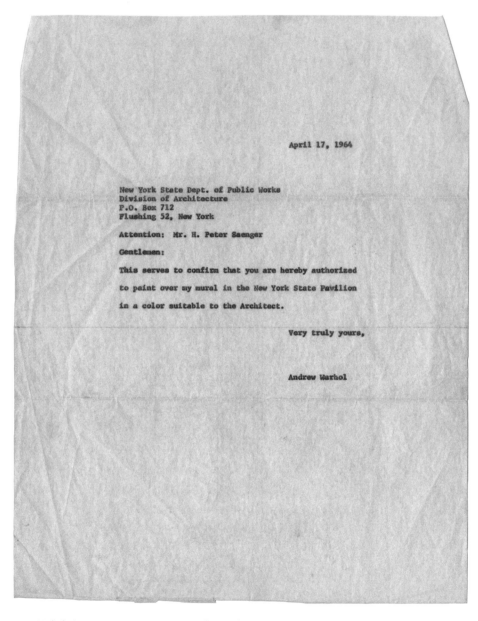

April 17, 1964

New York State Dept. of Public Works
Division of Architecture
P.O. Box 712
Flushing 52, New York

Attention: Mr. H. Peter Saenger

Gentlemen:

This serves to confirm that you are hereby authorized

to paint over my mural in the New York State Pavilion

in a color suitable to the Architect.

 Very truly yours,

 Andrew Warhol

Here Warhol gives permission to the New York State Department of Public Works to paint over *Thirteen Most Wanted Men.* The phrase "in a color suitable to the architect," as well as the fact that almost every inch of his new studio was being covered over in silver paint and tinfoil by an amphetamine-fueled Billy Name, may imply that Warhol and Johnson conferred on the color the mural would become.

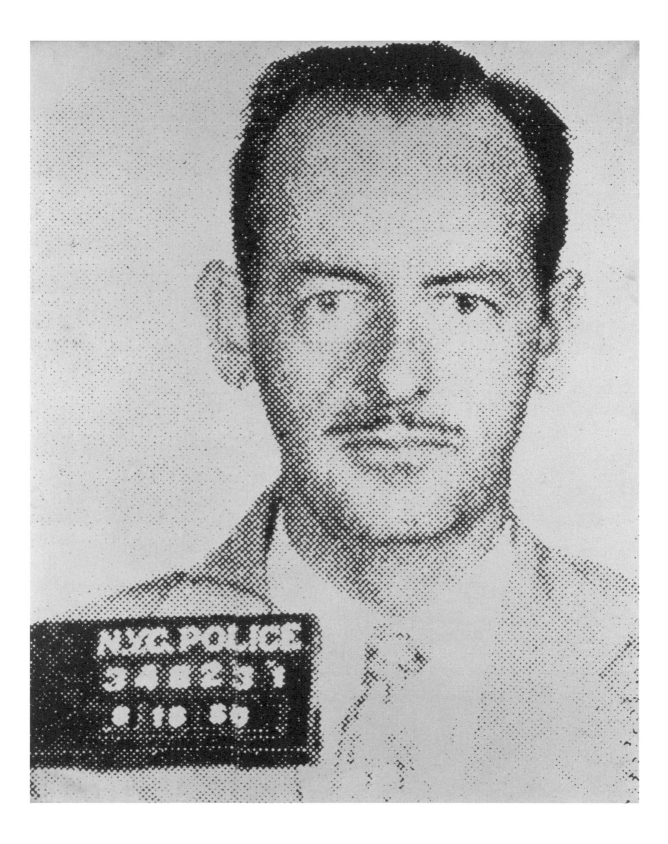

"Imagine the police raiding a film called *Blow Job* and finding a forty-minute silent portrait of a man's face!"

Richard Meyer is the author of *Outlaw Representation: Censorship and Homosexuality in Twentieth-Century American Art*, which contains one of the most comprehensive art-historical analyses of *Thirteen Most Wanted Men* to date. Art and film historian **Douglas Crimp** has written on issues central to queer life and politics since the 1970s, most recently in *Our Kind of Movie*, a book-length study of Warhol's films. Their conversation spans the coded meanings that *Thirteen Most Wanted Men* may have had to gay culture at the time; John Giorno's recounting of the dinner party where the idea for *Thirteen Most Wanted Men* was first floated; and the potential that Warhol's work holds for critical approaches that extend beyond art history to consider media, society, and urban life.

Richard Meyer

I'm just going to read something I wrote for a recent book called *Art and Queer Culture* as a way of starting a dialogue with Douglas about Warhol's mural.

> At the fair's insistence the mural was painted over prior to the official opening of the grounds, ostensibly because the Italian-American community might object to the suggestion that its members were criminals. In this work Warhol may well have been punning on the idea of wanting men as a form of criminality, and thus signaling, albeit in coded form, his own outlawed desires.[1]

This comes from an argument I made at greater length (in a book called *Outlaw Representation: Censorship and Homosexuality in Twentieth-Century American Art*) about the idea of *Thirteen Most Wanted Men* being wanted in more than one sense: wanted by the New York City police for criminal offenses, but also wanted by Warhol as a transgressive image of desire.[2] Certainly, various forms of outlaw masculinity, and of rough trade in particular, appealed to some gay men, including Warhol, at the time. Also the notion that wanting men was criminal behavior (for a man) if you acted upon that wanting, because there were laws against homosexuality, sodomy, and so literally your desires, once actualized, were criminalized.

Douglas Crimp is someone that I have been in conversation with about Warhol, and also about the *Thirteen Most Wanted Men*, for a number of years.

Douglas Crimp

There are a number of threads here. Perhaps I can start with the attraction of so-called rough trade. The first time I learned about your work was when you gave a paper called "Warhol's Clones." When you published the much more developed argument about *Thirteen Most Wanted Men* in your book *Outlaw Representation*, you dropped the idea of the clone. But it was an interesting idea, thinking about the seriality of Warhol's formal strategies in relation to his remark about James Dean, about not just wanting James Dean but wanting *to be like* James Dean.[3]

RM

For me, rather than this being an emphasis on the authenticity of the original object of desire or the star, it was about the notion that one could creatively remake oneself into another version that would be close enough to the original and capture the desire of others who also have a similar attraction.

DC

In that essay you also read an early self-portrait of Warhol as a gay clone, which is anachronistic, because the clone look emerged in the seventies, during a time when gay men were consciously appropriating stock notions of masculinity; the Village People popularized the look for a wide audience. But the anachronistic argument *is* useful for a discussion of *Thirteen Most Wanted Men* because in 1964 there was still a schematic division of gay sexuality between the effeminate gay man and rough trade, the hypermasculine object of desire.

RM

Which could be a sailor, it could be a trucker, it could be a—

DC

And it could be a criminal. The ethos of gay liberation, which emerged a few years later, suggested that you no longer had to remain content with desiring a particular form of masculinity; now you could also be it *as a homosexual*. So now there would be equality between so-called tops and bottoms.

RM

You could make yourself into a version of what you wanted. I did some research on a seventies party in San Francisco called "Stars," and it talked about how that trucker making out with the cowboy was really a stockbroker making out with a medical

resident. So it was also an interesting form of class drag, where liberated and often middle-class gay men embodied certain working-class fantasies for one another.

DC

These things were always to some degree class-coded. The desired body was the worker's body, desired because its musculature developed in actual laboring.

RM

Even though the body generally was not muscular through manual labor but through working out at the gym.

DC

Yes, eventually. But I'm talking now about 1964. The desire for rough trade—or in the case of the *Thirteen Most Wanted Men*, even criminals—is something that had existed in queer culture for a very long time.

RM

And it still does.

DC

And it still does, absolutely. I've been reading an interesting book by Barry Reay called *New York Hustlers*, a carefully researched history of hustlers in New York City from the 1930s to about 1970.[4] Reay discusses *Thirteen Most Wanted Men* together with other works by Warhol—the films *Blow Job*, *My Hustler*, and *Flesh*—in a chapter called "Hustler Hustled," about what he calls the "trade aesthetic." He refers to *Thirteen Most Wanted Men* as exhibiting "gangster masculinity." He seems to feel that this form of masculinity was explicit in its homoerotic message rather than implicit, as you argue in your book. But I prefer the way you link criminality to homosexuality through a kind of circuitry of looking—the men looking at each other and in turn the viewer looking at the men. In any case, the criminality is perfectly explicit, since the portraits are mug shots.

RM

You could think of this in relation to Warhol's "Death and Disaster" series, and consider the electric chair, which becomes really interesting. Warhol was delving into a whole iconography of criminal discipline and punishment in these works.

DC

It was not exactly a positive image of America, from the point of view of Robert Moses, the organizer of the World's Fair.

RM

The World's Fair was meant to be affirmative, and this is about as negative as you can get; it's about the underbelly of American culture, or deviance, a different kind of deviant subculture from homosexuality.

That's one reason why towards the end of the chapter I was really interested in talking about what it means that he kept the silk screens, and that you'd see them at the Factory. They can take on a different life within Warhol's world. He had the acetates for the New York State Pavilion mural taped up to the walls during spring 1964, and you see these in the black-and-white photos by Billy Name of that period. Then, in 1968, the paintings themselves return to the Factory after a tour of Paris, Munich, Hamburg, and London, and hang around wrapped in plastic, including one next to the bathroom that shows up in Name's color pictures (I used a few in my book). At least two were still there when Warhol died.

DC

That life associated with the Factory is also at the origin of *Thirteen Most Wanted Men*, or at least the story that we have about its origin.

RM

So let's tell that story. But before we do, I just want to say, one of the things that was important to me about the mural—unlike the individual canvases that followed the mural, and unlike the original source materials, where in both cases each profile and frontal image—

DC

Each mug shot—

RM

Each mug shot was seen individually. In the mural, on the other hand, you could imagine a circuit of gazes; you could imagine men looking at each other or men even looking at themselves or looking past themselves to the next most wanted man. And this to me was very interesting in terms of cruising and the idea that you take a public space and you use it for purposes that it's not intended to be used for, namely for erotic desires that are already to some extent prohibited between members of the same sex. I'm not saying that that was necessarily manifest, but I think that one of the effects, visually, of the mural is that a different kind of looking is possible than is possible in the brochure itself. (The brochure still exists in the Warhol Museum archives; *Thirteen Most Wanted* was a booklet put out in 1962 by the New York City Police Department.)

One of the questions that I asked in *Outlaw Representation* was, how did Warhol get this thing? In the *New York Journal-American* article—the only one that photographed and reported on the mural before it was censored—the police representative is quoted as saying, "As far as I know we did not give him the book but he may have gotten it from us. That is all I can tell you."

And then John Giorno, in his memoir, provides one answer to this based on a dinner party anecdote. Giorno appeared in Warhol's film *Sleep*, and he wrote a whole essay about the experience of being in Warhol's movies, and he radiates out from there. I think *Sleep* was '63, so not that much before the *Most Wanted Men*.

On April 23, 1963 [the painter] Wynn Chamberlain invited Andy, me, and a friend of his named Bobo Keeley, to dinner up in his loft on the top floor of 222 Bowery. . . .

At dinner we talked about Bob Indiana's new show at the Stable and the current gossip.

Robert Indiana was one of the other artists on the exterior facade of the New York State Pavilion at the World's Fair; he had the *Eat* mural.

Andy mentioned he had a problem because he had to do a piece for the 1964 World's Fair and he didn't have an idea. . . . "*Oh, I don't know what to do!*" said Andy.

We were eating coq au vin and drinking white wine. Wynn said, "Andy, I have a great idea for you. The Ten Most Wanted Men! You know, the mug shots the police issue of the ten most wanted."

"Oh, what a great idea!" said Andy.

"My boyfriend is a cop," said Wynn. "He can get you all the mug shots you want. He brings home a briefcase of them every night. . . ."

"Oh, what a great idea!" said Andy. "But Robert Moses has to approve it or something. . . . I don't care, I'm going to do it!"

Wynn Chamberlain had a lover, Jimmy O'Neill, who was gay and a New York City policeman, half Italian and half Irish, and he was gorgeous. Jimmy was a third-generation cop. His grandfather was a captain. Jimmy was hip. He gave Andy a big manila envelope filled with crime photos, mug shots, archival photographs, and the Ten Most Wanted Men."[5]

So, you can see how Giorno's account turns largely on the coincidence that a "third-generation cop" should also be a "hip" homosexual who brings home a briefcase of mug shots to his painter-boyfriend each night. This is a social and sexual network of gay men that links Warhol, however covertly, to a New York City police officer. This both subverts police protocol and enables Warhol's creative process. It's such a great story because the link between Warhol and O'Neill marks the presence of outlaw desires and secret commitments right inside law enforcement itself.

DC

You might say, to return to the notion of trade, that a cop is trade, too, because a cop is also a figure of working-class masculinity. So the criminal and the cop might be equivalent objects of desire, from the queer perspective. And indeed, men in uniform are part of the image repertoire of gay desire. One of the Village People dressed as a cop.

RM

That's what I think is fun about gay pride parades, often you don't know whether you're looking at an actual police officer or just some guy in a police uniform he bought as fetish-wear.

It's noteworthy that Giorno says of O'Neill not only that he's half Irish and gorgeous but also—

DC

Half Italian.

RM

Right, and half Italian—the official reason why they said they had to take the mural down was that they said they didn't want to offend Italian Americans with the stereotype of mafiosi.

First the story is that he brings home a briefcase of these mug shot pictures, but it suggests that even he, the cop, may be looking at these pictures for a different purpose than what would have been intended. Then for Wynn Chamberlain to pass them along to Warhol, for him and his boyfriend to look at them together, suggests that maybe there are other pleasures or uses besides just surveillance for a gay cop, in looking at these rough trade mug shots. There's something also delicious about the coq au vin—the whole story is perfect for our purposes.

It also speaks to the mural as a switching station between different sorts of knowledge.

DC

In his chapter on the "trade aesthetic," Reay gives a great many examples. But, of course, his focus is on actual male hustlers. He writes about the fact that there were boxers who were so secure in their masculinity that they could turn tricks as gay hustlers without feeling that it would compromise their heterosexual identity. Evidently many gay men went to boxing matches not to watch boxing but to watch boxers, who, of course, wear nothing but

shorts and boxing gloves. This desiring gaze then becomes the basis for gay artists' choice of subject matter. Reay uses literary examples as well as those drawn from visual art. So, for example, he discusses Tennessee Williams's characterizations of Stanley Kowalski in *Streetcar* and Brick Pollitt in *Cat on a Hot Tin Roof*.

It's not surprising that the image of Marlon Brando that Warhol chose for his silk-screen painting in 1963 was from *The Wild One*, in which Brando plays a biker—the leather jacket, the tough-guy outsider, rough trade. It's the same kind of image that Kenneth Anger would use in 1964 for his film *Scorpio Rising*. And coincidentally, *Scorpio Rising* was censored the same year as *Thirteen Most Wanted Men*: it was busted in LA in 1964.

RM

What you're suggesting is that the criminal, the boxer, the biker, maybe even the police officer constitute a kind of lexicon or visual repertoire of types that were already part of gay subculture as acknowledged objects of desire.

DC

Yes.

RM

So that's another way in which this mural, for certain viewers, might have been coded. One of the notable things about *Thirteen Most Wanted Men* is that it was only up for a couple of days, and by the time the fair opened it was painted over. But this makes it all the more resonant with the history of homoeroticism; the fact that the mural is so evanescent, that by the time the official fair opens it's just an empty space. It speaks, to paraphrase Benjamin Buchloh, of having been silenced.

DC

It makes me think of the Daniel Buren work that was removed from the Guggenheim International exhibition in 1971. It's probably Buren's best known and most reproduced work, even though the public never saw it. It was also taken down before the opening of the show.

RM

I wanted to make sure that we also talked about the broader crackdown on queer culture in New York as part of the preparations for the 1964 fair. The fact that there were gay bars at the time, for example, and queer avant-garde movies gives the lie to the notion that everything was so secret.

DC

There was a very vital queer culture at this time, especially in underground film, a scene that Warhol joined when he shot the film

Tarzan and Jane Regained. . . Sort Of in Los Angeles in 1963. *Sleep* was definitely a homoerotic film. Giorno, the sleeping man, was Warhol's boyfriend at the time, and he filmed him sleeping nude. Watching a lover sleeping is an age-old subject of art.

RM

And then *Blow Job* was '64—was it before this?

DC

It was made early in 1964. It's one of the first films Warhol shot at the Factory, just after he moved his studio there.

RM

And then there are the *Thirteen Most Beautiful Boys*.

DC

It seems that the idea for a film to be called the *Thirteen Most Beautiful Boys* came about at the same time Warhol began working on the mural, and, of course, the title comes from the same source, the New York City Police Department booklet. The idea of filmed portraits to be called the *Thirteen Most Beautiful Boys* led to one of the most important of Warhol's film projects from 1964 to 1966, the *Screen Tests*.

Callie Angell explains in her catalogue raisonné of the *Screen Tests* that the first mention of these portrait films appears in an entry in Kelly Edey's diary in January 1964. Edey was to be one of the *Thirteen Most Beautiful Boys* and the first of these portraits was evidently shot in his apartment. Angell writes:

> The identification of the very first *Screen Tests* with the *Thirteen Most Beautiful Boys* films made in January 1964 is confirmed by the film materials themselves. Only seventeen *Screen Tests*, all films of men, were found to have been made on 1963 stock, which indicates that they are the earliest *Screen Tests*, shot no later than early 1964. Of the seventeen earliest *Screen Tests*, twelve were marked as selected for the *Thirteen Most Beautiful Boys*. . . . The forty-two *Screen Tests* of thirty-five men. . . have been identified from notations found on the film boxes, on which Warhol or someone else wrote "13" or "Beautiful Boy."[6]

So it seems that Warhol shot a number of the *Screen Tests* destined for the *Thirteen Most Beautiful Boys* before he actually made the paintings for the World's Fair mural. But he only came up with the title as the series developed.

RM

But there is no *Thirteen Most Beautiful Boys* film.

DC

No such film was ever distributed, according to Angell, unlike *Thirteen Most Beautiful Women*, which was listed in the Film-Makers' Coop catalogue. There might have been screenings of *Thirteen Most Beautiful Boys* at the Factory. Angell writes that the only record of a public showing of the *Thirteen Most Beautiful Boys* is when one *Screen Test* from the series, that of Freddie Herko, was shown at the New Yorker Theater, when Warhol won *Film Culture*'s Independent Film Award in 1964.

RM

This speaks to a larger issue in the Warhol historiography, and also in your work, Douglas, and the limits of mine, and places that you've gone that I haven't been able to go. Going back to when I was first thinking about *Thirteen Most Wanted Men*: I was very excited when I learned of *Thirteen Most Beautiful Boys* and also *Thirteen Most Beautiful Women*, because I gathered that there would be no reason to use "thirteen." It wasn't like "ten," which is what you expect. To me it was important because first of all there were thirteen beautiful boys, not only beautiful women, and that it was about desire.

DC

Boys, not men.

RM

Right. And you expect women to be beautiful, but not boys—according to the rules of desirability in our culture.

DC

One remark about that, returning once again to the trade aesthetic: if you look at the men that he called "beautiful boys," they are not, for the most part, what we would call "rough trade." In this regard they are different from the man shown in *Blow Job*, or if not the man himself, then the way he's attired.

RM

That's also interesting in terms of the *Thirteen Most Wanted Men*. Because when I was doing the cover for my book, there was actually a different most wanted man, one with a black eye, that I really liked. And my friend Ira Sachs, a gay filmmaker, said no, you have to choose the cutest one [*laughs*] if you want gay men to buy the book—and that's the only reason why this guy is on the cover.

DC

So that was Ira's idea of the cutest one.

RM

Well, mine too, conventionally. But the reason I mention this is that I think part of the idea of "beautiful boys" is that the beauty is the light and the camera. The beauty is not so much necessarily their physical qualities; it's their appearance in front of the camera.

DC

One thing we could say about the *Screen Tests* that formally relates them to *Thirteen Most Wanted Men* is that most of them are straightforward frontal portraits, very dead-on, like mug shots. And of course it's right around this time that Warhol was also using the photo booth to make portraits, which also produces a mug-shot quality.

RM

I haven't thought about it in terms of the *Screen Tests*, but both the mug shot and the photo-booth photograph are among the most degraded photographic processes. The mug shot is just used for identification, and, in the police booklet, in certain cases when there wasn't a mug shot available, they used a snapshot.

DC

When I wrote my essay "Getting the Warhol We Deserve"—which was intended as a defense of visual studies, taking Warhol as an example of someone for whom an interdisciplinary methodological approach would be productive—one of the things that I did was to put your analysis of the censorship of *Thirteen Most Wanted Men* in relation to the wider cleanup of the city in preparation for the World's Fair.[7] I was particularly alert to that historical cleanup because I was writing during Mayor Giuliani's crackdown on queer culture and adult businesses in New York in the 1990s.

I was also beginning to think about Warhol's films, and in fact Warhol's very first film was caught up in that 1964 cleanup. Warhol became interested in filmmaking through his regard for and envy of Jack Smith. Warhol made a film, a kind of documentary, called *Jack Smith Filming Normal Love*. (Warhol is in Smith's *Normal Love*, too, at the very end, in the sequence where a group of people dance on the top of huge birthday cake made by Claes Oldenburg.) Coincidentally, it was on Wynn Chamberlain's property that Jack Smith filmed *Normal Love*. In 1964, during the cleanup, movie houses showing underground films were shut down by the police, and a screening of Jack Smith's *Flaming Creatures* was raided by the police and the film confiscated. Warhol's film was confiscated, too, and as a result, it's been forever lost. *Flaming Creatures*, one of the canonical works of underground filmmaking, was found to be obscene. That decision has never been overturned, so technically, showing *Flaming Creatures* is still illegal.

RM

I'm going to read from a letter that Frank O'Hara wrote to Larry Rivers in March 1964.

> In preparation for the World's Fair, New York has been undergoing a horrible cleanup (I wonder what they think people are *really* coming to NYC for, anyway?). All the queer bars except one are already closed, four movie theaters have been closed (small ones) for showing un-licensed films like Jack Smith's *Flaming Creatures* and Genet's *Chant d'amour*. . . . The fair itself, or its prepara-tions, are too ridiculous and boring to go into, except for the amusing fact that [fair president Robert] Moses flies over it in a *helicopter* every day to inspect progress.[8]

DC

It's a fairly typical thing; I think it was done for the 1939 World's Fair as well.

RM

I think it's interesting in relation to *Thirteen Most Wanted Men* because it speaks to another way in which the image of the city is being sanitized. A certain kind of citizen is being presented as definitive or normative, and others are being absented or ren-dered invisible.

DC

And certain kinds of culture as well.

RM

Right, because Frank O'Hara is saying, "What do they think peo-ple are coming to New York City for anyway?" Which speaks to the idea that people might be coming to go to see those films or go to those queer bars as well as going to the World's Fair. That queer people are also part of this huge national or international audience, that the two cultures are overlapping.

DC

Or the fair might be an excuse for queers to come to New York.

RM

I'm glad that you mentioned the connection between queer cul-ture and avant-garde cinema, and also Warhol's role in the latter, which increases as the sixties unfold. My research on Warhol's *Thirteen Most Wanted Men* was mainly on the silk screens, not on the films. Until recently, art history has followed a similarly exclusive path, looking primarily at the early-sixties silk screens but not at Warhol's films, photography, advertising, late work, magazine publishing, TV production, etc. This has the effect of

impoverishing Warhol, and the queer cultural achievement of his work, by insisting on a narrow slice of his career as art historical.

DC

Warhol began making films in 1963, and already by 1964 film-making had begun to occupy a great deal of his time. In 1966, he declared that he was not going to make paintings anymore, that he was only going to make films. That's when he made the helium-filled Scotchpak pillows called *Silver Clouds*, which he claimed were a way of saying good-bye to painting. In 1964, he was making silent, Minimal films, of which the *Screen Tests* are an important example. One of the fully canonized films from that moment is *Blow Job*, about which there are now two book-length studies. Angell suggested that *Blow Job* was a kind of tease. In spite of its title, it is nothing more than a film of a face. Imag-ine the police raiding a film called *Blow Job* and finding a forty-minute silent portrait of a man's face. You never see the blow job.

RM

Do we know that there is one?

DC

Anecdotally we do. We know anecdotally even who it was who gave the blow job. But in any case it is very clear that a blow job is taking place. You see the excitements and lulls of a fairly drawn out blow job. You see the man coming—I think it would be a very remarkable performance to fake it. Men don't fake coming [*laughs*]. I'm completely convinced that it is an actual blow job.

The guy who is getting the blow job, DeVerne Bookwalter, was an actor, and he eventually appeared in gay porn. But if you look at his *Screen Test* for *Thirteen Most Beautiful Boys*, you see that he was a fairly ordinary good-looking guy. In *Blow Job*, he's dressed in a leather jacket, like Brando in *The Wild One*. It's again an image of rough trade, and indeed in his book *Stargazer*, Ste-phen Koch calls the actor a hustler.[9] That is something that I argue against, because there was no evidence that he was a hustler; it's a presumption on Koch's part. Nevertheless, the hustler was a figure that Warhol was interested in, and he made the film *My Hustler* in 1965 with an actual hustler, whose name interestingly enough was Paul America—the hustler becomes the emblem of American masculinity.

Had scholarship paid greater attention to Warhol's filmmak-ing, we would have had a queer Warhol a little bit sooner.

RM

Do you think the films themselves were not accessible, or do you think it's a broader bias against the moving image on the part of people trained to look at painting and sculpture?

DC

I think it's both. The films were very queer and a lot of Warhol scholars didn't want to go near them. *Couch* is a highly sexually explicit film, with a blow job, fucking, a three-way; *Blue Movie* is a film with real fucking; there's sex and the promise of sex and the withholding of sex in many or even most of Warhol's films. And they are very challenging aesthetically.

RM

In terms of non-narrative—

DC

In all sorts of ways. Extended duration, for example, is a major aspect of Warhol's cinema. I believe the exhibition will include *Empire*, because—we know this thanks to Callie Angell's scholarship—one reason that Warhol was interested in the image of the Empire State Building was that the floodlights that light up the building by night—sadly, they've been recently replaced with LED lights—were put on the building in celebration of the World's Fair. The film is thus a direct response to the preparations for the World's Fair. I suppose you could call it a World's Fair work.

RM

The counterpart to the crackdown is the light-up.

DC

Exactly. Warhol saw the Empire State Building not only as a star but also a giant erection—even the Empire State Building had sexual implications for him.

It's not only the filmmaking that has been ignored by art history until recently. One of my former graduate students, Lucy Mulroney, wrote a brilliant dissertation on Warhol's publications.[10] Warhol produced publications of all kinds throughout his life: he illustrated books; made handmade books; published a novel, a memoir, a philosophy, a diary; founded a magazine; compiled photo books—the list goes on.

When she began looking at Warhol, Lucy found what a treasure trove there was and how much his publications change our ideas about publication in general, of making something public, of bringing about a public, of publicity—things that always concerned Warhol. Warhol emerges as a far more significant artist if you get beyond the absurdly limiting idea that he was important only for the paintings he made between 1962 and 1964.

RM

One of the things about Warhol, in terms of an argument for visual studies, is that we need models of curating, scholarship, and writing that are at least as ambitious as the enterprise of the artist that we're writing about. So we can't really have an art-historical model of Warhol that only deals with this one part or period of his career. One of the things that's interesting to me about this show is that it's going to have all this attention on the mural, and it wants to put the censorship of the mural on display. But it's also putting on display the contemporaneous films, as well as some of the sculptural objects from the Stable Gallery show that opened the same month, in April '64. And so I thought, to put Warhol's sculpture in relation to the mural and in relation to the film, but then also to be thinking about the site of the World's Fair as well as the contemporaneous news coverage, that's a fairly complicated curatorial premise, and it could be considered a more ambitious model of curating.

But one of the caveats that I have in reading the press release is that it says "exactly fifty years will have passed since a public artwork by Andy Warhol sparked a high-profile scandal at the 1964 New York World's Fair." In fact, the argument that I make is that there was no scandal, high-profile or otherwise. This was an extremely soft episode of censorship. I think some of the most interesting cases of censorship and self-censorship do not issue in scandal. Warhol basically tells the press at one point that one of the *Thirteen Most Wanted Men* wasn't wanted anymore, so the mural was not valid. At another point in *POPism* he says he didn't want any of the *Thirteen Most Wanted Men* to get caught because of his mural, he would have felt bad—neither of which was the real reason for the work's removal.[11] So far as we know, Warhol was happy with the way it looked; it was the fair officials who were unhappy. But in the press there were reports that Warhol was unhappy with the aesthetic effect of the mural—a narrative invented (and not by the artist) to explain the suppression of his work. It's often only retroactively that we can see how censorship is functioning. And because Warhol just simply wasn't the kind of artist to protest, it wasn't his sensibility, in certain ways—

DC

You can't cultivate an image of pure passivity and then fight for your rights.

RM

Exactly [*laughs*].

DC

Or you fight for them in a cagey way, such as his little rejoinder of a rather unappealing portrait of Robert Moses.

RM

That's brilliant. There is something brilliant about the fair opening with this Minimalist or Color-Field silver absence which definitely speaks of its own silencing. But in terms of Warhol as a passive. . . I don't know if you want to say resistor of censorship, a passive

vessel. . . . But in the face of all this, he came up with the idea that there would be twenty-five identical images of Robert Moses where the *Thirteen Most Wanted Men* had been. So the very image of the censor would have taken over the space of the mural he had censored.

DC

It makes him "most wanted" in another way.

RM

What do you mean?

DC

To many people, Robert Moses was himself a major criminal. This is the man who wanted to build a freeway down the middle of Fire Island! He destroyed San Juan Hill, a largely black and Latino neighborhood, in order to build Lincoln Center. He bulldozed neighborhoods, including the part of Greenwich Village that is now NYU housing. He wanted to put an expressway where SoHo is now. He was finally stopped in that bit of folly by Jane Jacobs

and a mass protest movement. There is a magisterial and devastatingly critical biography of him by Robert Caro called *The Power Broker*.[12] His was the face of the most brutal forms of urban renewal that we know from that era. Now, whether or not that's the understanding Warhol had of him, I don't know. I have no idea what he knew about Robert Moses or what he thought about him. But the portrait of him isn't exactly flattering.

RM

No, it's not flattering. It's most interesting to me as a response to the power. Generally, the thing that censorship never wants is to be rendered visible as censoring. And of course, they didn't let him do it, and even in the press they kept saying, well he's waiting for another inspiration [*laughs*]. It was months later, and he had his inspiration, but they never reported on that.

DC

Warhol never waited for an inspiration. He always asked other people to give him an idea.

1. Catherine Lord and Richard Meyer, *Art & Queer Culture* (London: Phaidon Press, 2013).
2. Richard Meyer, *Outlaw Representation: Censorship and Homosexuality in Twentieth-Century American Art* (Oxford and New York: Oxford University Press, 2002).
3. "So today if you see a person who looks like your teenage fantasy walking down the street, it's probably not your fantasy but someone who had the same fantasy as you and decided instead of getting it or being it, to look like it, and so he went and bought that look you both like. So forget it. Just think of all the James Deans and what it means." Andy Warhol, in *The Philosophy of Andy Warhol: From A to B and Back Again* (New York: Harcourt Brace Jovanovich, 1975), 53.
4. Barry Reay, *New York Hustlers: Masculinity and Sex in Modern America* (Manchester: Manchester University Press, 2010).
5. John Giorno, "Andy Warhol's Movie 'Sleep,'" in *You've Got to Burn to Shine: New and Selected Writings* (New York and London: High Risk Books, 1994), 128.
6. Callie Angell, *Andy Warhol Screen Tests: The Films of Andy Warhol Catalogue Raisonné* (New York: Abrams, 2006), 244–245.
7. Douglas Crimp, "Getting the Warhol We Deserve: Cultural Studies and Queer Culture," *Invisible Culture: An Electronic Journal for Visual Studies* 1, Winter 1999.
8. Frank O'Hara, letter to Larry Rivers, April 18, 1964. Larry Rivers Papers, MSS293, Fales Library and Special Collections, New York University Libraries.
9. Stephen Koch, *Stargazer; Andy Warhol's World and his Films* (New York: Praeger, 1973).
10. Lucy Mulroney, *Andy Warhol, Publisher* (Rochester, NY: University of Rochester, 2013).
11. Andy Warhol and Pat Hackett, *POPISM: The Warhol Sixties* (New York: Harcourt Brace Jovanovich: 1980), 90-91
12. Robert Caro, *The Power Broker: Robert Moses and the Fall of New York* (New York: Knopf, 1974).

4—Sat. April 18, 1964 ——— New York Journal-American

WORKERS RUSH FAIR PAVILION, BUT...

Belgian Village Is Behind The Times

By MORT YOUNG

Critical Phase Near in Talks On Rail Labor

WASHINGTON, April 18 (AP).—Railroad labor talks entered a critical phase today as the White House continued efforts to prevent a strike which President Johnson says would virtually paralyze the nation.

CONTINUE EFFORTS

MURAL TO COME DOWN AT THE FAIR
Most Wanted Criminals' Photos to Leave N. Y. Pavilion Wall

Fair's 'Most Wanted' Mural Becomes 'Least Desirable'

By MEL JUFFE

Barnes Blasts Road Builders For 'Foul-Up'
Continued from First Page

PULLING OUT ALL THE STOPS
POINT LOOKOUT, Me., April 16 (AP).—The festival of arts at the School of the Ozarks...

Rusk Guarded In Viet Terror
Continued from First Page

Police Leaves Off for Stall-In
Continued from First Page

A Fair World— The Unisphere

STUDENTS PULL A FAST ONE
FRANKLIN, Ind., April 18 (UPI)—Irate members of the Franklin College Student Council...

Girls Clubs Parley Set

See Court Test Of Liquor Law
ALBANY, April 18 (AP)—New York State's new liquor control law, adopted Thursday as a turbulent special session of the Legislature, is in for a vigorous court challenge.

Subs Visit Lisbon
LISBON, April 18 (UPI)—The first U.S. Submarine Division sailed into Lisbon yesterday on the first of two visits which officials described as a routine three-day visit.

Honor Student Wins Hellinger Award

Pick 'Mother of '64'
OTTAWA, April 18 (AP)—The Canadian mother of 1964, chosen in a national contest this week, is Mrs. Mildred Derksdorfson, an Indian of Kamloops, B.C., who has 12 children of her own, one adopted child and five foster children in her home.

The *Journal-American*'s April 18th follow-up to its April 15th story includes Philip Johnson's claim that painting over the mural was Warhol's decision ("he thought we hung it wrong") and that official objections were not, and would never have been, the deciding factor.

The full article text is available on p 145.

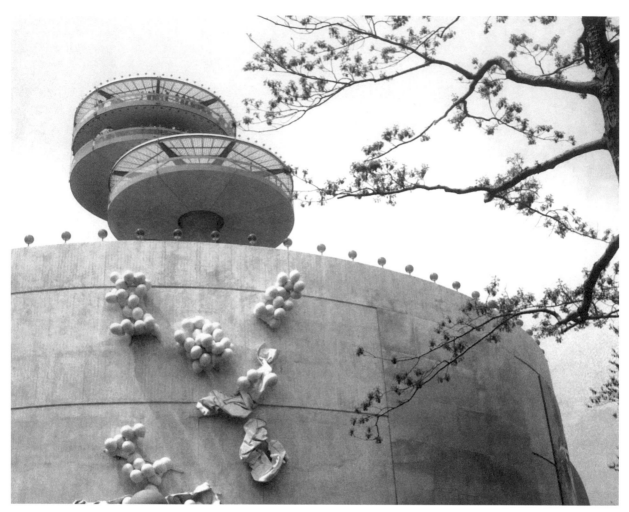

After triggering objections at the highest level, *Thirteen Most Wanted Men* was painted over in silver before the World's Fair opened. By April 22, the opening day of the fair, all that was visible was a silver square. This would remain on view throughout the summer of 1964 and the following summer as well. Warhol used the silkscreens he'd used for the mural to make separate canvases, which are reproduced throughout this publication. The silver panels themselves are presumed lost.

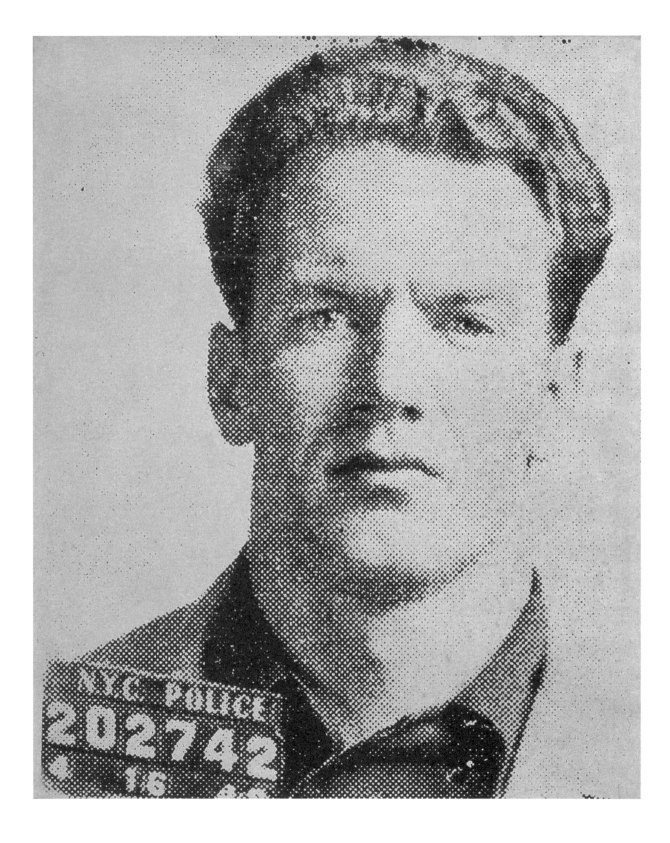

"I want something very ordinary, very common."

Curator **Larissa Harris** speaks with art historian **Anthony Grudin**, who has written extensively on Warhol and class. Their conversation touches on criminality in art, both in relation to *Thirteen Most Wanted Men* and to the historic position of the avant-garde; on the relative impacts of Warhol's artistic statement—if indeed it could be called a statement—and of civil rights protestors at the fair; and on Warhol's profound identification with animals and animality.

Larissa Harris

In one of the only newspaper articles covering the piece before it was painted over, Warhol mentions that an early idea for the New York State Pavilion commission was a Heinz pickle.[1] That would have been an acceptable, predictable Pop artwork (as well as a gay in-joke). The *Thirteen Most Wanted Men* seem other, beyond the pale.

Anthony Grudin

Yes. When I started thinking about our conversation it occurred to me that, as far as I know, the mural was the first large-scale public artwork to make mug shots its exclusive subject matter. There are very few large-scale public artworks in the history of Western art that focus exclusively on figures who are defined by their contemporaries as unambiguously criminal. Not just antiheroes, but socially designated criminals. Duchamp had produced a self-portrait as mug shot in 1923. He reproduced it as a wanted poster for his 1963 retrospective in Pasadena, and Warhol probably saw it. There's Rauschenberg's *Hymnal* (1955), which is another precedent and possible influence. But neither of these works make the figure of the actual contemporary criminal as central and unmediated as it is in *Thirteen Most Wanted Men*.

Of course, Warhol realized that the expression "most wanted men" had many noncriminal valences: sexual, as Richard Meyer has brilliantly demonstrated, but commercial too. I was interested to find high-end help-wanted ads in the *New York Times* that, during the late 1950s and early 1960s, repurposed this expression as a snappy recruitment headline, right across the top: "Most Wanted Men." It's fascinating how capitalism can just take these dire expressions and effortlessly turn them into commercial copy.

But it's also crucial to remember that Warhol was always focused on the art world's blind spots and unspoken assumptions, and one such assumption, which he seems to have been the first to expose so directly, is that the criminal figure is reproducible

in some artistic contexts and not in others. Criminality, Warhol showed us, is one of public art's unthinkable borders. It needs to be mentioned alongside the classic Kantian boundaries of sexual and commercial interests, animality, and disgust, all of which were also deeply unsettled by Warhol's engagement with them.

Warhol's method of engaging or testing this border is fascinating in its own right. Meyer suggests that Warhol's individual *Thirteen Most Wanted Men* canvases constitute "a kind of countersurveillance operation, one in which the disciplinary gaze of the law is returned and eroticized by the outlaws it aims to capture."[2] This argument might be extended to the World's Fair version as well. Structurally, Warhol produced not just a reverse-panopticon, but a reverse-panopticism. In Jeremy Bentham's panopticon, the observers are centralized and invisible. Building on Bentham's insights, Michel Foucault described a modern world in which the logic of the panopticon has been universalized beyond the prison, and internalized by all subjects.[3]

Thirteen Most Wanted Men highlights the way in which criminality is always with us as an outer border of behavior: the police seem to hover and observe everywhere, even when we're out and about enjoying ourselves. In a direct reversal of this logic, *Thirteen Most Wanted Men* would have given the presumed criminals the central, elevated position, the position of the observer, rendering them as viewed and viewable images rather than imagined observers. But these centralized faces would have been depicted as haunted by surveillance, and spectators would have been forced to reckon with this haunting. This reckoning would have persisted even when those spectators were "outside," "in public," far away from the prison—at the World's Fair, the place where capitalist modernity curated its own publicity. The proximity of the pavilion's observation towers only heightens this effect.

Additionally, this unprecedented confrontation with criminality would have been tinged, as Meyer has demonstrated, with eroticism and homoeroticism. Herbert Muschamp thought that the mural might have been inspired by the widely publicized shipment of Michelangelo's *Pietà* from Rome to Flushing Meadows. Is there a more striking example in the history of Western art of an eroticized male figure of the redeemed criminal than Michelangelo's monument? All told, the mural would have been, to my mind, one of the boldest engagements with criminality ever attempted by a visual artist.

LH

The show includes documents of the criminalization of Warhol's milieu as part of the police "cleanup" of the city in preparation for the fair. This could have been part of his thinking—along the lines of, "You calling us criminals? I'll give you criminals." But at the same time, Warhol was not the kind of artist to make such explicit statements, and the content of the piece had been decided for a long time.

AG

There are other precedents or comparisons—definitely the *Race Riots*, because the protestors in those paintings are in the process of being criminalized as the photographs are taken; the police and their dogs are making that designation before our eyes. And the protesters in Birmingham are not romanticized or mediated figures; they are everyday real people who are being criminalized and attacked.

It's useful to add these works to the conversation, I think, because they remind us of art's varying degrees of political efficacy. It's important to give Warhol his due, and to look into how deep and rich the mural is, but also to step back from it and say, this is a deeply mediated and indirect form of political action, and other, far more direct forms of political action were happening right next door to this. For instance, the censorship of the mural is all the more striking because the mural had to compete for attention with a planned traffic jam coordinated by the Brooklyn chapter of the Congress of Racial Equality (CORE), a widely publicized action that threatened to bring the roads around the fairgrounds to a standstill through a mass stalling of automobiles on the feeder roads around the fairgrounds. On April 24, a week after the decision to cover the Warhol mural, *Life* magazine ran a full-page photograph of a poster stapled to a wall at CORE's headquarters. The poster consists of a newsprint photograph of Robert Moses surrounded by inward-pointing arrows hastily drawn in black marker. The text reads: "TARGET/APRIL 22 1964." It's a handmade most-wanted sign.

CORE's political action helps us put the efficacy of Warhol's mural into context. Both refer to the trope of a wanted poster, but for CORE, the poster is a spur for action, a method for stimulating what Jonathan Flatley might call a revolutionary mood. CORE's idea for an actual intervention—a collaborative traffic jam built out of stalled cars—was brilliantly economical, harnessing and short-circuiting the fair's emphasis on the automobile and the highway. Where Warhol turned the grid into a metaphor for a jail and a cage, opening up possible correspondences between the inmates, CORE hoped to produce actual gridlock. Contemporary journalists labeled their effort a failure, but preparations to prevent it involved local, state, and national authorities, and results included two full-page articles in *Life* (in both cases, these articles included the only photographs of African Americans in their issues).

But, if we go back to the art context, Warhol was deeply aware of how the history of modernist art—let's say the hundred years before him since Courbet—was a history of rule breaking, of law breaking. But he also knew that, in order to succeed in art, you can't break the rules in a way that admits that your goal is to get into the museum.

LH

In an informal conversation with us, John Giorno remembered that Wynn Chamberlain had called Warhol a "prophet of doom"—a joke, of course, but to me quite telling in relation to this particular moment in time when a humanist AbEx was really ceding ground to nihilist Pop.

AG

Yes, but others saw Warhol and his colleagues as heralding unprecedented forms of creativity. I'm working on a book about the importance of the animal in Warhol, which I think has interesting connections with the dimensions of class, gender, criminality, and sexuality. I focus on what I call Warhol's animal life: his powerful, abiding, and ambivalent interest in animality and what Jacques Derrida called the *animot*, the irreducibly individual animal. Warhol was infatuated and intrigued by the animals around him—the dogs and cats that he lived with throughout his life, but also snakes and reptiles, bulls and cows and horses, bumblebees and cockroaches. In a beautiful way, he sees a commonality between himself and the animals around him, and I think that the *Thirteen Most Wanted Men* are inflected by this interest.

Art and our myths around it are intended to draw a line between the truly human and the animal—which is defined by its appetites, which has no self-reflection, which has no soul, no language. The animal is supposed to lack all these things. The very ability to produce and enjoy art elevates the human above the animal, as an artist or patron or viewer. And this definition of the animal has so much in common with the criminal. The criminal is the human being who just pursues his or her interests without thought for others. It's that same kind of driven-by-appetite diagnosis that people have long used to dismiss and devalue the animal.

Of course, panopticism is in part a method of animalizing the human subject; the precedent for Bentham's panopticon was a menagerie. And more generally, as a variety of scholars working after Foucault have remarked, the deprecation of animals is often used to justify the mistreatment of criminals. Humans can reflect. "We" can be disinterested, "we" can have a soul, "we" can have language. And then the criminal/animal/machine is everything that we look at and say, "Well, you can't do that but we can.

That's what separates us from the beasts." Warhol was always questioning that line. I believe he was questioning it in part because he refused to be a hypocrite about his own "inhuman" feelings and appetites. He was deeply aware of his own animality and his connections to animals.

LH

He identified with them.

AG

Exactly. Derrida's critique of this boundary between human and animal includes Emmanuel Levinas. Levinas developed this powerful theory of the face: each of us acknowledges each other's face, and that's how we build an ethical world. But when his students ask him whether a dog has a face that way, Levinas says no, it's not the same between a dog and human. This argument is relevant to the mug shot, which is an intensely dehumanizing photograph. It turns what should be an ethical relationship between faces into a scientific, objectified study of a face.

LH

With *Thirteen Most Wanted Men*, Warhol seems to appropriate an act of sadism that we don't think of as sadism because the people who undergo it "deserve" it. This channeling of the apparatus of the state—you could also say that the *Screen Tests* setup shares some qualities with a police interrogation.

AG

And Warhol is completely aware of that. As you say, the same thing is true of the *Screen Tests*. The sadism is apparent, but he also catches those moments where it's impossible not to empathize with the figure when they start tearing up. You think, "Oh my god, I'm right there with this person." So he has this amazing sense of those in-between moments, in between sadism and empathy, or in between dehumanization and humanization, in between de-eroticization and eroticization. He senses that's when the work is going to be powerful.

LH

It is interesting to think about identifying with animals, in terms of the silence and the relative stillness of the *Screen Tests*. What you see is the living, breathing part of being a person.

AG

Bare life, creaturely life. Hal Foster makes the crucial point that the emphasis on creaturely life tends to coincide with moments of intense political upheaval.[4] Warhol wrote frequently in his diaries about cockroaches and how he couldn't smoosh them in his apartment because, as he evocatively puts it, they're "just like a life, like living."

I think that animals are Warhol's utopian response to America's social exploitation and turmoil. There are interesting moments in *The Philosophy of Andy Warhol* where he expresses these utopian longings: "Why can't we all be the same?" "Why can't we all be movie stars?"[5] But he's always expressing that from a position of "Of course we can't." I think he sees or senses in animals a different world, a world beyond exploitation and deception. Animals offered Warhol alternate forms of sociality and kinship, beyond human relationships and all their difficulties.

LH

I feel like it must have something to do with identifying with the things that can't speak. My dad said that my one-and-a-half-year-old daughter must love puppies and kittens so much because they don't talk incomprehensibly all the time.

AG

In Warhol's diaries and interviews, he repeatedly mentions having trouble with speech. I knew that he affected this mumbly monosyllabic voice, but it turns out that—at least according to what he wrote—he had a tough time speaking in multiple syllables. He says that in the middle of words he'd get confused and end them with the wrong syllable. It's fascinating that you went straight to that, because I think that's really at the heart of the matter, and of course speech is a crucial way that "people" distinguish themselves from "animals."

LH

There are a few great photographs by Billy Name from spring 1964 when the acetates of the individual *Most Wanted Men* are taped up around the Factory while the box sculptures—Brillo, Motts, Campbell's Tomato Juice—are being produced on the floor. The Stable Gallery show, which introduced those box sculptures, opened on April 21, the day before the World's Fair. Your 2010 article "A Sign of Good Taste: Andy Warhol and the Rise of Brand Image Advertising" looks carefully at the meaning of the particular brands Warhol chose to use in terms of their own history and Warhol's understanding of advertising.[6]

AG

This specificity of Warhol's brand choices has been obscured by many of the more prominent readings of his work, like Arthur Danto's and Fredric Jameson's, which assume that Warhol chose his motifs at random. I don't think that reading does justice to Warhol's strategic intelligence. Nathan Gluck, Warhol's assistant from 1955 to 1965, remembered Warhol as being well aware of the Brillo Box's downmarket connotations:

When he wanted to do his box sculptures, he sent me across to the A&P and said, "Get me some boxes." I came back with things that were very artsy, maybe a Blue Parrot pineapple box or something like that. And he said, "No, no, no. I want something very ordinary, very common." So I went back and got a Brillo Box.[7]

The "Sign of Good Taste" article investigates the ways in which advertisers were targeting the brands you mention at what they explicitly called "the working class." The faces in Warhol's *Most Wanted* mural also seem to carry class connotations—although it's striking in this regard that these connotations are by no means consistent from face to face; there are a couple that always seem to me to project a striking air of confidence and ease.

But the other place where I think that class needs to be acknowledged in this work is the style of its depiction. My upcoming book on Warhol and class argues that both Warhol's visual reproductive technologies—overhead projectors, silk screens, amateur-grade cameras—and the intentionally slapdash way in which he employed them carried distinct class connotations of their own. These technologies of amateur visual reproduction were prominently advertised in publications that were traditionally associated with a working-class readership desperate for upward mobility: comic books, tabloid magazines, downmarket newspapers. The promises are really explicit: "You can make a better living if you learn how to reproduce images, and we'll help you—either through mail away art school or through these technological tricks." Warhol used all these technologies, and he would constantly emphasize the amateurishness of his style. This effectively communicated a déclassé authorial voice (a voice which was true to Warhol's family background but not to his current professional stature), which really stands out when Warhol's installation is compared with the works near it on the pavilion.

Throughout his childhood, Warhol is being told, "You can draw, and your ability to reproduce the stuff that you love is going to be your ticket out of here." But, paradoxically, this attachment to mass culture is also going to be a marker of both Warhol's class and his non-normative sexuality. It's downmarket and queer to care so much about Shirley Temple; it's downmarket and queer to love the movies so much. It's a really interesting shell game of upward mobility and social stigmatization.

1. Richard Barr and Cyril Egan, Jr, "Some Not-So-Fair Faces: Mural is Something Yegg-Stra," *New York Jounal American*, April 15, 1964, 1.
2. Richard Meyer, *Outlaw Representation* (Oxford and New York: Oxford University Press, 2002), 156.
3. Michel Foucault, *Discipline and Punish: The Birth of the Prison* (New York: Pantheon Books, 1977), 203.
4. Hal Foster, "I Am the Decider," *London Review of Books*, March 17, 2011, 32.
5. Andy Warhol and Pat Hackett, *POPISM: The Warhol Sixties* (New York: Harcourt Brace Jovanovich, 1980).
6. Anthony E. Grudin, "'A Sign of Good Taste': Andy Warhol and the Rise of Brand Image Advertising," *Oxford Art Journal* 33.2, June 2010, 211–232.
7. John O'Conner and Benjamin Liu, *Unseen Warhol* (New York: Rizzoli, 1996), 35.

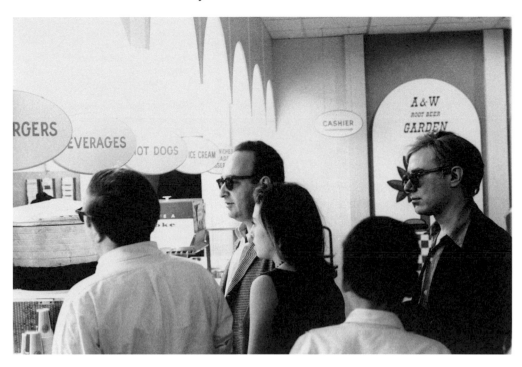

Warhol and friends, including
Castelli Gallery director Ivan
Karp (in checked jacket at the
snack bar) and Billy Name,
the photographer of these
pictures, visited the Fair in July
to inspect the silvered-over
Thirteen Most Wanted Men.
Warhol on the phone at the
Fair can be added to the many
photographs of him involved in
one of his favorite activities.

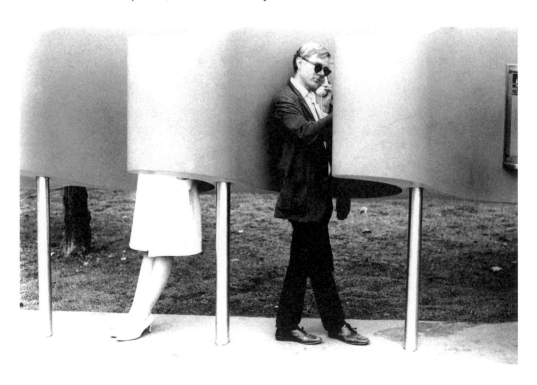

During the summer of 1964, Warhol had left the Stable Gallery and had not yet joined Leo Castelli Gallery. This allowed him to take commissions such as this portrait of Watson Powell, the chairman of the American Republic Insurance Company in Des Moines, Iowa. Commissioned by his son, Watson Powell, Jr., to commemorate the 32nd year of his presidency of the company, Warhol chose to reproduce Powell's headshot 32 times (four of 32 panels are shown here). In its subject matter, format, and coloring, this work bears a resemblance to Warhol's 25-panel portrait of Robert Moses, his rejected replacement for the *Thirteen Most Wanted Men*. Warhol was known to refer to *The American Man* as "Mr. Nobody."

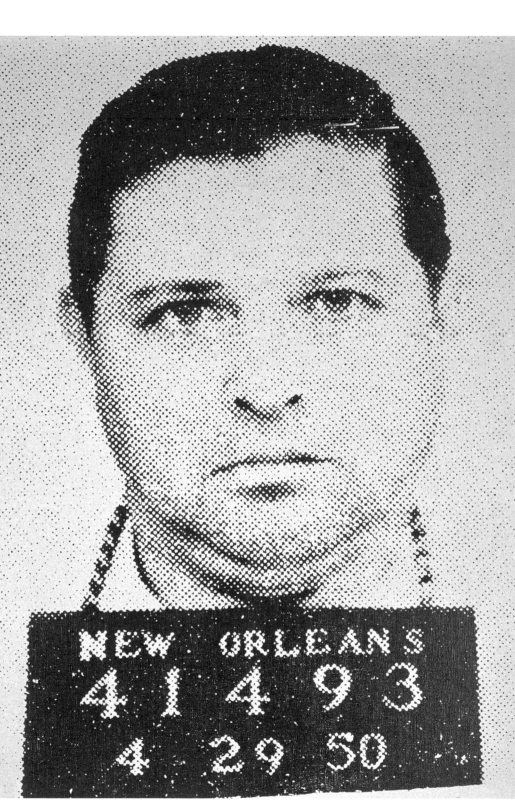

"I was natural, but Andy, he was purely synthetic."

In the winter of 1963–64, **Billy Name** helped Warhol set up the studio on Forty-Seventh Street that became known as the Silver Factory, and eventually became its photographer and archivist as well as a poet, filmmaker, and lighting designer. Name spoke with **Eric Shiner**, director of The Andy Warhol Museum, about working with Warhol before and after the *Thirteen Most Wanted Men* controversy, and why Warhol's work should be seen as "concrete Dada poetry."

Eric Shiner
When did you first walk into the space that would become the Factory?

Billy Name
I suppose it was in December of 1963; I don't recall exactly. Fifty years ago! I'll have to make everything up again.

ES
We all know about the poetic license of the Warhol world, so you can really say whatever you want. What was the space like when you first walked in?

BN
Oh, it was horrible. The walls were cement and brick, and were crumbling, and the cement floors were crumbling and dirty. Andy started painting up by the front windows, because in the afternoons the sun came in there. You couldn't see anything in the rest of the place because there was no electricity. There were overhead outlets but nothing in them, just dangling wires. The first thing that I had to do was install the lights. I went out to the local hardware store and bought these porcelain socket things, and put spotlights in.

ES
Was there any hesitation at all, on your part or Andy's, to take it, since it was so rough?

BN
Oh no, that's why he wanted it. It was one single space, from front to back and from side to side. There were standing columns, one-two-three, one-two-three, and that was it!

ES
Did you and Andy have a specific conversation about painting the space silver, or did you just decide to do it?

BN
No, he left it all to me. "Okay Billy, you just do it," he said. I was doing what I had done to my apartment. He didn't interfere, or suggest things, or say, "Why don't you try this or that." Nothing. Nothing. Nothing. Nothing. He was all painting. That was his focus.

ES
Were you working on the interior as he was painting, or did you do it in different shifts so that you weren't conflicting with one another?

BN
I did it concurrent with him, because I wasn't living in the Factory yet. But travelling up on the bus from the Lower East Side and then going back all the way downtown was really tedious. I'm used to living where I work, so I said, "Why don't you let me have the keys, and I'll be able to work all night?" So he did, and I moved up there.

ES
In your own apartment, had you started painting it silver immediately, or did it happen over time?

BN
I had to discover the silver. I lived in a ramshackle Lower East Side apartment, so I thought I'd start putting some color in. I went to the local hardware store and got cans of spray paint—this was before everyone was using spray paint—and tried a red, a blue, a green: basic primary colors. But none of them really appealed to me. Then I saw a can of silver spray paint, and it just struck me as primeval, it had to be. So I got more cans of silver, and I did the whole apartment—the bathroom, the toilet, the refrigerator, everything.

ES
Amazing. After you moved into the Factory, were you the only one that lived there?

BN
I was the only one that was constantly living there. Danny Williams lived there for a short period; I think he had been living up at Andy's house. I was adamant about no one staying there, because we didn't want people hanging around. I stayed there,

watched the place, and took care of it. Andy said to me, "Danny's going to have to move in here." I said, "No, he can't move down here." But Andy said, "We have to do this, Billy." And I said, "Well okay, we'll do it for a while." And he did move in for a while. Other than Danny, there wasn't anyone.

ES

Just the cats.

BN

The cats were mine. They moved in when I moved in. The previous year, I had taken in a stray calico cat from the sidewalk in front of my apartment. She nestled in the bottom of my closet, and then one day she had three kittens, and that's when I found out she had been pregnant. As soon as she finished nursing, she took off and left them there. There was a black kitten, and a red kitten, and a grey kitten. I kept two, and I asked people if they wanted a kitten. Only Lucinda Childs wanted one. She took the grey one, which was named Gun because he was gunmetal grey. I kept the red one and the black one. They were named Ruby and Lacy, and I brought them with me when I moved into the Factory.

They stayed for a while. But one morning Andy said, "Oh Billy! The cats are going to have to go, because they're walking on the paintings!" I had to convince Johnny Dodd to take them; he sent them to the orphanage in New Orleans where he had been raised. That was a very difficult scene. But the cats were quite the thing. They were in *Eat* with Robert Indiana and in photographs with Andy carrying the Brillo Box. Ruby and Lacy are superstars!

ES

Thinking about the political climate of late 1963 into 1964, how do you remember the vibe in New York City?

BN

I remember when Kennedy was killed, in November 1963. I was in a taxicab going to the draft board. I was twenty-three, and I had been called in for another checkup. I had been qualified as 4-F, meaning that I wouldn't be drafted because of medical reasons.

ES

What was the first thing you connected with in New York? Was it the group around Judson Dance Theater, or the poetry scene, or your haircutting parties, or Warhol?

BN

It was La Monte Young. I hooked up with La Monte because he was Mormon, and he acted like a Mormon patriarch. He was always the center of his establishment, his clan, and it was so easy

to fit in there. La Monte and I hit it off very well. I became a part of his place, and then I started to meet other people, and other things happened.

ES

Do you remember Andy's World's Fair commission, and how it came about? Do you recall who asked Andy to be part of the project?

BN

I remember *when* he was asked to be part of the project, and the people who were upset about it. There was a young fellow, maybe my age, named Soren Agenoux. His real name was Frank Hansen, I believe. He was a boy-about-town, friends with Dorothy Podber, John Daley, and Malka Safro. Soren came to Andy with a crusade, saying, "How could you work for Robert Moses? How could you exploit yourself and let them use you?" Soren was always doing these crusades; he was like Julian Beck and Judith Malina at The Living Theatre, who were serious crusaders against corporate America. Soren told Andy, "You can't do a painting for the World's Fair Pavilion! You're prostituting yourself, just working for all these corporations!"

But Andy thought it was great that he was going to have something on the New York State Pavilion. He ignored Soren, and went ahead and did *Thirteen Most Wanted Men*. And Soren subsequently crusaded against the changing of the telephone exchanges to numbers. You see, at Andy's Factory, we weren't turned on by crusades. Just as I'd say, "Alright, they're changing from the letter exchanges to number exchanges, and that's what's happening now," I'd say, "Andy's getting a painting on the New York State Pavilion at the World's Fair."

ES

Andy said, "Things don't change, you have to change them yourself," because he wanted to take that active role in making things happen. In terms of his own politics, he wasn't reactionary, or trying to lead the charge.

BN

We were cool enough to jive in with what they considered to be cool. We didn't buck anything. We always went along with everything.

ES

But still radically changing everything. When Andy came up with the idea of doing *Thirteen Most Wanted Men*, he was clearly making a subversive statement by putting up the thirteen most wanted criminals in New York City in such a public location.

BN

And making them glamorous. They were gorgeous men! When the committee wouldn't accept them, and said, "No, you have to paint that over," you can imagine that Andy was angry.

ES

What do you think made them do that? The fact that they were criminals, or the fact that there was a homoerotic undertone to it? Or was the homoerotic part lost on them?

BN

No, I don't think it was totally lost. You had to see the glamour of the criminals to grasp the piece.

ES

Do you think Andy was consciously thinking of criminals like Bonnie and Clyde who had been glamourized in Hollywood cinema prior to this?

BN

I can't tell you what Andy was thinking; I don't know if he thought. He was almost completely intuitive. He did things, and then he would see and make connections. I don't think he thought about it in the sense of having planned it out.

ES

So he wasn't actively thinking, "How can I subvert the power structure of New York City?"

BN

No, not at all.

ES

Do you think it was more of an inside joke?

BN

Yes, he could have played it as an inside joke, but it wasn't intended that way. It was intended to be beautiful. Almost like concrete poetry, where you just take a letter and let it stand alone. A black thing on a white sheet of paper, and it resonates like a bell. And Andy was into the *belles arts*.

ES

Did you and Andy every talk about poetry?

BN

No, we never talked about anything. But I had a sense of what Andy was and what I was. I was a concrete poet, and later developed a whole body of concrete poetry. And I think of Andy's

work as concrete Dada poetry. There is repetition, but otherwise it stands all by itself. It demonstrates its beauty; it rings its own bell. Anyone who tries to attribute things to the work is just missing the boat. They're sticking things on. "Oh! Is that satirical? Oh! Is that political?" No. It's just plain beauty.

ES

I think that's an important point, especially here, because fifty years of history and hundreds of art historians and critics stand between those paintings and today.

BN

I've heard so many things. I've read so many versions of Warhol and they're all logical, or rational, or have some place they fit into. But to me, they are not really seeing Warhol for what he was doing. He wasn't doing anything other than painting.

ES

Did you ever see Andy take a step back and look at something? Was there ever a look of satisfaction?

BN

Oh yes, he was always satisfied—when he was satisfied. When he started making films, he was totally dissatisfied with them. He didn't really like any of the handheld camera movies, like *Tarzan and Jane Regained. . . Sort Of*. At a certain point, he said, "I'm going to get a tripod and put the camera on the tripod and let the camera do it, and see what the camera does." When we got the reels back from the lab and screened them, Andy said, "They're Andy Warhol films!" He actually said that. He didn't do handheld things anymore; he did everything on the tripod. He may have played with the zoom lens, and the jump editing, but he kept the camera on the tripod from that point on. That's what gave the films the "Andy Warhol" look.

ES

When Andy first found out that he had to paint over *Thirteen Most Wanted Men*, do you think he wanted to refuse and stand firm? Do you think it hurt his feelings when they decided they were going to paint over his work?

BN

It made him angry! That's what really hurt him, when they wouldn't do *Thirteen Most Wanted Men*. He didn't know what they wanted, because they had commissioned him to do a piece—

ES

—with complete free rein to do what he wanted.

BN

Right, yes! Then they said, "No, you can't do that." They made excuses. It was the attitude of these snobby people. It was the thing then to step on Andy Warhol's toes. People liked to trash him, because they figured he was just putting trash in the art market. But what he was putting on the market took the American populace by storm. The Campbell's Soup can. Marilyn Monroe. They were beautiful. The can was such great concrete poetry, and Marilyn Monroe was such a beautiful icon. You couldn't deny it!

They made excuses, and he had already spent all the money he was given for the commission, and there was no money available to have more silk screens made up, so he had a single silk screen made of Robert Moses. That was Andy's response to the committee who had told him he couldn't have the paintings up there. It was his knife thrown back at them.

ES

It must have been really difficult for Andy, especially after having received a fair amount of harsh criticism from the establishment. Certain people had championed him as the new voice forward, but he had a lot of criticism leveled at him for two years. Then to all of a sudden have the World's Fair commission taken away, after having been invited without restrictions to represent his state, his country, along with some of the most avant-garde artists of the younger generation—it must have been really, really tragic.

BN

Well, it wasn't tragic. It wasn't anything. It just made him angry.

ES

Did he express his anger in a specific way?

BN

No. He was just angry about it, and that's why he did the Robert Moses portrait, to spite them. To say, "Alright, if they won't accept the *Thirteen Most Wanted Men*, then I'll do twenty-three portraits of Robert Moses!" Because who else could it be but the star of the World's Fair? Having Moses there as a Warhol painting would have been quite a coup.

ES

What did the World's Fair mean, overall, for you? What was it like when the Warhol Factory crowd went to the fair? Did you all stick out?

BN

I went a number of times! We didn't stick out; we were just part of the crowd. People were at a fairground to see the rides and the shows. They weren't focused on the crowd itself.

ES

Did Philip Johnson or David Whitney frequent the Factory?

BN

I don't recall Philip Johnson ever visiting the Factory, but David Whitney was there a number of times, yes. He was our friend, especially in the beginning. I have a photo of him jitterbugging with Naomi Levine and he was just having a great time.

ES

Did David and Phillip ride the line between Andy's swish side and the more macho sexuality of people like Jasper Johns?

BN

No, they didn't ride any line. Robert Rauschenberg and Jasper Johns hadn't come out yet as lovers, but Andy was just out. He was Andy, and he was gay. I was gay too, and the Factory was both a gay scene and a straight scene. The gay part of the Factory was totally open and fresh. It was sincere and there was absolutely no closeting or hiding anything about being gay, because we were openly gay and the straight people who were involved with us were openly straight.

ES

It's strange because for a period of time, people wanted to put Andy back in the closet.

BN

I know. Andy was always gay, but people like Frank O'Hara wanted to put Andy back in the closet and keep him there. He didn't want anyone to know.

I came out in 1958, in my senior year of high school. I told people I was a homosexual, even though I hated that word. I was just using it because it was available. Then I started thinking, "What is this genealogy we have with being heterosexual? Where do these archaic monstrosities come from? Where did these different names and categories come from, where you have to be one or the other?" I was gay because I had always been gay. It was such a relief to have it come into the public eye and have it be open, open, open until it was a blossom.

ES

In an interview you identified as pure butch.

BN

It means I'm masculine. I don't have a limp wrist. I'm not Taylor Mead.

ES

I used to have a limp wrist and then it got stronger [*laughs*].

It's interesting to think about Warhol's mural, and how Stonewall would happen several years later and be marked as the defining moment in gay pride and gay rights, while the Factory and many other factories—many other subcultures—had been thriving, open, and plugging along. It wasn't really underground or under the radar, they were just there.

BN

There were a lot of people coming of age in that period too; it had to do with being young. There were these old hardened homos who had been fighting for decades and winning little bits of respect, but this younger generation just opened up and that's who they were.

ES

Isn't it interesting how cyclical it is? That it opens and closes and then it opens up and closes again?

BN

I'm wondering how long this will last, if everyone will close down on it again, or if it will stay open. I think it will stay open. Now that we're in the twenty-first century, things are cultural forces. They aren't overwhelming or offensive; they are just natural parts of culture.

Andy and I were lovers throughout 1964. We were together most of the time, and we worked well together. In astrological terms, his sun was in Leo and my moon was in Leo. He was the sun and I was the moon. For that first year, we worked together in synchronicity. We had a ball, and made these great paintings. We would just look at each other and then look back at the paintings. You felt your heart beating when you saw the beautiful things we were making. It was so wonderful!

That lasted for about a year. Then all of these other people came in, like Edie, Paul, and Fred. People like Jane Holzer had fun and then left, but Edie, Paul, and Fred, these people stayed around. They dug in and became problems or things we had to deal with.

ES

Did Andy show the *Thirteen Most Wanted Men* paintings in New York?

BN

At the time, it wasn't suitable for him to show them in New York, so Ileana Sonnabend was going to show them in Paris. She bought, I think, ten or so. But she wrote out the check to me, so that Andy's accountant wouldn't see that he had received that cash. So in order for Andy to get his money, I was going to cash the check for him. It was only for a thousand dollars.

ES

A last question—what was it about Andy that first attracted you?

BN

His synthetic-ness. It was almost like he was a can of spray paint. He just absorbed the whole scene while he was in the scene. He may have seemed helpless, he may have seemed lost, he may have seemed "uh. . . uh. . . uh," but he was doing something. He started to take over places and things just by being there. I was natural, but Andy, he was purely synthetic.

Warhol's replacement for *Thirteen Most Wanted Men* was a 25-panel portrait of Robert Moses, President of the fair, seen here drying on the floor in a photograph by Mark Lancaster, a young British painter visiting the Factory that summer. This new work was rejected by Philip Johnson, and, after it was accessioned by the Leo Castelli Gallery at the end of the summer, lost. Images of the Robert Moses portraits can be counted on the fingers of one hand: this photo and another by Lancaster; the photograph taken upon its accession into Castelli's inventory; and fleeting glimpses in a film documenting the 1964 Factory by Marie Menken. Although through this action Warhol appears to be identifying him as censor of *Thirteen Most Wanted Men*, there is no evidence that Moses was involved in either the mural's commissioning or its covering-over.

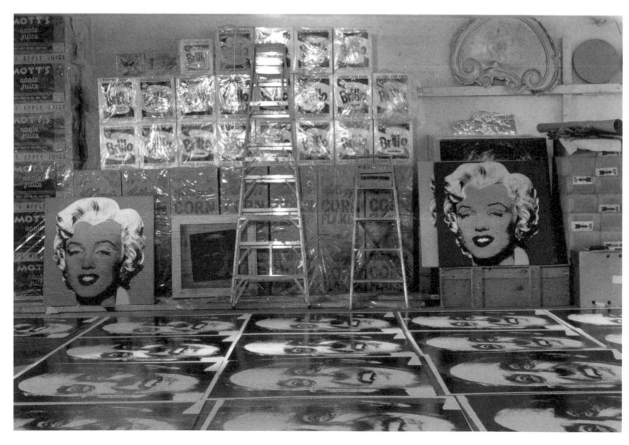

"The Empire State" is the nickname for New York State. The lights on the Empire State Building were installed for the 1964 New York World's Fair. *Empire* is an eight-hour-long film portrait of the Empire State Building in which night falls, its lights go on, and then go off at midnight. It was shot by Jonas Mekas on July 25 and 26, 1964 from the offices of the Rockefeller Foundation, which provided a perfect viewpoint from many perspectives. This work was made only a few months after *Thirteen Most Wanted Men* was silvered over at the "Empire State" Pavilion on the fairground itself.

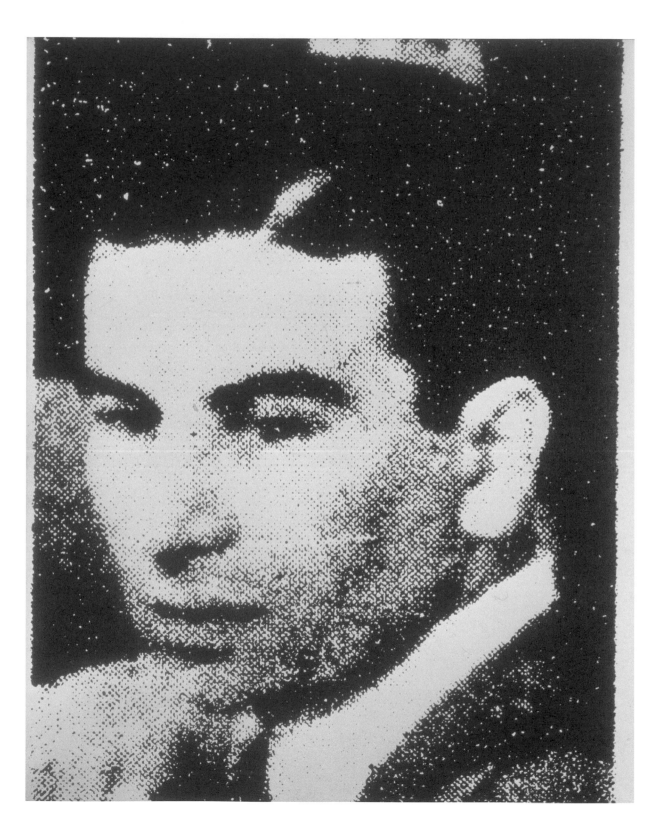

Jonas Mekas, founder of *Film Culture* magazine, the Film-Makers' Cinematheque, the Film-Makers' Cooperative, and Anthology Film Archives, and himself a filmmaker of note, has been a central figure in American avant-garde cinema and New York City's cultural world since the late 1950s. His compilation *Censorship in the Sixties: Documents, Memos, Articles, Bulletins, Photos, Letters, Newspaper Clippings, Etc.* evokes an atmosphere of high anxiety amongst the underground, including in the months leading up to the 1964 New York World's Fair.[1] In 2007, Mekas spoke with filmmaker and legal scholar **Brian Frye** about his adventures in film censorship during the 1960s, including a March 3, 1964 raid on a screening of Jack Smith's *Flaming Creatures* which resulted in the confiscation of Andy Warhol's first film, a single reel from the summer of 1963 that captured Smith shooting his second film, *Normal Love*.[2]

Brian Frye

Can you describe the controversy surrounding the seizure of Jack Smith's *Flaming Creatures* [1963]?

Jonas Mekas

The first, controversial screening of *Flaming Creatures* took place in Belgium at the Experimental Film Festival in Knokke-le-Zoute in December '63. I was there on the jury. I went there with Barbara Rubin and we took some other films. Before the public screening, the festival saw the film and decided that they should not screen it to the public. So Barbara Rubin, P. Adams Sitney, and I had a press conference where we denounced the festival. Then we decided on some guerrilla activity. I went into the projection room and took out the first reel of Brakhage's *Dog Star Man* [1961]— Brakhage did not like this when I told him—and put in *Flaming Creatures* instead.

Later, another film was being screened in a different theater. We managed to get into the projection room and told the projectionist that he should just stay away and that we would handle the situation. He said, "I cannot do this because they will fire me. Can't you do something, like tie me up?" So we tied him with some rope around the chair. (I met the projectionist years later and he thought it was really funny.)

On stage, there was an official presentation of the awards. The minister of justice was talking and we projected *Flaming Creatures* on his face. We could not lock the doors against all the officials who tried to stop us. We tried to hold the door but were not powerful enough. They managed to push in and stop the screening.

Then we decided to screen the film in our hotel room for those who were interested. The screening was very well attended. Agnès Varda was there, Godard was there, Roman Polanski was there. We had a very special audience. Then we came back to New York and decided to screen it at the Filmmakers Showcase run by the Film-Makers' Cooperative on Twenty-Eighth Street. We had one show and then we announced another screening. Somebody called the owner of the theater and before the second screening the owner cancelled the contract for the theater. That was the end of the Filmmakers Showcase. So I made arrangements to screen it on Eighth Street at the St. Mark's Theater. To get in, I also put on the program a little film by Andy Warhol—just one roll of film—about Jack Smith making *Normal Love* [1963] and also something by George and Mike Kuchar.

Ken Jacobs was the manager, Florence the ticket-taker, and Jerry Sims was helping out. We were all arrested and the film seized. We spent one or two days in jail. We were bailed out thanks to Jerome Hill, who put up the money and paid all the expenses for the lawyers. The Lenny Bruce case was a month or two before us, and it had destroyed him completely. We were told we needed a very good lawyer, otherwise we might end up in jail for a year or two. So Jerome got us a lawyer, Emile Zola Berman. He was known as a criminal lawyer who had not lost a case. Then without telling anybody Jerome decided to complicate the case and let us get arrested one more time. That's when I said I would screen Jean Genet's *Un Chant d'amour* [1950] and *Flaming Creatures* again. This was at the Writers' Stage on Fourth Street. In the audience was a policeman, and I knew we would be arrested. But I was prepared: I had a chicken sandwich in my pocket.

We were arrested and the films seized. Again we were bailed out by Jerome Hill. The court procedures took place and we had witnesses in our support—Susan Sontag, Allen Ginsberg—and we lost. We were sentenced to a six-month suspended sentence. Emile Zola did his job in that at least we got only a suspended sentence.

But we did not accept that and went to the court of appeals. We lost. Then we went to the Supreme Court in Washington, and that's where a judge named Abe Fortas came out in support of *Flaming Creatures*. He made copies and distributed them to the other judges and some senators, and that caused his downfall. He was being promoted by President Johnson as the new chief justice. But they said he was a peddler of pornography, and he was not appointed.

The case created a big stir and was reported in all the

newspapers. As a result, a year later, censorship in New York was practically abandoned. So, it was not for nothing.

BF

The original case was going through New York State courts?

JM

It was first New York City, then Albany, then Washington. We went through all the stages. And we lost it at the Supreme Court. It was not reversed.

BF

What was the original charge?

JM

Pornography.

BF

Do you know who was pressing the prosecution?

JM

He was the attorney general in New York. He had become known for destroying Lenny Bruce. I forget his name now.

BF

Was there any sense that it was unusual they were bringing charges?

JM

No, it was very normal in those days. Every film had to be approved by the license board and every screening had to be licensed if it was a public screening. And we refused to submit our films to be licensed. If you submitted them, they would say, "Cut out this, cut out that." In the case of *Flaming Creatures*, half of the film would have been cut out. They were very strict. There was even a little brochure listing what should not be shown, what parts of the human body.

BF

Of course, some people were showing pornography.

JM

Yes, but nobody advertised it, nobody knew about it. We advertised.

BF

Was the prosecution as much about the fact that you were advertising it as showing it?

JM

Yes. We said, "But this is for a very limited audience, a very specific limited audience, not very general." We did not say there would be orgies and things like that. But it was against the moral—they used the term—and prurient public interest.

BF

Were you or your lawyers ever contacted by people showing what we would normally think of as pornography?

JM

No. Emile Zola Berman's office did everything not to mention anything to do with pornography. This was an art film.

BF

Obviously you continued showing films in New York, just not those particular films.

JM

But that was not the first problem. When the theater was closed, when the contract was cancelled, the Eighth Street Filmmakers Showcase started screening at midnight at the Bleeker Street Cinema. After the first two screenings, we were thrown out by the manager. It was not just the police. They thought we would give their theater a bad name.

BF

Did the police continue to monitor what you were screening?

JM

They keep watching for a year or two until censorship started disappearing and there was some official decision that licensing of films should be abandoned in New York City. Within two years there was drastic change. There was a lot of discussion in the press and the public about police policies.

BF

Was a lot of that coming from the art world or was it a more general political shift?

JM

It was a general political shift, but also influenced by the artistic community.

BF

The reason I ask is I find it very interesting that you lost in the Supreme Court and with a film that is clearly not pornographic in the traditional sense.

JM

Yeah, but the official attitudes to what is pornographic have changed drastically in the past forty years. That little brochure said very specifically that you could not show a woman's breasts, could not show genitals. That's where the official public moral, ethical, and sexual attitudes were in 1964. *Flaming Creatures* included those elements. The court decision followed the rules described officially in the laws of New York City about what could not be shown publicly.

During the second screening, not only was *Flaming Creatures* seized, but also Jean Genet's *Un Chant d'amour*. Genet was very well known at that time, and I thought we would have a lot of support because two of his plays were playing then in New York City, *The Balcony* and *The Maids*. He was a very respectable playwright, etc. That's why I included Genet's film. I was smart. But the district attorney was smart, too. He said, "Okay, we have a case of two films. They are both pornographic. But let's say we dismiss one and don't deal with it." So, they dismissed Genet's film and concentrated on *Flaming Creatures*, because Jack Smith was unknown. If they had kept in the Genet, we may have had a chance of winning.

I got the print of Genet's film from Nico Patatakis, who was a filmmaker in Paris and a dear friend of Nico, the singer in The Velvet Underground. Genet directed the film, but Nico [Patatakis] sponsored it. The film was in 35 mm, and it was bulky. I was afraid that if I went from Paris to New York, the film would be confiscated. Customs was very strict. Twice when I came to New York from Paris I had some Olympia publications in my pocket and they were seized. So I said, "If I go to New York with this, I have no chance. I have to go first to London." And that's what I did. I cut the film into three pieces and put them in my raincoat pockets, and went to London. When you come from Paris, US customs says, "Oh, Paris, hum, Paris." If you come from London, well that's more conservative, and you have a chance to pass through.

I was on the plane to New York from London and I was talking with my neighbor, who happened to be the playwright Harold Pinter. When I told him what I had in my pockets, he said, "Maybe you should let me go first. You come after me." So I followed him and we got to customs and they opened Pinter's suitcase. It was full of plays, copies of the same play. They said, "What's this?" "Oh, it's my play," he said. "It's opening on Broadway." "Play! On Broadway!" The customs man got so gaga, so excited, that he motioned his neighbors. They all converged and were so yapping with excitement that I just passed through. And that's how the film got in the country. If I had been by myself, I don't know what would have happened. So, thanks Pinter!

1. *Censorship in the Sixties: Documents, Memos, Articles, Bulletins, Photos, Letters, Newspaper Clippings, Etc.* (New York: Anthology Film Archives, 2007).
2. This interview was originally published as "'Me, I Just Film My Life': An Interview with Jonas Mekas," *Senses of Cinema* 44 (August 2007), online at: <http://sensesofcinema.com/2007/feature-articles/jonas-mekas-interview/>

Silver Square 'So Nothing' At Fair It Satisfies Warhol

By KIT KINCADE
Of the World-Telegram Staff

Pop artist Andy Warhol stood in front of a 200-inch square covered with silver paint at the New York State's World's Fair pavilion.

"I don't believe in anything, so this painting is more me now," he confided.

The huge square had been a Warhol painting a year ago. But its depiction of the FBI's 13 most wanted men was deemed inappropriate for a fair. So the whole painting was covered over with silver paint and left to hang on the pavilion wall.

Why does the silver paint make the painting more "him" than it was when he first completed it?

"Because silver is so nothing," Warhol said. "It makes everything disappear."

Warhol always wears dark glasses, perhaps because he is afraid of disappearing. From the rear his hair is long and black. But in the front it is all silver. If he didn't wear dark glasses, you might not notice him from the front.

"If you have any furniture you hate, you can just paint it silver," said Warhol, with a nod toward his silver-covered painting. "Or people."

"Will you get the painting back when the Fair is over?" asked one of his followers. "Oh yes, I suppose so," he sighed.

"Will you take the silver paint off?"

"Oh no. Oh no," he said softly.

Someone suggested that he exhibit it with the silver paint left on. "Yes, that's what I should do," he said.

Andy Warhol is getting used to having his work banned. Earlier this year his sculpture was stopped at the Canadian border. Authorities ruled that his realistic representations of soap boxes and cereal boxes were "merchandise" rather than "original sculpture."

A guide asked Warhol if he would like to see the modern art exhibit at the American Express Pavilion at the Fair.

"No," he said, smiling at his followers. "We really don't like art."

NEW YORK WORLD'S FAIR
1964-1965 CORPORATION

SUBJECT; N.Y. STATE PAVILION

FROM; N.Y. WORLD TELEGRAM P.

DATE; JULY 6, 1965

CIRCULATION: 403.348

The Fair was on view from April through October in both 1964 and 1965. In July 1965, Warhol visited the Fair again and was interviewed by a reporter about his thoughts on the silver square. "This painting is more me now," he is reported as saying, and adds that silver is great for making things, including people, disappear.

It was not until 1967 that the *Men* canvases were shown—and in Paris, at Ileana Sonnabend's gallery. Sonnabend, the ex-wife of Leo Castelli, had given Warhol his first European show—the "Death and Disaster" paintings in January 1964—almost a year before her husband signed Warhol to his gallery in New York. In the booklet accompanying her exhibition, the individual *Men* are dated to 1963, emphasizing their connection to the "Disaster" series and deemphasizing their connection to the World's Fair.

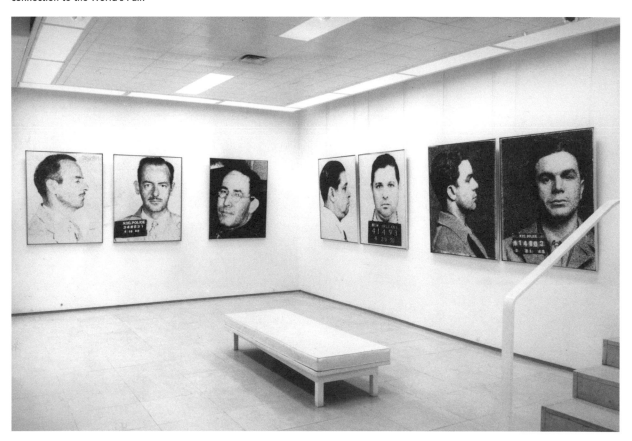

"The very idea that anyone would notice the work they did is ridiculous."

Philip Johnson (1906–2005) founded the Department of Architecture and Design at the Museum of Modern Art in 1930, and remained involved with the museum throughout his long life, becoming a close associate of the Rockefeller family and donating what would become some of MoMA's most important works by Andy Warhol. Independently wealthy, he merged his roles as critic, catalyst, and aesthete in an architecture practice that produced a sophisticated and controversial body of work. Asked by Nelson Rockefeller to design the New York State Pavilion for the 1964 New York World's Fair, Johnson invited Warhol and nine other artists to each contribute a twenty-by-twenty-foot work to the curved outer wall of the Theaterama, one of the pavilion's three main structures. Here, curator **Larissa Harris** talks with **Mark Wigley**, cocurator with Johnson of the landmark 1988 MoMA exhibition "Deconstructivist Architecture" and most recently Dean of the Graduate School of Architecture, Planning and Preservation at Columbia University about Johnson's role as a collector; the Pavilion's relationship to Johnson's other projects in 1964; and how Johnson's characteristic capacity to playfully repurpose the work of others preceded the label "postmodern" by some thirty years.

Larissa Harris

Can you begin by telling us a little bit about your relationship to Philip Johnson?

Mark Wigley

I knew Johnson very well for about a year in 1987–88, when we curated an exhibition together at the Museum of Modern Art. At that point he was a much older guy, and was very much disliked by the staff at the museum because he was, of course, such a huge part of their legacy and he was eternally disappointed with what they were doing. They very clearly wanted him to donate his collection, so they allowed him to do an exhibition. They were very upset, or frightened, by having the ghost of their own past moving around in the building, but they couldn't do anything about it because Johnson, in a way, *was* the museum.

He gave me unlimited support. If there were problems from the museum with anything I wanted to do, he would see that it was carried out. And there were problems with everything, because absolutely everything we did systematically violated all of their protocols—which was the point.

It was wonderful, because not only was the museum ideologically conservative, but they knew it, too, and they knew what it

meant. I had never met a group of people who were so thoroughly aware of the ideological implications of different typefaces. So if you chose a different typeface from theirs, they would not only tell you "You can't do it," but they could tell you why. Which was of course an added incentive to do it. It was warfare, and for me it was just exhilarating. The Department of Architecture and Design that Johnson had founded had been a key laboratory; rather than reporting on important work, it had generated that work. But it had long lost this role. The show was an attempt to reboot.

Johnson was a complicated and controversial person, zero naïveté, while I was a quintessentially naive person, because I knew so little of the world. I was devoid of compromise, brutal even.

LH

And he recognized that as a value?

MW

Yes. He had been in his midtwenties himself and hadn't yet studied architecture when he curated the famous "Modern Architecture: International Exhibition" show with Henry-Russell Hitchcock in 1932. So the very young curator, the naive curator, is a classic role in that place. One of the things about Johnson is that people find it very difficult to be respectful of him—for a number of reasons—yet regard him with a certain awe. Certainly for a long time he was seen as all-powerful. But I could see perfectly during that time that he had no power at all, even in the museum. He was somewhat lonely and trying to remain alive and thoughtful. People gave him authority by assuming that he already had it, which he didn't.

It was very interesting to watch him analyze the behavior of others. When looking at a building like the '64 project for the fair, you have to read him always at these different levels. There is the level of the critic—very perceptive about the implications of things. Then there is the aesthete. Then there is the collector, and then the person moving in a certain social circle, and so on, and so on. Then finally there is the level of the architect, the least understood of all these roles. But all the levels are there at every moment, and they are interconnected, with the movements between them defining what is really happening. So when Johnson chooses ten works of art by so-called younger artists that he himself has started to collect and befriend, there are architectural implications, political implications, art-market implications, propaganda implications, etc. I would not allow any idea of an accident in there.

And there was a very, very deep bond between Warhol and Johnson over the course of their relationship—they were much more aligned than any of us might be able to accept. When Warhol famously makes lethargic comments about his own disinterest, these echo comments of Johnson's throughout his career where he continually—

LH
Talks about himself as a dilettante.

MW
Yes, and with a lazy tone. Both Johnson and Warhol were authorities on the implications of those seemingly casual comments. They adored being obvious. Those comments, usually for the media, are part of their work as artists and communicators. They are not comments on the work. They are not even just a framing of the work. They are part of the work. So what fascinates me is that Warhol's comments about the *Thirteen Most Most Wanted Men* are well documented and studied and are, you could almost say, routinely interesting. But Johnson's comments haven't been read or even noted with the same degree of sophistication. We tend to see one figure as the artist with the canny politics and the self-conscious play with the commerce of his art, and the other person as an architect who is taken to be complicit with authority on many levels.

So you have two approaches: the subversive camp and the complicit camp. And this might ultimately be the correct analysis, right? But the work has been done on Warhol, whereas the work has not been done on Johnson to try to identify what it really meant for him to want to hang these ten things on the outside of that concrete cylinder.

The ultimate answer might be: Johnson's behavior is entirely consistent with a kind of closeted, complicit relationship with authority in the form of, most obviously, Robert Moses, and slightly less obviously, Rockefeller. But even in this view there would be a few twists along the way.

I would suggest that we consider the selection of the ten as an artistic act. In other words, to treat it as a performance and say: What was the intention of this? What was the message? How was it communicated? What did it produce? Rather than just accepting that Johnson operated as a curator by providing a display space and selecting ten people, the question becomes: Do we have any evidence that Johnson in any way cared about the content of any of the ten works?

Certainly if you take Warhol out of the story, Johnson is as complacent about the content of the works of art as Warhol claims to be about the content of his own work. I am really struck by Warhol's comment that ultimately the silvered-over version was more—

LH
More "me."

MW
More "him" in its lack of content. And I'm also very struck by the fact that the painting-over, the censorship of the work—and maybe we have to hesitate before even saying "censorship"—was such a nonevent in every realm except very far away from the fair in the supposedly antithetical worlds of art criticism on the one side, and conservative upholders of traditional cultural values on the other.

LH
Yes, and we don't really get any sense of there being deeply conservative forces, but merely political expediency. Rockefeller was ultimately the one to say, "We have to paint it over," and he isn't a deeply conservative force in any way.

MW
In the Warhol piece you have twenty-five panels. The seriality of the panels is really important and part of the mechanism. There are multiple levels of Minimalism in Warhol. But Johnson himself is also doing a serial work. It's not eleven or twelve; it's ten. And each are twenty by twenty. So it's ten artists at twenty by twenty. It's almost a Minimalist formula. In a serial work, it doesn't matter which piece is where. It doesn't even matter which artists are in the group. Maybe only four of the ten were already at that time recognizably Pop, and yet there's a vague sense that the set of ten comes to represent Pop. Which raises the interesting possibility that you can actually represent Pop art with little Pop. Pop is anyway never as simple as it appears. That is even its point. And working with seriality deflects attention from the differences between the objects that have been put into the grouping. So the replacement of one of the works with a silver panel doesn't in any way interfere with the project of the architect—which is not simply an art project or an architectural project.

So what is the project of the architect? Twelve million people visited the pavilion in the first season. Any artist interested in exposure—or in looking at the world of exposure and drawing something from it, as was so typical of the Pop artists—has to be drawn to this scenario like a moth to a flame. These were young artists, and almost all of them say, "This was my first big commission." And by "big" they mean big—twenty by twenty feet. And it's right there in the middle of the World's Fair. But the very idea that anyone would notice the work they did is kind of ridiculous.

Just to start with the local context: The ten works are hung on the outside of a cylinder next to two enormous horizontal surfaces. One is the largest map in the history of the world, the Texaco map—four thousand times the size of a regular road map used

by drivers. It was a hugely popular device, with crowds of people walking, kids being pushed in little cars, and marching bands performing on the hour. How could you possibly compete? Then suspended over the map is one of the largest multicolored plastic surfaces ever produced.

So there are two enormous horizontals through which twelve million people will pour—the very idea that the eye would, even for a moment, be caught by a twenty-by-twenty piece is absurd.

The way that the Tent of Tomorrow was designed was just to float these two enormous horizontal surfaces. Then you have the Astro-View, which is again a set of horizontal disks flying in the air. The purpose of the verticals is only to support the horizontals, which carry all the color. So it's not just the plastic tent and the Texaco map that infantilize the art but also the yellow that is on the perimeter of all the flying horizontal disks.

The Tent of Tomorrow, which was used to hang the fiberglass, was the largest cable-net structure in the world at that time. And this was the first time that columns had been poured using the slip method, where you just slide the formwork up as you go. The technology used to suspend these horizontal images was published in *Popular Science* and *Engineering News* as state-of-the-art. It was big news from a technical point of view. There was also a color consultant who worked for a year on the plastic patterns. So it's very scientific. If all the vertical surfaces were meant to have little visibility, being just props, then the "great" space that the artists were given was in reality a site of nonvision.

LH

It's the only concrete-colored horizontal.

MW

Yes. It's a brilliant idea, in the sense that Johnson is making an anti-museum, or an anti-gallery. Because not only are you not on the inside of a white cube, abstracted away from the world, you are flung into the world—and not just any world, but the world of the World's Fair, which is a hyperversion of the world. So this is yet another reason that even if the artwork could be seen relative to the big Texaco map, which is impossible, it could never be seen relative to the fair, because the fair is not just pop culture, it is pop culture on steroids with highly sophisticated designers involved. For instance, the IBM Pavilion is an enormous golf ball, the biggest thing you've ever seen. It will permanently infantilize any of Oldenburg's work. And who's doing it? Eero Saarinen and Charles and Ray Eames. Incredibly sophisticated. So a World's Fair is a layering of almost every definition of Pop. If you take, for example, the history of the Independent Group in London, they were very clear that Pop art was not produced by artists; it was the vernacular art of consumer society, particularly in postwar America. But this so-called vernacular world is highly

designed. It's more science than art. This is taken to another level in a World's Fair. So Johnson not only put so-called Pop art back into the popular environment from which it had drawn itself, but into a supercharged version of it. A blown-up comic-book frame is invisible in an entire world of blowups.

So one potential reading of the situation is that Johnson quite knowingly infantilizes the very work that he appears to be promoting. The art came very late in the evolution of the building's design: if you look at an image of a model from quite far along in the process, there is nothing on that surface. It's even rendered as if white. And we know from the images that we found together in the Queens Museum archives that the final official rendering of the project is that same model, with the art added like molding. It's clearly being used as decoration. Fair buildings are usually seen to be all about decoration, or more precisely, decoration turned into building. In that sense, this pavilion is just another borderline kitsch building that is all about decoration. But in fact the main image of the project is all about structure. The only decorative thing in this system is the art. Even the budget Johnson was using to pay for the ten artists was labeled "external embellishments." So he's almost literally saying, "I have to do something with that cylinder. I'm going to put some things around it." It very knowingly infantilizes the work.

LH

The Tent of Tomorrow covers an open horizontal, so he doesn't have to worry about decorating it, while the Theaterama is a wall whose surface he has to deal with.

MW

Yes. In earlier versions of the project, the cylinder is more of a floating horizontal that you enter from underneath at different points, but towards the end it becomes a wall, which upsets the overall logic, so the art is called in. The art is not seen, but neither is the cylinder. The art takes the eye away from the concrete but is unable to hold our focus. It assists blindness—maybe with the exception of the Lichtenstein, the one that has a window in it. That piece is kind of witty, because in a way he's playing with the surface.

So you could easily say Johnson is deploying avant-garde art as a form of decoration. If you don't like Johnson—and most people don't—you see -him setting everybody up, and you respect Andy for having found a way to not be set up. And that's a decent narrative. Another view is again getting back to that more Warhol thing of "Well, I just put some art there. It's really not a big deal." So we have this very casual treatment of the artists on the one side, and this absolutely noncasual pavilion. Nothing in this system is half thought through, even if Johnson might pretend that's the case. [*pointing toward image of silvered-out Warhol*

behind a tree] The monochrome looks perfectly fine as a work. But it doesn't really matter because no one is ever going to look!

LH

Isn't it true that the New York State Pavilion is very similar to an earlier World's Fair pavilion, by Edward Durell Stone?

MW

Yes. In 1958, Durell Stone did the American Pavilion at the Brussels World's Fair. The 1964 New York State Pavilion is unambiguously derivative of that earlier building, a play on it. Durell Stone is not highly respected within the field of architecture because his work is seen to appeal too much to sensuality, relative to modernist orthodoxy. His work is treated as borderline kitsch. Yet he was the chosen architect of American foreign policy, doing US embassies all over the world in what would have been seen by architects, interestingly enough, as operating in a World's Fair mode. He was seen as a World's Fair architect no matter what he did. That effect was doubled when he actually did a building for the World's Fair, and tripled when Johnson echoed it in another fair. Johnson would have studied it as a key precedent.

The 1958 pavilion also had a suspended fiberglass colored ceiling over an enormous circle with a map, and had two cylinders off to the side. Johnson famously always takes something and then gives it only a minor twist. If he is making a kind of Pop play on an architect who makes plays for popular appeal relative to modern architecture, which is the more sophisticated work? Johnson's pavilion or the work of the ten artists? Of course, this is a false comparison; they're working in different media and different genres. But let's say that in the field of architecture Johnson is as canny with his use of the materials, of the systems, as Warhol is with his. Both have the power to offend by disowning their own originality. Both outsource. Both are highly mechanized. Neither waste a single word in any sentence.

Now, to my friends in the world of art criticism, this is a kind of heresy. This is like putting the archvillain, the very figure of complicity, alongside an important counterfigure. I, too, would make a distinction, but a distinction that is not going to be based on an easy, complacent sense that there's something inherently radical in what Warhol does and inherently nonradical or complicitous in Johnson's work. Like Warhol, Johnson spent his entire career declaring how uninteresting he was as an architect, and he believed it.

LH

Why do you think this attitude is understood as revolutionary in art but is unacceptable in architecture?

MW

Architecture is understood to be so complicit with the status quo that even the idea of avant-garde architectural work is controversial. And yet the line between architecture and art is not so easily drawn. There is, for example, an architecture, even a very strict architecture, to avant-garde art.

LH

The way I have come to understand the *Thirteen Most Wanted Men* is as a gesture that was all about the New York State Pavilion and the fair. The piece actually loses some of its power—

MW

—in any other context.

LH

Yes. So you're saying that Johnson was doing something similar—playing with and reacting to all the assumptions around what a World's Fair pavilion should be, at that date and under those circumstances? He was working on other buildings at the exact same time—maybe you can shed more light through comparison?

MW

He had three projects at the time. The pavilion for the fair, the garden at the Museum of Modern Art, and the theater at Lincoln Center. It's a really interesting bandwidth—from the fair to spaces for protecting high art and culture. I suppose the current reception of Johnson would be to say that the garden is very beautiful, that the theater is better than we had thought, and it's not worth talking about the pavilion. But is what Johnson does for the fair fundamentally different from what he did for the museum or Lincoln Center? I would argue absolutely not. They are all horizontal projects, landscape works. He tailors to each taste, knowing perfectly how to play the game for the World's Fair, for MoMA itself, and for a cultural center. Perhaps the hypothetical audience of the fair is working class, while MoMA addresses the middle class and Lincoln Center addresses the elite. But the techniques are not so different in the end, and most importantly, the three scenes are interdependent. I find it hard to see a difference in the approaches—especially as MoMA, since the last renovation, is talking all the time about visitor numbers and the need to expand to accommodate them, and Lincoln Center was an urban-renewal project that knocked down a huge amount of housing to build what was famously one of the most unwelcoming pseudopublic spaces in New York. In one scene the public is encouraged to be eating hot dogs while having their experience, in the next they are supposed to be speaking quietly and a little dressed up, and in the last they are supposed to be absolutely quiet and totally dressed up for the performance. But they are

interdependent, and the hesitation to talk about the pavilion repeats the very prejudice that Pop tried to subvert. There continues to be a total fear of popular Pop. In other words, it is still regarded as something of a crime for one's work to reach a very wide audience.

In all three projects, Johnson's approach is camp. So when we see Johnson and Rockefeller, the MoMA stalwarts, in Queens doing the World's Fair, we have to understand the dropping of these ten "younger artists"—many of whom will end up on the interior white walls of MoMA—onto the circular exterior concrete wall as part of a single ecosystem.

I'm not saying this in defense of Johnson, but we can't start this conversation by saying there's a world of high art at MoMA and a world of low art in Queens. There's a very low world in MoMA, or at least a very middle-class set of values organizing the way the place works. And maybe the World's Fair extends the invitation more widely. Moses was very clear that he would be elevating the people who came. He was against elitism, and said he was not going to exhibit any art, yet he didn't want the Amusement Zone to be a theme park, saying, "It cannot be like Coney Island!" He wanted to offer an elevation to the mass audience, rejecting art but treating the fair itself as an ennobling artwork.

So the scene is complicated. If Johnson were alive, I suppose our question to him would be along the lines of: "But you must have known that no one would ever have seen that work." And, of course, he would have responded, in a Warhol way, something like: "It never occurred to me to think about it. I had a wall that was too empty. I had some money. They wanted exposure. It was no big deal."

LH

And so what was the reaction to the building at the time?

MW

Within the architectural community it was quite well received when it first went up. Ada Louise Huxtable thought it was carnival done well.[1] But she was canny; she spoke for the reader rather than for the field, and she was a really sharp reader. Vincent Scully, who would later become the promoter of Robert Venturi and Denise Scott Brown doing a kind of American Pop, remained a bit uncomfortable with the pavilion's seduction.[2] Because, of course, the permanent crime of Johnson is seduction, and this goes back to his fascism. Or you could say forward to his fascism, in the sense that it's part of fascism itself.

Johnson is understood to be powerful by virtue of being seductive. Seduction and power get fused. It was the same with Durell Stone. Power, specifically American power, is represented by a seductive architecture. The problem with the work is that it

is liked, that it gets under people's skin, that it appeals, in what seemed to be a precritical mode.

Speaking of seduction, there is some analogy between the *Thirteen Most Wanted Men* of Warhol and the ten men assembled by Johnson for his piece, which took the form of a kind of lineup. They also find themselves facing each other in unexpected circumstances, and this again empowers Johnson in relation to the people he's collecting, many of whom he's also socializing with.

I want to at least point at a parallel between Warhol's gathering together of the officially designated criminals and Johnson's gathering together of these designated artists, because those artists will be framed, in a way, as criminals. After the *New York Times* reported that there were going to be these ten "avant-garde" artists, conservative art people immediately responded with letters to the editor saying, "This is terrible," "Blasphemous!" So basically ten quasi-criminal artists are being exhibited on the curved wall, and one of them exhibits a set of official criminals on it, which gets promptly covered over.

I think it was a year later that Johnson would do his bunker in the Glass House landscape, which was a concrete drum for displaying art, where most of the ten artists from the fair were displayed on revolving panels that defetishized the idea of the gallery wall—fusing storage system and display. So again, the conspiracy theory would be that he does his own serial work, lackadaisically commissioning the ten, giving $4,000 to each to produce this stuff, not caring about it very much, not fighting for it, not fighting for Warhol, but also absorbing them into his collection, which hardly anyone could see.

LH

And then, in the end, there is the invisibility of the work—all of the work, not just the painted-over one. The project sparked comment at the beginning, but then it turned out to have little impact in that environment. That's often the fate of public art generally.

MW

Well, it's funny you should say that, because when I saw that he had $60,000 for "external embellishments," I thought, "Well, that's the art budget—the 'percent for art.'" Now, if you went back to him and said that it was offensive to treat this art as decoration, he would have said, again with an entirely Warhol kind of reproach, "Who would ever suggest that art was anything *more* than decoration? I love decoration! Don't you?"

LH

Yes [*laughs*]. But it was only a blip for them, too. It was probably tough for a time and then their friendship continued.

MW

Right. If we stay where we are in the conversation—trying to compare what it means for Johnson to pin those ten artists on the wall versus Warhol pinning the *Thirteen Most Wanted Men*—it seems to me that Warhol's move is directly subversive of the situation. As you said, it is a very site-specific, transgressive act with multiple and complex levels of reading. I don't see Johnson's hanging of the ten in the same regard, but the guiding philosophy is similar. In a way, Johnson's gesture is a more sly one. Warhol lifts the everyday into visibility, whereas Johnson blends it back in. It's precisely because Warhol threatens to be seen that he is pushed back, bringing all ten into line. Their invisibility in front of twelve million people was then exchanged for hypervisibility in front of a few friends in a bunker.

In a class presentation yesterday—the students are going to a new lab we are opening in Johannesburg to study public art—one student showed an image of an artist's work: a ten-story-high figure of a young Nelson Mandela as a boxer in 1953, which went up more or less on the day of his death. This image of the building apparently went viral on social media. And when I was looking at it, I thought, "Well, there's an artist with a certain Pop sensibility," this big blowup image at the full height of a building. I don't know how they did it, but I imagine it uses the technology of those big advertisements. But more importantly, it engaged with the mass electronic audience, producing a kind of World's Fair effect.

LH

Right. But also with the tradition of a monument or a memorial, modes which still actually resonate for most people as public art.

MW

Right, whereas twenty by twenty, I don't know. That was really big at the time, versus today, when the art market has so inflated the size of works along with their perceived value. So if you were an artist, and you were offered a twenty-by-twenty—

LH

Yes, you think it's fantastic! And then you see it—

MW

Right. It looks tame. It has been tamed. Only Lichtenstein seems to have some heft.

LH

I have a really naive question about postmodernism for you: Can postmodernism have been influenced by Pop as a movement outside of its own discipline? And how do you think about the difference between the two?

MW

Yes. It's complicated, though. In postmodern architecture, there were several streams that denied that they knew each other. If you take the Scott Brown and Venturi line, they would, for example, deny that they were postmodernists, but they would only do that because there were lots of other people called postmodern that they didn't like. They're explicitly drawing on Pop art for their references, in particular American Pop art. Denise Scott Brown wrote an important article in 1971 called "Learning from Pop."[3] In *Learning from Las Vegas* a year later, the billboards of Vegas are presented as the Pop art that inspired the Pop artists, which in turn inspired them.[4] What they repeatedly point out, but their readers never notice, is that they don't necessarily like it. They say, "We hate it, but as artists we have to realize that it's a fertile incubator of new architecture."

LH

"We hate" the vernacular?

MW

Yes. "We pretend to like it," basically.

LH

Lichtenstein would have said that. But not Warhol.

MW

Then you've got a stream of postmodernist classicists who are saying that modern architecture has lost a connection with the language that people understand. That we should use the classical vocabulary not because we believe that the proportions of a classical temple connect us to the harmonies of the universe, but because people have spent generations seeing classical columns and pediments when they went to the town hall or the bank, and so they're familiar with it, and so that's popular, and architecture should be a medium of popular communication.

According to the standard view, Johnson was relatively late into these arguments, but his AT&T building of 1984 became an icon of postmodernism. He appeared on the cover of *Time* magazine holding a model of the building, and is described there as essentially the "godfather of postmodernism," once again being given the retroactive power to preside over others.[5]

But the World's Fair pavilion undoes that story, because there you have—starting in '62, '63, and then built already in '64—a building that uses so many Pop references. It makes nonsense of the idea that he becomes postmodern later, or at least it suggests that when he started to do self-consciously postmodern work, he was just taking advantage of this quality. It was certainly not a big shift for him.

When I knew him in '87 through '88, the mission—which was so clear that it was never even stated between us—was to kill postmodernism, once and for all. And it was successful, by the way. Not by being special but by literally acting as a kind of cathartic scene, like a death at the end of an opera that the audience expects, waits for, and yet is moved by.

In the end, I don't see Johnson's strategy as having changed at all. When he did his Glass House in 1949, it was an unbelievably canny rip-off of Mies van der Rohe's house of the same year. He was always doing that, with pride. It does make it odd that with the pavilion for the World's Fair he never spoke about Durell Stone. Perhaps this was because Durell Stone did the original Museum of Modern Art building. Johnson had wanted to do it with Mies van der Rohe, who he idolized, but Durell Stone got to do it. Miesian constraint gave way to a different kind of seduction. So already the Museum of Modern Art pandered to the popular. Architects find it hard to respect Durell Stone. Too flirtatious, too much seduction. Johnson doing Durell Stone is even less acceptable. His pavilion is as invisible to the field as the artworks attached to it were to the fairgoers. After all, even postmodernism can be understood as a nervous attempt to engage with the threat of decoration, which has always been the threat of seduction.

You know, architects don't smile. Look at pictures of architects. They never smile. Many artists smile, but almost every architect is earnestly filled with exaggerated seriousness. Durell Stone's architecture can't stop smiling and asks you to join in. Not by chance did his original building for MoMA open during the 1939 World's Fair. The facade was a huge, gleaming billboard with a curved metal canopy inviting you in, and it even said MoMA in huge letters on the roof, so that you could read it from an airplane. Already with that first building, the Rockefeller mentality is to go for a kind of shiny seduction instead of Miesian restraint. It is no surprise that Johnson will cannily echo both Mies and Durell Stone, but it remains interesting that he is silent about his appropriation of Durell Stone's pavilion. Normally, he says very openly: "I'm a whore. I'm totally unoriginal." He normally lists all his sources, forcing us all to think about originality and appropriation.

LH

Right. It's interesting about these two threads of postmodernism. Anachronism apart, I wouldn't be able to say whether the New York State Pavilion was one or the other.

MW

Yes. There's a little classicism in the way these columns are worked. I think it's a really sophisticated building, by the way, particularly in these metal fins at the intersection of the columns and the plastic horizontal, which abstract the capital of a classical column.

LH

There's something classical in the uplift itself.

MW

Classical architecture is just columns. There is not really even a roof. It's just a logic of vertical ornament. So there is a kind of classicism in the pavilion, but ultimately the building turns in favor of the colored horizontals, subordinating the vertical structure to the horizontal ornament. Such classicism is always there with Durell Stone, but it's campy. Postmodernism is modern architecture in drag. That's actually a very precise description of what it is. But for Johnson, modern architecture was already in drag. Architecture itself is camp, from the beginning. Architecture is not rooted in the ground or in society. It's hung in front of society as a supposedly flattering mirror, which is no guarantee that it is ever seen. On the contrary, Johnson's building was so popular that it disappeared in architectural discourse—even if it's one of the only buildings to remain on the site as a huge, haunting ruin. On the other side of the coin, Warhol's *Thirteen Most Wanted Men*, which was covered over before anyone even arrived at the fair, has become one of his most studied works. Nothing could be less surprising.

1. Ada Louise Huxtable, "World's Fair: International Scope," *New York Times*, May 10, 1964, section 2, 5.
2. Vincent Scully Jr., "If This Is Architecture, God Help Us," *Life*, July 31, 1964, 9.
3. Denise Scott Brown, "Learning from Pop," *Casabella*, December 1971, 359-360.
4. Robert Venturi, Denise Scott Brown and Steven Izenour, *Learning from Las Vegas: The Forgotten Symbolism of Architectural Form* (Cambridge, Mass.: MIT Press, 1972).
5. Robert Hughes, "Doing Their Own Thing; U.S. Architects: Goodbye to Glass Boxes and All That," *Time Magazine*, January 8, 1979, Vol. 113, Issue 2, 52.

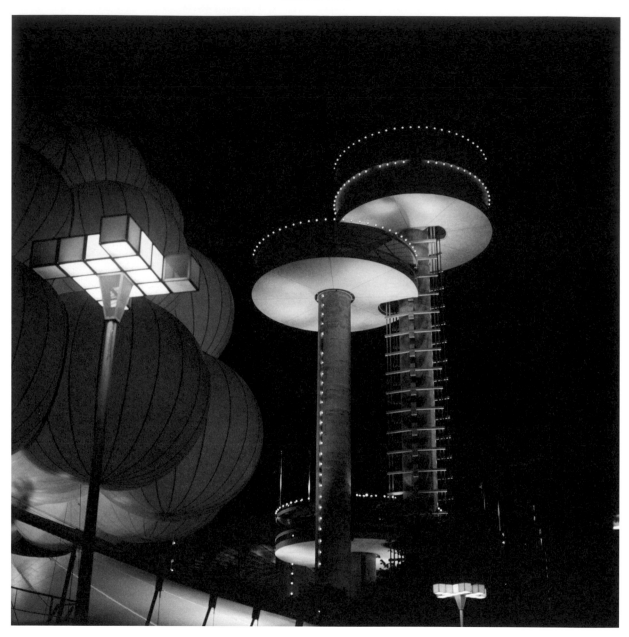

Philip Johnson's multi-part New York State Pavilion for the 1964 World's Fair featured the world's largest terrazzo map of New York State sheltered by the Tent of Tomorrow, an innovative suspension roof of brightly colored translucent panels, and three observation towers: a restaurant and lounge 85 feet up, and two observation decks, one 181 feet and the other 226 feet high, all reachable by elevator. (New York State Governor Nelson Rockefeller had apparently asked Johnson to make this Pavilion the tallest at the Fair.) All of this probably attracted attention away from the circular, concrete Theaterama whose ten large new works of contemporary art were spaced at regular intervals around its exterior. Johnson had funds for "external embellishments" on this structure, which was the only closed horizontal surface in the whole pavilion complex and is the only building still in use today.

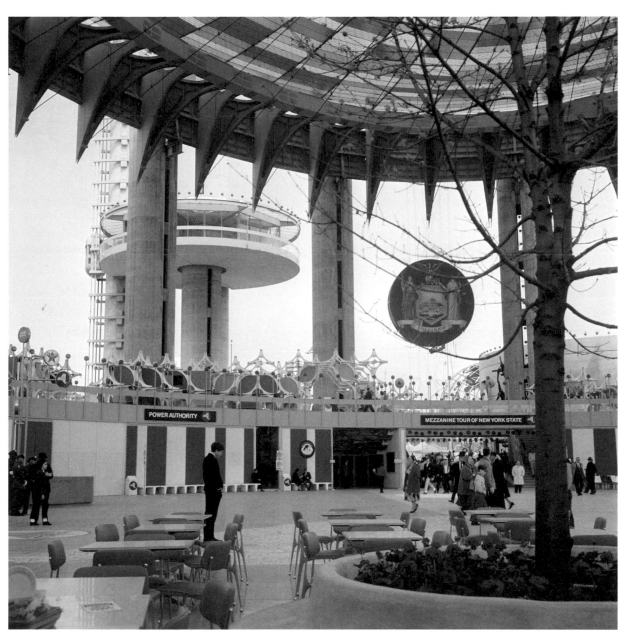

...What will it be?

... New York State will have one of the most dramatic and exciting exhibits at the Fair. Consisting of three distinct units, it is geared to the theme "State Fair of the Future" and will provide a fascinating display of permanent exhibits and a daily panorama of activities and experiences. There is something for everybody, young or adult.

NEW YORK STATE COMMISSION on the WORLD'S FAIR

Lieutenant Governor Malcolm Wilson, *Chairman*

Mrs. Paul E. Peabody, *Vice Chairman*

Charles J. Browne
Senator William T. Conklin
Mrs. Preston Davie
Ira H. Genet
Mortimor S. Gordon
Joseph A. Kaiser
Otto Kinzel
Herman I. Merinoff
Julius L. Mintz
Dr. Clilan B. Powell
William A. Shea
Joseph T. P. Sullivan
Crawford Wettlaufer

Ex-Officio
Senator Walter J. Mahoney
Assemblyman Joseph F. Carlino
Senator Joseph Zaretzki
Assemblyman George L. Ingalls
Assemblyman Anthony J. Travia
Senator Elisha T. Barrett
Assemblyman Fred W. Preller

Office:
1270 Avenue of the Americas
New York 20, N. Y.

1988.88.92 WF-64

NEW YORK STATE EXHIBIT

NEW YORK 1964-65 WORLD'S FAIR

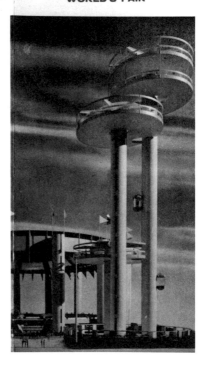

YOUNG ARTISTS AT THE FAIR AND AT LINCOLN CENTER

Philip Johnson

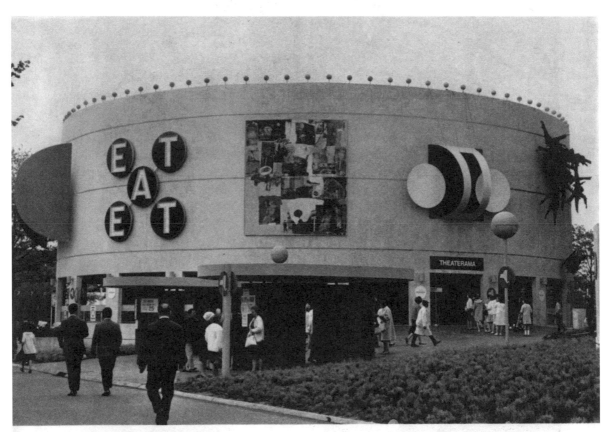

AT THE FAIR

It is a pleasure to see several of our mid-generation artists handle the same-sized space next to one another on the same building. The commission was a challenge to all the schools of art represented. All of them met it with courage.

Fascinating also to see the change in all these artists' work in the year since the commissioning. Change in their work and change in their position in the pecking order in the mad scramble of today's art battles.

They have survived. I frankly love my choices.

Developments that surprised me: The almost mournful dignity of Rauschenberg. The carrying power of the "pop" Lichtenstein. (The carrying power of Rosenquist I expected.) Automobiles welded into a "decorative" baroque cartouche by Chamberlain.

More predictable: Kelly's kissing hemicircles. Agostini's rococo drapery and mock balloons. Liberman's dashing symmetry and Mallary's souls in hell. Indiana's banal, commanding, elevated vulgarity—EAT.

American art is at a lively stage, at such a very American lively stage, so varied, so to the point in time and in space, we should all be as happy as kings.

Philip Johnson *designed both the New York State Exhibit building at the New York World's Fair and the New York State Theater at Lincoln Center (see page 122). He decorated each structure with the work of experimental artists. Photos of the Fair art installations were taken for Art in America by Eric Pollitzer.*

 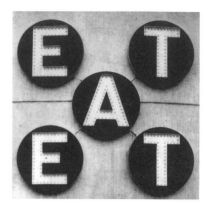

 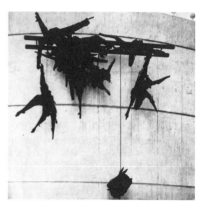

In the August 1964 issue of *Art in America*, architect Philip Johnson describes the artwork at his two most recent buildings—the New York State Pavilion at the 1964 World's Fair and the New York State Theater at Manhattan's new Lincoln Center (not pictured here)—and the challenges of choosing and installing them. In his overview of the artists on the New York State Pavilion's Theaterama, he does not mention Warhol at all, and neither *Thirteen Most Wanted Men* nor the silver monochrome that replaced it are reproduced.

Top (L to R): *World's Fair Mural*, Roy Lichtenstein, *Two Curves*, Ellsworth Kelly, *EAT*, Robert Indiana. Middle (L to R): *Skyway*, Robert Rauschenberg, *Prometheus*, Alexander Liberman, *The Cliffhanger*, Robert Mallary.

Bottom (L to R): *Untitled*, John Chamberlain, *World's Fair Mural*, James Rosenquist, *A Windy Summer Day*, Peter Agostini

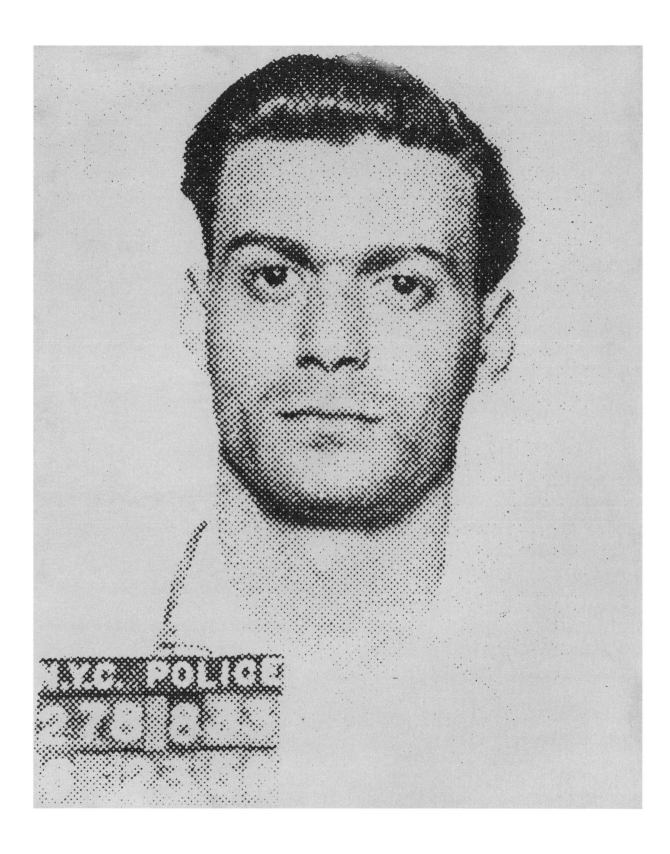

In his early twenties, **Albert Fisher** was named director of television for the 1964 New York World's Fair. In this conversation with historian **Lori Walters**, Fisher gives a first-person account of the inner workings of the fair. He recalls barely noticing the *Thirteen Most Wanted Men* controversy amidst his wide-ranging duties as a media and celebrity wrangler, which included generating ideas for stunts with *Candid Camera* and hosting Lucille Ball on "Lucy Day." Fisher had the distinction of being personally fired by fair president Robert Moses for bringing the wrong kind of entertainment to a wintertime Flushing Meadows Park. In the course of his recollections, Fisher exposes the mechanics of how the burgeoning medium of television interfaced with the global event that was the 1964 World's Fair.

Lori Walters

Can you describe how NBC's World's Fair program was planned, and some of the celebrities it featured?

Albert Fisher

NBC's opening-night special on the World's Fair, which aired on April 22, 1964 on the NBC network in prime time, was a ninety-minute program. We started preplanning in late 1963, and then started shooting on the fairgrounds in December of '63, and all the way up to and including opening day.

The television show featured a bunch of different celebrities that represented various areas of the fair. The overall host was the actor Henry Fonda, but then representing the industrial section we had Carol Channing, who had just opened on Broadway starring in *Hello, Dolly!*, which was *the* big hit for years and years. Representing the religion section we had the acclaimed African American singer Marian Anderson. Representing the states we had Lorne Greene, who was one of the stars of NBC's *Bonanza* television series. Representing the international area we had the Mexican comic actor Cantinflas, who was best known, I guess, for having played Passepartout in Michael Todd's *Around the World in 80 Days*, opposite David Niven.

I was involved in that show right up to and including opening day, because portions of that show were done live, although a good deal of the program had been prerecorded. We were working with film at the time and had to shoot the fairgrounds during construction, but make it look like it was opening day. It was freezing cold outside, and we had all of these extras, performers, and bands, and somehow we had to make it look like a beautiful springtime day in April. We had to shoot low from the ground,

looking up, because the ground was covered with snow at times. And there were always, always construction trucks around.

But the show came off really well, although we did have one problem with the live portion: on opening day, on April 22, '64, there were protests all over the fairgrounds by CORE, the Congress on Racial Equality. It had been raining all day long and some of these CORE members took an ax to some of our television cables, and we lost one or two cameras in the live portion of it as a result.

LW

Do you remember Andy Warhol's work on the exterior of the New York State Pavilion? Did that work feature in your NBC show?

AF

Well, if things had gone according to our plans, it probably would have been in the show. As I mentioned, the show had different segments, and Lorne Greene was the host for the section devoted to states. We decided to open that segment with Greene on the highest of the three towers at the New York State Pavilion, to kick off the states exhibit from up there with a nice panoramic view of the fairgrounds. On the floor below, inside the Tent of Tomorrow, where they had this gigantic terrazzo map of the entire state of New York, we had assembled a group of high school marching bands. So Greene would introduce the section, then blow a whistle, and the bands would start marching out of the building and across the fairgrounds, around the Unisphere, then lead us to all of the different major state exhibits.

We were planning that segment when the word came down that we were not to position our cameras in a way that showed the Andy Warhol artwork. I don't recall specifically who it was that said that but I remember that we had to position the cameras so that you did not see that portion of the building.

Later, when I went to work for the fair, I heard a little bit more. Just talk among people, nothing really formal, that the Warhol piece had become controversial and that the decision to initially cover it up, and then to take it down, had come from Robert Moses, with some influence from Nelson Rockefeller, who was governor at the time.

LW

Later, when the Warhol work was covered up and then taken down, did it create any level of sensation that you felt when you were at the fairgrounds?

AF

No, I don't think it was that big a deal. You have to understand that this was all taking place just before the opening of the fair, which was a huge event, so this was a tiny little blip. There were so many other things going around. Every single pavilion—and there were hundreds of pavilions at the fair—had its own public relations firm, and they were all vying for local, national, and international publicity and press. So the Andy Warhol thing, from my perspective, really got pushed to the sidelines.

LW

So it was during the course of this NBC opening-day program that you were hired to work directly for the fair?

AF

Yes, the public relations and television department made me an offer to join the television and film department of the World's Fair immediately after the NBC special. My job was not only to handle and coordinate all of the television shows that originated from the fairgrounds and other media projects, but also to woo the producers and stars of television shows and films, to get them to come out to the fair and either do segments from the fair, or talk about the fair in their ongoing programs.

LW

How did the World's Fair Corporation, and Moses in particular, view all of the television coverage that was going on—be it the *Bell Telephone Hour*, or the opening-day celebrations, and all of the television programs, such as *Candid Camera*? Did they embrace it, or did they look at it as a necessary evil, something that they had to put up with?

AF

Oh, no, no, they definitely embraced it. I mean, they were very, very public relations conscious. Bill Berns, the director of public relations for the fair, was keenly aware of the need for positive press in all media. That's why we were hired in our department, to embrace those media. So it wasn't a "necessary evil"; they genuinely wanted to have shows and events that promoted the fair. But always, obviously, in a positive light.

LW

Did you find any of those entertainers that you were attempting to woo reluctant to do a program originating from the fair, or were they all fairly receptive?

AF

Well, as far as being reluctant, we would take a lot of people around the fairgrounds and they'd say, "God, we really love it,

but there's nothing here that really fits into what we're doing." A lot of the people planned shows and programs so far in advance that they just had no way of squeezing something in.

We concentrated more on ongoing shows such as the Goodson-Todman game shows *To Tell the Truth*, *What's My Line?*, and *I've Got a Secret*. We were always putting people from the World's Fair into those types of shows. *Candid Camera* with Allen Funt did a lot of shooting on the fairgrounds, and we did segments from the fair on shows like *Queen for a Day* on ABC.

The show that I worked for, prior to going with the New York fair, was *Ted Mack & the Original Amateur Hour* on CBS. And I got them to come out to the fairgrounds and we held auditions there. And then we would bring acts from the fair to our studios in New York and feature them on the show.

LW

Of all of the celebrities, who did you find to be the most enchanted with the fair? Who really felt that the fair was just an incredible experience, and you could genuinely see it in how they reacted while they were at the fairgrounds?

AF

Well, certainly Lucille Ball. We did "Lucy Day" at the World's Fair in 1964, and that turned out to be one of the biggest media events that was held during the course of the first year of the fair. And I was very involved in that. It took months and months of work, where we devoted an entire day to Lucille Ball. CBS, and the underwriters—including Macy's and I forget who else, airlines and people like that—flew in over a hundred top columnists, newspaper and magazine columnists, from all over the world to be a part of this Lucy Day.

Lucille Ball was just thrilled with the fairgrounds. I spent the entire day with her, and also some time just before and just after the Lucy Day itself, and she was a huge proponent of the fair.

Somebody else that loved the fairgrounds was Ed Sullivan. He put acts from different pavilions on *The Ed Sullivan Show*. I spent a lot of time with Ed and his wife Sylvia, taking them around the fairgrounds, and to the different restaurants and shows there.

LW

Did you work for the fair until it closed? How long did your job last?

AF

The job lasted until the winter of '64, when I left the fair at the invitation of Mr. Moses, which is a polite way of saying that he fired me over a dispute involving yet another television show, an NBC show starring Jonathan Winters. I had the unpleasant task of having to let Winters and his NBC crew know that they could not

continue shooting, after I had already given the green light, because Mr. Moses did not like Jonathan Winters's type of humor.

So I was fired, but I had already begun work, independently, on the official radio series for the World's Fair, and I continued to do that once I had left the television department. We did twenty radio shows, hosted by Joan Crawford, Bud Collyer, Arlene Francis, and Pat Boone, and they were distributed to radio stations all over the world. Then I partnered with Gil Cates, who went on later to become famous for producing all of the Academy Awards. Gil Cates and I produced the reopening night special, for April 22, 1965, at the second year of the fair. That was a special on ABC network hosted by Gordon and Sheila MacRae.

LW

How did Jonathan Winters react to the news of Robert Moses being displeased with his presence at the fairgrounds?

AF

Oh, he was infuriated. You have to put this in the context of the fair's perception by the media and particularly the New York public. The fair was in big financial trouble by the time it closed its first season in October of 1964, and Robert Moses and the board of directors were really under fire by the New York press.

Part of my job was to try to get television shows to do something positive about the fair when it was closed, and we considered it a great coup to have gotten Jonathan Winters. He was under contract with NBC that year to do four television specials, and "Jonathan Winters at the World's Fair" would have been one of them. The premise was that a BBC reporter arrives to cover the World's Fair, not realizing that it isn't open in the winter. So in the British stiff-upper-lip tradition, the character would decide that the show must go on. He would interview what few people were on the fairgrounds, and all of them would be portrayed by Winters. One would be the guy at the Sinclair "Dinoland," who would have electric blankets to keep the dinosaurs warm in the snow. Another would be the custodian of the Chinese Pavilion—you would walk into the pavilion with your clothes all disheveled and when you came out they would be all cleaned and pressed. Winters had a recurring character called "the world's wealthiest man," and here he had his own Me Pavilion. For that we used the Federal Pavilion, and had big posters of this man all around the building.

So all of this was set up, and the show was to go on the air on a Saturday night. We were shooting on Thursday morning when I got a message that Mr. Moses wanted to see me. He was just fuming. He said, "Who let this buffoon onto my fairgrounds?" I said, "We all did, in the television department. This is going to be great for the fair, in the middle of the winter when you can't get publicity." And Moses said, "I don't approve of this guy's humor.

I don't like him. I want him off the grounds now."

So Winters and his team suddenly had to improvise a totally different show. They opened live that Saturday night and tore the World's Fair to shreds.

LW

In view of your interactions with Robert Moses, I was wondering if you could convey what you observed of him, both in relation to the fair, and just in general?

AF

It's interesting that you're asking this today because today is Moses's birthday. You know, my memories about my personal interaction with him and my feelings about him are tainted to a certain degree by history, of knowing so much about him. Bear in mind that, when I was there in 1964, I was twenty-two years old, and did not know who Moses was. In retrospect, I have the most profound respect and admiration for him as the master builder, not just for the World's Fair but for all of New York. At the time, I know he had a reputation for being very difficult to deal with, and I certainly saw that in my personal encounters. But in retrospect, I don't think there is anybody that could have put this World's Fair together the way that Moses did.

Particularly near the end of the first year of the World's Fair, there was a lot of criticism in the media about the lack of attendance as well as its financial losses. There was talk that Moses should be ousted from his role as president. My own personal feeling is that once the fair opened, they should have had a president for the fair that was more of a PR-type person. I remember hearing the rumor that they had even discussed having someone like Dwight Eisenhower be the honorary president of the fair. They needed someone that would glad-hand the celebrities and the politicians and the world leaders that came there, more than Moses was able to do.

Moses was pretty aloof, I think, on that level. He certainly gave the impression that "This is my fair," and that he was responsible for it happening. Had it been me, I don't know if I would have had any different feeling about it myself. But my feeling, in retrospect, is that he was just a brilliant master builder. I had a number of encounters with him, one of which ultimately resulted in my leaving the fair during the winter between the two seasons. Otherwise, though, he was there all the time, and when he was criticized by the press, he would just turn around and lambast the press right back. He was a person who certainly spoke his mind.

LW

Moving away from the television and the public relations aspect, I just want to ask one or two questions about your observations of people at the fair. How did people seem to you when they

were at the fair, in relation to their level of enjoyment and things of that nature?

AF

I think, by and large, everybody was thrilled with the fair. It was a big, big event, and families just loved it. There was something for everybody to do. The entertainment level was so high with all of these different exhibits.

The only things that really did not do well were in the amusement section, which was tucked in the back end of the fair; you had to go across these bridges to get to it. These were all venues where the general public had to pay money to buy tickets. *To Broadway with Love*, which was a fabulous Broadway musical, was at the Texas Pavilion in the amusement section, but it was competing with all these free events. It was the same with most of those things, like the show that had been at the Aquacade at the '39 fair, by Leon Leonidoff, who was the head of Radio City Music Hall. These were wonderful shows, but how can something which you have to pay money for compete, when you can see something just as spectacular, or even more spectacular, for free at all of the industrial pavilions? So they were all hurting in the amusement section.

LW

What is your most vivid memory of the fair itself? What really sticks in your mind the most after all these years?

AF

I guess the thing that really stands out for me about the New York fair was the idea that in one location, you could see and experience so much on so many different levels. The introduction of new types of technology, the ability to be able to literally travel the world just in that seven-hundred-plus acres in Flushing Meadows, to go from country to country, from state to state, from industry to industry.

I think probably the most impressive things to me, which would probably reflect most of the people that went to the fair, was certainly the ability to see, in person, Michelangelo's Pietà at the Vatican Pavilion. I think the *Pietà*, and the General Motors Futurama ride, were the two biggest hits of the fair.

The other thing that really impressed me at the fair was the use of a brand new form of technology, the name of which was coined by Walt Disney, which was Audio-Animatronics. Disney had four attractions at the fair, all of which used this Audio-Animatronic technology. The Illinois Pavilion, with *Great Moments with Mr. Lincoln*, had an Audio-Animatronic of Abraham Lincoln moving and telling sections of many of his great speeches.

There was the General Electric Carousel of Progress, where the audience rotated around a central stage, and you would go through different eras of a family experiencing new forms of technology, going from the late 1800s, to the 1920s, to the 1940s, to the future. And then, of course, probably the most lasting hit by Disney, underwritten by Pepsi-Cola, was 'It's a Small World', which still resides in virtually every one of the Disney theme parks. It's that tune which nobody can get out of their head.

LW

[*Laughs.*] For certain.

AF

There were also great dining experiences at the fair, some truly exceptional restaurants, the number-one being the Toledo restaurant at the Spanish Pavilion. Of all the international pavilions, the Spanish Pavilion truly was the greatest hit, architecturally and for its exhibits, just everything about it. But you know there were some really, really fine restaurants at the fairgrounds as well. The Gas Pavilion had a wonderful restaurant, as did the Indonesian Pavilion. A lot of the international pavilions just pulled out all of the stops to showcase the finest cuisine from the different countries.

And then for families that were there on a very limited budget, you could certainly get fast food inexpensively. I mean, they had all the Brass Rail restaurants for hot dogs and hamburgers and that kind of stuff. But even like Chun King, the Chinese food people—you can't call it gourmet Chinese food by any means, but I remember you could get an appetizer, main course, dessert, and a drink for ninety-nine cents at the fair. You know, for a family, you just couldn't beat some of those prices. There were just so many things that were great, great memories for me, as far as the diversity of the types of pavilions and exhibits.

LW

Which was your favorite pavilion?

AF

That's a little hard. It's almost like saying, "Who's your favorite child?" You know, there were so many of them. The first thing that pops into my head is Johnson Wax with Francis Thompson's film *To Be Alive!*, which won the Academy Award in 1965. It was such an exhilarating film, and it still holds up today. That was certainly a favorite.

And of course there was the diorama of New York and the five boroughs, which still exists now at the newly refurbished Queens Museum, and is just a spectacular thing to see—it was great to be able to take a simulated helicopter ride around all of the Manhattan area narrated by Lowell Thomas. And the New York State Pavilion, that was a really fun area to go to, with the big Texaco map of New York as the floor underneath the tent, and all the different

ongoing free shows that they had there. And the ice skating show that Dick Button put on inside the New York City pavilion as well.

LW

A last question. You actually met Andy Warhol, later. Could you tell us about it?

AF

Yeah, I did. The first time that I met Andy personally was around the middle of 1965. The fair was still going on. After my job ended at the fair, I went to work for my friend, the host of *The Merv Griffin Show*, and we were invited to come to Andy's offices, which were called the Factory. We went there with a camera crew and we spent a good part of a day with Andy and all of his people at the Factory, shooting him at work and doing an interview with him.

I had a Nikon camera, and I did most of the photography in the early years on the Griffin show. It started out really more as a hobby and then, along with my regular job—I was director of publicity, promotion, and public relations for the Griffin show—I did all of the official photography for those years, from 1965 to 1970.

So I was taking some pictures, and Andy turned to me—and there was a big wall of mirrors on one side—and he said, "What you should do is aim the camera so that you see yourself in the mirror, along with me, and then you can do your own self-portrait of us together. And then when you do it, don't print that out, but print all the contact sheet." That was just a little throwaway, casual thing that he said, but I did it. It's a photograph now of the four frames that I shot, and you see all the sprocket holes in the film. In one of the frames, you see me in focus with the camera held up, and Andy soft in the foreground, and in the next frame Andy is sharp in the foreground with me soft-focused behind him.

When I had a chance to talk to him a little bit, I told Andy, "I remembered your painting, Mr. Warhol, of the *Thirteen Most Wanted Men*, and that it had been covered over and then taken down." And I mentioned that I knew there was a little bit of controversy, or a *lot* of controversy, about the artwork. And I said, "So was that all the result of your not getting along with Robert Moses?"

He was not a man of many words. The thing he said to me, which I remember because it really startled me, was, "Moses—he was a pompous asshole." And that really was the end of that part of the conversation.

This mosaic was designed and installed by the New York City Parks department between 1994 and 1996 after extensive historical research on the Fair and the Park. Although for Warhol watchers a surprising image—as Warhol's rejected replacement for the *Thirteen* *Most Wanted Men* had never been seen in public and had been lost since 1964—it provides an unexpected way of representing Robert Moses, the Park's most important figure, and Andy Warhol, the fair's least predictable participant, at once.

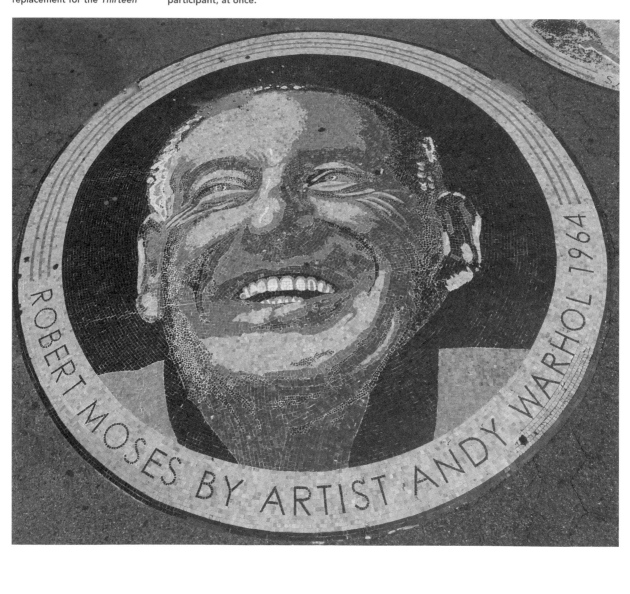

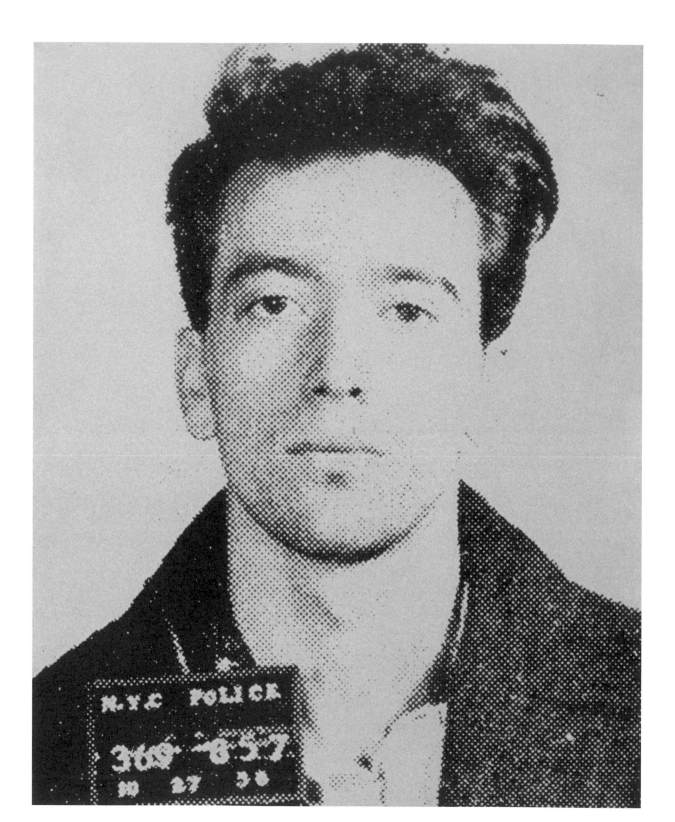

"By '64 he had to be one of the most hated men in town."

City planner, master builder, and "power broker" **Robert Moses** (1888–1981) had an incomparable impact on the infrastructure of New York City between the Depression and the Vietnam War, building the bridges, parks, highways, public housing, and cultural centers that would permanently change the face of the city and the way people entered, left, and lived in it. Although at his peak he held numerous influential nonelective public posts, by 1964 Robert Moses was at odds with Nelson Rockefeller, the art-loving plutocrat and governor of New York State. Moses's role as president of the 1964 New York World's Fair was widely understood to be a "consolation prize" for the loss of most of his other city and state offices. Urban historian **Hilary Ballon** organized the three-venue exhibition "Robert Moses and the Modern City" in 2007, a major reassessment of Moses. She is University Professor of Urban Studies and Architecture at the Robert F. Wagner Graduate School of Public Service, New York University, and deputy vice chancellor, NYU Abu Dhabi. She discussed Moses and his status in the mid-1960s with **Tom Finkelpearl**, then president and executive director of the Queens Museum.

Tom Finkelpearl

By the time of the '64 fair, was Robert Moses's power and influence in decline?

Hilary Ballon

In 1960, when appointed president of the New York World's Fair, Moses was a shadow of his former self, his power largely eroded. He had been removed as commissioner of the Parks Department, as city construction coordinator, and as head of the urban renewal program. In 1963, Governor Nelson Rockefeller also removed him from a variety of state positions. Running the World's Fair was a consolation prize, something the mayor and governor could give him with relatively little political risk while they took away Moses's other power bases.

TF

As I understand it, Moses was in control of the 1964 fair. It was his fair in a more substantial way than the 1939 New York World's Fair had been.

HB

The 1939 fair was also a Moses creation. To create the fairgrounds, he built an extensive infrastructure of parkways and bridges, and he transformed an ash heap into Flushing Meadows Park. The fair in '39 was seen very much as something Moses brought into being. And if the '39 fair hadn't come along, he might have invented it. He used the fair's deadline to drive public works to completion—the park site, the highways, and the Triborough Bridge—so that visitors could reach the site. Like Olympic projects these days, part of his argument for the fair was that it was a way to create a longer-lasting public benefit. I don't think the '64 fair was more a creation of Moses than the '39 fair. In fact, I believe there was considerably less personal investment in the '64 fair because it was such a late-career project. In '39 he was in his prime; he was still "the good Moses" in public opinion, the widely appreciated park and parkway builder. By '64 he had to be one of the most hated men in town. The fair was his last hurrah, and I suppose on some level an opportunity to redeem some popular favor, although he professed disinterest in public opinion.

In the forties and the fifties he acquired new powers, for example as city construction coordinator and head of the slum-clearance program, but his MO and public persona were fully formed in the 1930s. He had established himself as an authority figure who was both inside and outside government—the outsider claim being that he was not partisan, that he was above the fray, incorruptible, part of no machine, a man above the party who had the public interest at heart. In 1939 he headed the Triborough Bridge Authority and the New York City Parks Department. In 1964 he had been marginalized by Rockefeller. Running the fair was a relatively minor undertaking for a toppled autocrat.

TF

One narrative of the destruction of Warhol's mural is that Moses and Rockefeller must have worked together to rid the fair of a controversial artwork. But you're saying that they were adversaries at the time.

HB

Yes, fierce adversaries. In late 1962, Rockefeller pushed Moses out of his posts in the state park system to make way for his brother Laurance. In pique, Moses also resigned from other state posts, including the Power Authority and the Long Island State Park Commission. But in the bigger picture, Moses was not interested in art or art-world concerns. He described the fair as a "great summer university" and believed in its uplifting educational mission. Throughout his career he had a distaste for "cheap midway amusements" and "honky-tonk" entertainments. But he

also had no sympathy for avant-garde or highbrow art. Rockefeller knew a lot more about art and had an interest in contemporary art. Warhol certainly was not Moses's kind of artist. Aymar Embury [architect of many Moses-commissioned projects, including the New York City Building, which now houses the Queens Museum], whose work you know well, embodied the kind of figure, and the kind of architecture, Moses would have valued when he was paying attention to these things. Embury's architecture was respectful, decorous; it worked within a historical vocabulary even if it was a little more streamlined—a version of modernism that was inoffensive. After the New Deal era, there's nary a shred of evidence that Moses paid attention to the quality of art or architecture. He cared far more about getting things done. What interested him was figuring out how to motivate the real-estate community, how to connect them with whatever agenda he was serving—whether it was middle-income housing or highway construction.

Take Lincoln Center, which opened in phases beginning in 1962. Under the leadership of John D. Rockefeller III, architectural quality was a goal of Lincoln Center, but that attainment, which set it apart from most of Moses's slum-clearance projects, was irrelevant to him. His focus was on maximizing federal funds and assuring that middle-income housing was part of the urban renewal program. Aesthetic concerns did not enter his equation.

Moses was interested in the '64 fair partially because of his association with the '39 fair and the site, which had fallen on hard times. The '64 fair provided an opportunity to reinvest in Flushing Meadows Park and perhaps recuperate some degree of public appreciation. It's not that he acknowledged caring what people thought of him. Au contraire, his public posture was: "I don't give a damn what anyone thinks of me. I'm tough enough to take the slings and arrows because posterity will prove that I worked in the public interest and improved the city. I will be vindicated by history."

TF

So then the fair, even though it lost money, was popular. But it was the last hurrah. Do you think that Moses saw the fair as a success?

HB

Yes, he considered it a success primarily because it funded long-term park improvements, while also claiming that it drew larger crowds than earlier fairs. He attributed the financial failure to decisions taken out of his hands, but he also argued that the balance sheet of the fair was not the ultimate measure of success. Throughout his career, Moses argued that public investments and infrastructure recoup their cost by increasing the value of adjacent property and increasing tax revenues, so it was in the

long-term interest of the city to invest in infrastructure. The up-front costs would yield long-term gains for the city. In any event, he would not have conceded that anything he did was a failure. One of the reasons we perceive him to be always victorious and omnipotent is because the failures were invariably written out. He had no humility and never acknowledged when he lost—but he did lose battles.

TF

Lincoln Center was a model for developments all over the country. The idea was, "Let's leverage the power of the arts in the city. It's going to be good for economic development and the transformation of the neighborhood." But what wasn't talked about, certainly in those days, was the value that people like Warhol and his contingent brought to a city— the bohemian, countercultural, gay "creative class" wasn't on anybody's mind at the time.

HB

Yes, I agree with you. When Lincoln Center was created, it was a significant evolution in the way that cultural centers functioned in the city. The Metropolitan Opera, for example, had been supported by an elite clientele that didn't have a tradition of public philanthropy. The establishment of Lincoln Center required massive fundraising campaigns, which the Rockefeller family was behind. It involved each of the founding institutional members—the Metropolitan Opera, New York City Ballet, the New York Philharmonic—as well as a coordinated campaign to build public support in the larger metropolitan region, in a way that these arts institutions had never done before. In order to raise the massive amounts of money needed to build and operate Lincoln Center, a modern fundraising campaign, perhaps the first for the arts, was launched. Department stores in the suburbs displayed Lincoln Center promotions in their windows. The intention was to enlist a much wider spectrum of people to contribute to and attend the theaters. Underlying the fundraising was an awareness of the need to build a broad constituency for the arts and to cast Lincoln Center as a public resource. Moreover, while Lincoln Center was raising money and attracting a prosperous middle-class audience for the new theaters, it was also developing an educational program with outreach to public schools, sending the resident companies into the schools and bringing school groups to the center.

TF

It was Lincoln Center Institute—now called Lincoln Center Education.

HB

That's the kind of shift that I see Lincoln Center instigating at this

moment. But that's different from the creative ferment of the bohemian sort that you mentioned.

TF

Yes. Of course, fifty years later, Warhol is one of the biggest draws any museum could imagine, but the craziness of Warholian bohemianism, all the drugs and sex and everything—well, perhaps that's still not acceptable to everyone.

HB

There's no way that Moses would have appreciated that bohemianism. He would have seen it as a form of decadence. In 1964, Moses was seventy-six years old; his mindset and value system were shaped by a much earlier era. When he was trying to "save the city," he was trying to save it for the middle-class nuclear family.

TF

It's hard to say what got saved, who won, who lost, but somehow it seems that Warhol came out on top.

HB

And there's something wonderfully paradoxical: if you look back at that moment in terms of public figures in New York, Moses would have been considered one of the most wanted men, with a bull's-eye on his back!

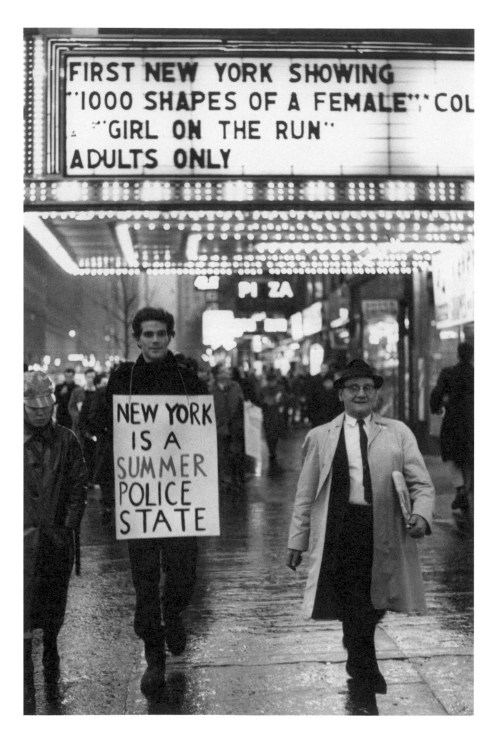

Spring 1964 and the run-up to the World's Fair brought increased police pressure on the gay and artistic underground. On the opening day of the fair, a group of artists and poets including Taylor Mead, Alan Marlowe, Diane di Prima, Julian Beck, Allen Ginsberg and others marched from Bryant Park to the newly constructed Lincoln Center where they dumped a coffin marked "Will Free Expression Be Buried?" next to the fountains adjacent to the New York State Theater, another Philip Johnson building that would open officially the following day. In this photo, Alan Marlowe, Diane di Prima's husband and her co-star in Warhol's film *Diane di Prima/Alan Marlowe*, 1963, holds a sign that riffs off "New York is a Summer Festival," a World's-Fair-related slogan in wide use that summer.

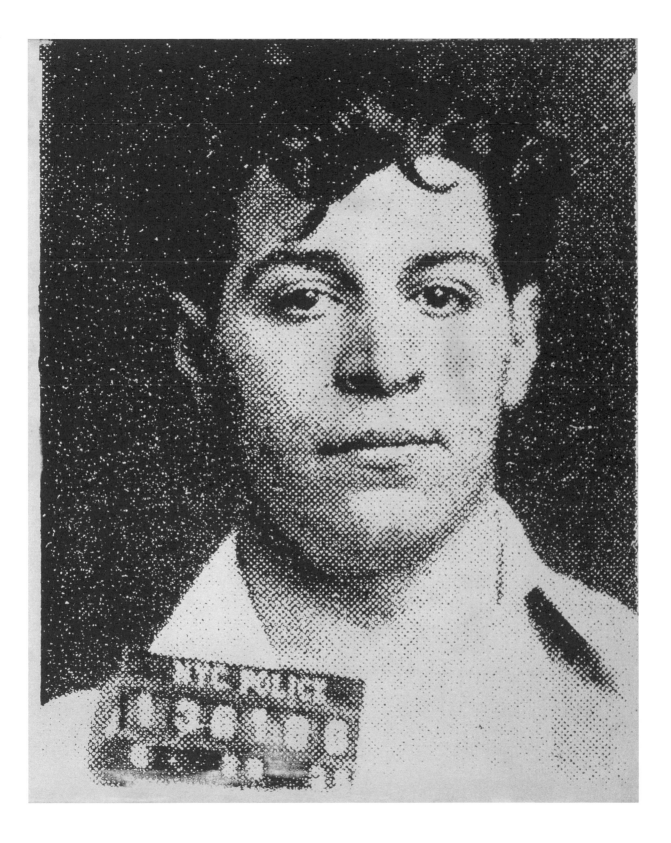

"The perfect opportunity for urban civil rights activists to advance their calls for racial justice"

On April 22, 1964, the New York World's Fair opened with an address by President Lyndon Johnson. Back in Washington DC, members of the Senate were filibustering the Civil Rights Act. Robert Moses, a leading architect of "urban renewal" had, as President of the Fair, allowed it to be built largely by the segregated building trades. All this, plus the opportunity for national and international media exposure, prompted widespread opening-day civil rights demonstrations on the fairgrounds and a "stall-in," in which cars, slowing down or stopping, were meant to impede traffic for miles around the fair site. Historians **Felicia Kornbluh**, author of *The Battle for Welfare Rights* and a forthcoming book on social movements in post-1945 America, and **Brian Purnell**, author of *Fighting Jim Crow in the County of Kings: The Congress of Racial Equality in Brooklyn*, talk with curator **Larissa Harris** and curatorial advisor **Timothy Mennel** about the fair protests and the northern civil rights movement in the context of Freedom Summer in the South. They also draw attention to the local actions that lent momentum to national legislation, and how they laid the groundwork for future struggles for women's and LGBT rights.

Timothy Mennel

Where and how did the specific plans for the sit-ins develop? How did they evolve from the pre-opening protests and the threats to paralyze fair traffic?

Brian Purnell

From as early as the fall of 1963, New York City activists, especially people connected with CORE (Congress of Racial Equality) chapters in Queens, the Bronx, Brooklyn, Harlem, and the Lower East Side, had planned to stage demonstrations at the World's Fair. Throughout the summer of 1963 in New York City, civil rights activists staged major demonstrations against racial discrimination in building-trades unions at major construction sites. Construction unions in the 1960s, especially in the skilled trades, were practically all-white, and it was practically impossible for outsiders to break into the apprenticeship programs that served as gatekeepers for lucrative full-time employment in the building trades.

Protests against the building-trades unions in the summer of '63 spearheaded the creation of an umbrella organization called the Joint Committee for Equality, which staged sit-ins at the Manhattan offices of the mayor and the governor. When all of those demands for immediate racial integration of construction unions failed to produce concrete jobs for black and Puerto Rican workers, activists turned their attention to the biggest construction project in the city: the World's Fair pavilions at Flushing Meadows Park.

The plan to hold sit-ins inside the fair, at least the ones that the national office of CORE held, evolved from these earlier protests. National CORE also wanted to use nonviolent sit-ins to draw attention away from its Brooklyn chapter's threat of a traffic "stall-in" on the fair's opening day.

TM

The fair positioned itself as an exhibition of scientific wonder, technological progress, high culture, and exotica. But it didn't profess to engage much with social or political issues. What made it such a rich target for race-based protests?

BP

The 1964 World's Fair was certainly one of the largest public works projects in the city's history. For civil rights activists, especially activists based in New York City who spent many months fighting for economic issues like employment in all-white job sectors, no bigger stage existed from which to put forward their demands and critiques than the World's Fair. Every major leading institution and individual in media, politics, and business had representatives involved in the fair. An international event in what was at that time the most important city in the world was the perfect opportunity for urban civil rights activists to advance their calls for racial justice in employment, housing, public education, and policing practices.

TM

Beyond CORE, what were some of the other groups involved in protests at the time, and what were their demands?

Felicia Kornbluh

New York City was a hotbed of social protest in the late 1950s and early 1960s. We often forget this, preferring a narrative in which the civil rights movement began in the South and migrated north sometime in the middle to late 1960s. But in fact, civil rights and other forms of protest were epidemic in the urban North, tied to the demands of the southern movement and distinct from them—more focused on housing, public welfare, publicly funded jobs, and health care.

CORE members and activists further to the left made persistent demands after World War II for good-quality housing and

prosecutions of landlords who failed to follow building codes. These demands culminated in a rent strike that began in Harlem and spread to other parts of the city in the fall and winter of 1963–64.

The New York City chapter of the NAACP had an especially active education committee. The NAACP's education campaign culminated in the formation of a coalition of civil rights groups under the leadership of Bayard Rustin to boycott the New York City public schools in February 1964. The massive boycott was the largest civil rights demonstration in the United States up to that point, and was commended by Rev. Martin Luther King Jr. for "punctur[ing] the thin veneer of the North's racial self-righteousness."[1]

Although they were not identified with any particular civil rights or community group, perhaps the most influential "protesters" of this period in New York City were the residents of Harlem, Bedford-Stuyvesant, and many other neighborhoods who rioted beginning on July 16, 1964 in response to what they saw as police brutality. They were responding to a particular incident, in which a white policeman shot an unarmed African American fifteen-year-old, as well as to long-term efforts to control police behavior. At the time of the riots, a proposal for a Civilian Complaint Review Board was before the New York City Council, having been introduced by Council Member (later, US Congressman) Theodore Weiss. The riots probably did a lot to depress attendance at the fair; Moses received several personal appeals from white southerners who feared driving up to New York for the spectacle, and who reported that their friends warned them to stay away from the city.

Larissa Harris
Urban renewal of course included Lincoln Center, another project of Rockefeller, Moses, and Johnson. But beyond issues of racial inequality, there was also important antiwar activism around that time, and also Latino movements. Could you speak to that?

FK
In 1961, a mostly white, middle-class peace movement emerged in the New York City area under the name Women Strike for Peace. Members of this movement started by opposing US atomic bomb tests and Cold War military maneuvers and became vehement opponents of the war in Vietnam. On August 6, 1965, four hundred members of Women Strike for Peace protested in black around the Unisphere and the Japanese Pavilion—a combined reminder of the US use of the atomic bomb against Japan in World War II and of the recent commitment of US ground troops to the battle in Vietnam.

Puerto Ricans were the largest group of Latinos/as in New York between the 1930s and the 1960s, and they were

increasingly well organized by the time of the World's Fair. Frank Espada, an electrical worker and community organizer, came to the World's Fair protests from his base in the Puerto Rican and African American communities of Brooklyn, and was arrested for dancing on the bar in the Schaefer Beer Pavilion in protest over Schaefer's poor record in hiring people of color. Espada's son, the poet Martin Espada, later wrote a poem about his father's arrest and disappearance on the opening day of the World's Fair, called "The Sign in My Father's Hands":

> The beer company
> did not hire Blacks or Puerto Ricans,
> so my father joined the picket line
> at the Schaefer Beer Pavilion, New York World's Fair,
> amid the crowds glaring with canine hostility.
> But the cops brandished nightsticks
> and handcuffs to protect the beer,
> and my father disappeared.
>
> That day my father returned
> from the netherworld
> easily as riding the elevator to apartment 14-F,
> and the brewery cops could only watch
> in drunken disappointment.
> I searched my father's hands
> for a sign of the miracle.[2]

TM
These protests all came relatively early in the 1960s. Nationwide, many protests later that decade either focused on foreign policy or can be seen as the dawn of various identity-based movements. What do you think accounts for the relative eclipse of economics-based protests?

FK
My current book project, *Constant Craving: Economic Justice in Modern America*, argues that there was, in fact, no eclipse of economics-based protests after the early 1960s. The social movements that were strongest at the end of the 1960s and into the later decades of the twentieth century—including the LGBT movement, the women's movement, and the disability rights movement—were all deeply engaged with economic questions. So were the proponents of Black Power who became leading voices in the African American movement in the late 1960s and early 1970s (although, of course, the form of their economic demands was somewhat different than it had been for earlier activists).

Beginning directly after the *Brown v. Board* decision in 1954, activists in New York City sought educational integration and

access to quality education for African American and Puerto Rican children. This was an economic demand in that parents understood that their children would not have social mobility without decent schools. Parents of disabled children sought similar access in a variety of individual and group acts of advocacy and activism. These efforts resulted ultimately in the passage of the Education for All Handicapped Children Act of 1974 (Public Law 94-142). Feminists similarly sought access to higher education, including college and professional school training, as part of their campaign to make women economically secure irrespective of their marital status.

The World's Fair protests were largely provoked by the sense that the government of New York City had failed repeatedly to hire African Americans and Puerto Ricans, and also by the perception that workers of color were not employed at the fair itself. Moses and other officials of the fair did not do much to improve their relationships with communities of color. For example, when the chairman of the New York State Commission Against Discrimination asked Moses to notify all of the private consultants and contractors who were creating exhibits at the fair that there was an antidiscrimination law on the books in New York State, he refused, claiming that such an action was not "appropriate for the Fair Corporation to take."[3]

The employment advocacy of communities of color in New York City was not different in kind from the employment advocacy other movements pursued later in the 1960s and in the 1970s, 1980s, and 1990s. Black Power activists tended to favor community control of economic resources to integration of African American workers into majority-white worksites, but their goal of ensuring jobs and income for people who were marginalized and poor was the same. Feminists, of course, cared as much for the employment protection they gained in the Civil Rights Act of 1964 as men of color did—and they fought as hard in the later 1960s and 1970s to make the promise of that law a reality by pressuring unions, local governments, and the federal Equal Employment Opportunity Commission to take their discrimination claims seriously.

Insofar as there were changes in the character and mood of social protest after the CORE heyday in the early to middle 1960s, I would say that it was precisely the intransigence of political and, even more, economic forces in the face of nonviolent, integrationist campaigns that best explains the change. The passage of an antidiscrimination law at the state level after World War II did not make New York City hire people of color or integrate the schools; *Brown v. Board* did not do it; a decade of nonviolent protest (including protest on the opening day of the New York World's Fair) did not do it. Activists and the communities they were attempting to lead kept trying to improve their economic situations, but were less and less convinced that they had responsive allies on the other side of any negotiations.

TM

CORE had a volatile history and saw the nature and extent of its power change greatly over the course of the 1960s. What sort of political and cultural influence did it have in New York specifically—and in the North generally—by the spring of 1964?

BP

CORE had spotty political influence in New York, and in northern cities in general, over the course of the early 1960s. It waged some successful housing integration campaigns, and it led some of the earliest campaigns for what would later be called "affirmative action" in racially exclusive employment sectors. In some local industries, like the Ebinger's Baking Company and Sealtest Dairy Company, both in New York City, it won jobs for black workers.

But overall, CORE and many other civil rights organizations only dented the social and economic barriers that created racially divided cities outside the South; they never cracked those barriers completely, or tore them down. By the spring of 1964, the nonviolent, direct-action protest approach to fighting racial discrimination in northern cities had won many piecemeal victories, but its adherents could not point to any large, significant, tangible change in racially discriminatory patterns in housing, public schools, or employment.

TM

What do you see as the long-term impact of the fair protests? Did they specifically influence subsequent actions or political responses?

BP

The fair's protests certainly resonated with other activists during that time. Like many civil rights protests in liberal cities, where social and economic racial disparities stemmed from underhanded institutional and personal practices rather than state-sanctioned laws, elected officials promised to make improvements in the issues that activists raised at the fair. But over time, the city saw much more of the same.

And there were moments when the protests registered beyond the world of activism and the fair proper. The Brooklyn CORE stall-in inspired national comedian Dick Gregory, who included references to it in his stand-up routines. St. Louis CORE activist Ivory Perry recreated the stall-in on a highway in his hometown. The *Chicago Sun Times* featured a cartoon by famed illustrator Bill Mauldin that depicted a broken-down car on the side of the road leading to the World's Fair and had the ironic caption, "A Century of Progress"—Mauldin's criticism that the nation had stalled in its efforts to enact meaningful civil rights legislation in American cities like New York.

FK

The protests helped lead to the failure of the fair in terms of finances, attendance, and, most important, in terms of historical memory. The 1939 World's Fair, like the 1964 fair, was protested by African Americans and accused of symbolizing a country and city that failed to live up to their self-congratulatory rhetoric. The earlier fair, like the later one, too, was a financial disappointment. The corporation that managed the 1939 fair failed to repay its creditors fully and had virtually no resources with which to do the improvements on Flushing Meadows Park that it had promised the city and state as part of the justification of their financial involvement (and which were the chief sources of Robert Moses's interest in the project). The main difference between 1939 and 1964 lay in the way the two World's Fairs were remembered politically and historically. And because the later fair was remembered as a failure, it became the last of the great fairs in US history—ending a tradition of fairs that celebrated science, consumerism, and territorial expansion beginning with Chicago's "white city" exposition in 1893.

Why was the 1964 fair remembered as a failure? I do not think that the protests, or even the totality of events at the fair, were entirely responsible for the way the fair was remembered. There was a call-and-response process between, on the one hand, events elsewhere in the US and in countries such as Vietnam, and on the other, the protests and other occurrences at the fair, which produced this memory. For example, the 1964 fair was remembered negatively in part because it was the last major project overseen by Robert Moses. Biographer Robert Caro tells us that Moses was accused of corruption for the first time after the depth of the fair's financial troubles were revealed, and that his reputation was forever tarnished. No doubt, the protests at the fair contributed to the tarnishing of Moses's reputation. But so did the protests over urban renewal throughout New York City in the late 1950s and early 1960s, which centered on the use of Title I of the National Housing Act to take land under the power of eminent domain. Moses was the director of the city's Title I program, and he was the first in the country to use this authority to replace tenements with large-scale projects other than housing (such as the Manhattan expansion of Fordham University and the development of Lincoln Center and the Lincoln Square apartment complex).

LH

But there were also political reasons for the fair's "failure"?

FK

Yes. The 1964 fair was remembered negatively also because it was a swan song for the Democratic Party machine in New York City under Mayor Robert F. Wagner Jr. and appointed officials

such as Moses. John V. Lindsay won the mayoralty in 1965 on a fusion Republican-Liberal ticket and on the strength of votes from African Americans, Puerto Ricans, and reformist whites. Lindsay held the office through 1973, after which the city entered a period of fiscal crisis and near-bankruptcy. The Lindsay and post-Lindsay periods were deliberate departures from the era of Wagner, Moses, and the World's Fair. Lindsay liberalism was indebted to precisely those communities that had protested the fair and were (at that moment in history, although not later) located geographically far from Flushing Meadows Park. Mayor Beame, a Democrat who saw the city through the worst of the fiscal crisis, had a single mandate, to right the city's finances. From 1965 through the late 1970s, then, an interpretation of the 1964 World's Fair as an expensive mistake set in among many leading New Yorkers, and the fair site was left mostly untouched and unloved.

The whole culture of the 1960s and early 1970s ultimately made the aesthetic, political, and economic messages of the fair untenable. The fair's promise of "Peace Through Understanding" and its celebration of US power seemed grotesque to those who objected to the war in Vietnam—a conflict that the US participated in and which was unpopular in some circles even before the formal commitment of US ground troops, which Women Strike for Peace protested in 1965. The "Port Huron Statement" of Students for a Democratic Society, issued in 1962, was an early critique of mass consumerism; within a decade, such sentiments would be very widely shared. Even science and technology, the signal sources of optimism at World's Fairs from the Crystal Palace in London in 1851 through the 1964 New York City fair, came under attack later in this period. The same forces that gave relatively wealthy people in the industrialized West telephones and fast transportation were seen as sources of danger (e.g., the atomic bomb), ill health, and spiritual degradation.

LH

Felicia, could you tell us about the relationship between the grassroots organizing you mentioned previously and the Civil Rights Act of 1964? Were people galvanized by such a major piece of legislation? Did they feel ownership over it?

FK

Activists north and south were galvanized by the continuing filibuster of the Civil Rights Act in the United States Senate. Recall that the bill had originally been introduced by President Kennedy in June 1963; lack of progress was already a sore point by the time of the massive march on Washington on August 28. After Kennedy's assassination, President Johnson promoted the bill actively. Still, it was filibustered in the Senate by segregationist Democrats (and one Republican) beginning on March 30, 1964.

When the fair opened in April, the bill was still stuck—activists thought, perhaps irretrievably. Members of CORE and other groups were boiling mad at the seeming inability or unwillingness of Lyndon Johnson's administration or liberal Democrats in Congress to break the filibuster and get the bill passed. This helps explain why they demonstrated during President Johnson's opening-day address at the fair—an even more radical act than it would be today to shout down a United States president at a major address. And it explains why the United States Pavilion was a key target of demonstrations at the "Olympics" of human understanding that Robert Moses promised the World's Fair to be.

When the Civil Rights Act finally passed Congress and was signed by Johnson on July 2, many activists did, indeed, consider this a great sign of progress. They believed it was as much their achievement as it was the achievement of inside-the-Beltway officials. The Civil Rights Act was not enough for many people, though, especially after the months of inaction and the vile things that were said in the course of that struggle. This is in part why the Harlem riots started days after Johnson signed the act.

LH

Do you think the Freedom Riders [in the summer of 1964] also drew attention away from work in the North? Was there conversation about this in the leadership?

FK

I think that the African American movement in the North dropped out of memory because the events in the South that summer were so dramatic. News of the World's Fair protests was displaced on newspaper front pages (in the *New York Times* as well as Harlem's *Amsterdam News*) by the arrival in the Deep South of white volunteers for Freedom Summer, and, in June, by the disappearance and horrible murders of civil rights activists James Chaney, Andrew Goodman, and Michael Schwerner.

I don't think that the Freedom Riders themselves were a great draw of attention away from the northern movement or the protests at the fair. For people who were steeped in the movement, especially people affiliated with CORE (which organized the first Freedom Rides in the late 1950s and in 1961), there was not the same gap between the southern and northern struggles that is often in people's memories today. The Freedom Riders were people who were willing to go south in integrated groups to test the federal government's willingness to enforce national laws that mandated an end to Jim Crow in interstate travel. They were the same kinds of activists who were willing to join interracial groups in the protests at the World's Fair.

1. Martin Luther King Jr., "The School Boycott Concept," *Amsterdam News*, April 1, 1964, 10.
2. Martin Espada, "The Sign in My Father's Hands," *Imagine the Angels of Bread* (New York: W. W. Norton and Company, Inc., 1996), 27.
3. Robert Moses to Elmer Carter, July 12, 1961. Robert Moses papers, Manuscripts and Archives Division, The New York Public Library, Box 121.

Two parallel civil rights demonstrations hoped to leverage the publicity surrounding the opening day of the World's Fair. The "stall-in" (mentioned frequently in newspapers in the days leading up to the fair) was an attempt to back up traffic on feeder roads around the fair spearheaded by the Brooklyn chapter of Congress for Racial Equality (CORE). Pickets and sit-ins at the fair pavilions themselves, one of which is pictured here, took place during the opening speeches and were organized by national CORE.

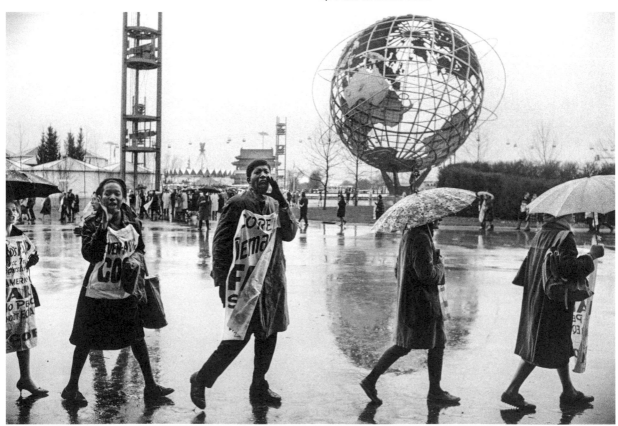

"Everything I did had to do with freedom of expression—freedom of expression in the arts."

Diane di Prima is a San Francisco–based writer and poet. Often associated with the Beats, she was a driving force in New York's downtown countercultural scene throughout the 1960s. She founded the New York Poets Theater with LeRoi Jones and dancer Freddie Herko, who appeared in Warhol's *Thirteen Most Beautiful Boys*, *Haircut*, and other films, and whose dramatic October 1964 suicide represented a turning point for their milieu. With the Poets Theater a police target in the lead-up to the World's Fair, di Prima was active in protests at the time. In her interview with project assistant curator **Anastasia Rygle**, di Prima touches on sexuality, drug use, and her friendship with Herko as well as Billy Name, and evokes divisions in the avant-garde between a humanist, egalitarian ethos and the newly emerging, harder edge of Pop.

Anastasia Rygle

To begin, can you tell us about your situation in 1964?

Diane di Prima

I was thirty. I had three kids by then, and many books, and presses, and theaters, and god knows what else. Now I read what I did then, and I can't imagine anyone doing it now, me or anyone else.

AR

What was the thing you cared most about?

DP

I can't say most, but everything I did had to do with freedom of expression—freedom of expression in the arts.

In preparation for our conversation, I was thinking about the whole Warhol scene, which is why I pulled out this book, which never got published. It's a book I wrote to Freddie Herko, to let him go. I wrote it during the year after he died, as a way of dealing with the situation.

I would go up to my study and light a stick of incense. I would write as long and as steady as I could until that whole thing burnt out and then I would drop it for the day and go away. So the writing is in little chunks. I had long wanted to do a book that was organized by the seasons, because my editor had remarked that I was very involved with the seasons. So I called it *Spring and Autumn Annals*, which is an ancient Chinese way of keeping the court records. It went through fall, winter, spring, summer, and fall. I wrote through the seasons; not every day, but when I could,

and I stopped on the day of his death, a year later. I pulled it out because there might be things we can look up or refer to, things that might give you a sense of that time.

AR

You were a close friend of Freddie's, perhaps his closest friend. Can you speak about when you first met him, and your relationship?

DP

I met Freddie after I had dropped out of school, after a year of college. I was living alone on the Lower East Side, and I hung out in Washington Square Park. It was either 1952 or 1953. He was sitting on a bench in the rain by himself, and I sat down next to him, and we began to talk. It was pretty rainy, and I had a little bit of money and I said, "Let's go to Rienzi's." There weren't so many coffeehouses then; that happened later. There was Rienzi's and a few other Italian ones, which I liked, but they weren't inclined to having beatniks hanging around all the time. They tolerated me because I was Italian and I knew a few words. Freddie and I went to this one coffeehouse and we talked for a long time. From then on we began to be friends, but I don't know how we arranged to see each other again. He was still living in Ossining at the time, where his family lived.

I moved to an apartment on Fifth Street between Avenue A and Avenue B. It was only three or four rooms, but lots of people lived in it with me at different times. It was always full, and whoever needed a place to stay would come by, because I would always let people sleep on the floor, and I would always have at least one roommate.

Freddie stayed there for an interval while he was still living in Ossining. He was supposed to be a pianist; he was going to Julliard. He took one dance class at Julliard because it was required, and it turned out that he loved it, so he wanted to change majors. But his parents were not willing to pay for him to change majors, so at some point he dropped out of school. He started taking dance classes all over town, like at the Ballet Theatre and the various schools. He studied with everybody he could get into a class with. Some of the classes were really picky those days, you had to be in a company to get into them, so he studied anywhere he could.

I think one of the big problems of Freddie's life was that he could never get into a company—his dance just wasn't that classical. Maybe it was his line, or maybe they thought he was too

untrained. Or maybe it was his lifestyle. I don't know what it was, but he could never get in. He really just wanted to get a job in a regular company. Instead he made a lot of really beautiful pieces and ended up killing himself in 1964. So those years, from when I first left school in 1951 to 1964, we were the tightest of friends. He was my confidante every day until he met Alan Marlowe, who I later married for no good reason and had two wonderful kids with. But Alan was completely insane, and I mean that literally.

AR

Was it really the case that sexuality was a much more fluid concept in the 1960s?

DP

For me and for some of the people I knew, it didn't really matter what the sex of somebody was—if you wanted to sleep with them, you did. Sex was a way of learning, a journey into someone, so you came closer to them and knew them and their life better. And if they were a woman or a man or they liked this or that, that was just part of it, that is what you were learning. It wasn't so much, "Now I'm being gay, now I'm being straight." At least that's how it was for me.

Some people were secret, the people who had regular jobs. I remember the forlornness of this. There were certain bars they went to, Lenny's Hideaway, which is on the same block where Stonewall happened. I was there one New Year's Eve with my friend Joan O'Malley, and the guys kissing there were so sad, they seemed so frightened and alone. Everyone else, they were what they were. They were that publically and in your face, and it didn't matter because they didn't care. It depended on whether you had a lot at stake. I've written about this: in the arts, if you have something to lose, you're a loss. You have to have already decided to give it all up so you can just work. Then you can do anything.

AR

What role did being a woman play in your social and professional life?

DP

It sort of annoyed the other women I was friends with, like Hettie [Jones, wife of poet LeRoi Jones]. All they wanted was a nice house, the dishes, to be married to a famous writer.

AR

Were there any other female writers in your circle?

DP

There were, but they were there briefly and then they would disappear. Like this woman I write about who I met at a party at Roi's [LeRoi Jones]. She was around for a while, and then she never showed up again anywhere. I saw her one day being a prostitute on Second Avenue under the El. I was in a cafeteria and I saw her on the street. Her name was Lee.

Women were also getting locked up a lot; their parents would send them away for having a baby or this and that. They would also happen to be writers or painters. Women were disappearing from the scene often, and you didn't get a chance to stay friends with them.

AR

Speaking of friends, in addition to being close friends with Freddie Herko, you were also close with Billy Name.

DP

I've known Billy a long, long time. He saved my life at one point. He made macrobiotic food for me. I saved his life, two times at least. The first time was around 1962, and then years later he showed up at another house I had, to recover from years of Andy. It was around 1970, I think, after the Holy Ghost had told him to leave Andy forever. That was when he left everything behind. He was completely out of his mind. He read the same page of the same book for several months: page thirty-seven of *Esoteric Astrology* by Alice Bailey. He would see things in the air and he would catch them. This went on for months and months. I gave him a place to sleep and didn't ask many questions. Sometimes we took him with us to Tibetan meditation. He is a wonderful man. He took really interesting photographs of all that stuff that was going on, all those stills of Andy's movies.

AR

Speaking of movies, you were actually the star of a short Warhol film, *Alan Marlowe/Diane di Prima*. What was that experience like?

DP

Yes, very short. He came over; we did a three-minute movie. I've never seen it—did it ever show up anywhere? Alan loved to sleep with that animal skin. Someone had given it to him. I'm stomping on him. In my mind I had a nice image of Kali dancing on the body of Shiva. I don't know what was in Alan's mind. I was mad at Alan—it was nice to stomp on him.

AR

Did Warhol give you any direction?

DP

No. He just set up the camera. Our bedroom was just a bed

under the eaves; I don't think he could have gotten anyone in there. There was nothing to do in bed but lie in bed. The way the house was, it was eaves upon eaves. Some parts were bigger than others and the bedroom was the tiniest little part of the house.

AR

Was that the first time you met Andy?

DP

No, I knew Andy a whole bunch. I just didn't hang out with that crowd because I wasn't comfortable with Andy.

AR

Why?

DP

I always felt like he was using people. I think also that the aesthetic was so far from mine that I didn't know what to do with it. I wouldn't have been able to verbalize that then, but I can see it now. Whenever I was there at his studio, whoever was there wanted to draw me out and involve me in whatever was going on, and I didn't want that. I think I was just thinking, "What's going on here?"

AR

And how did you feel about it?

DP

I felt a hierarchy there, and all the scenes I hung out in were fiercely—more than they needed to be—egalitarian, to the point where I egalitarianized everything, even my family life.

AR

Many of Warhol's films were screened at the New York Poets Theater. What was your experience of watching his films?

DP

I saw *Haircut 1*; I screened it. I remember the movies where he shot people sleeping, and the movie of just the Empire State Building. I remember it as the Chrysler Building, which I loved more as a building, shape-wise. We were in the habit of going to things where you could hang out, and stay at, stay there while it happened and happened and happened. You would write.

Did anyone talk to you about La Monte Young's performances? They would go on for twelve hours! We would bring pillows and blankets, people would sleep, people would write, you would go away and come back, people would get sandwiches. The thing would go on and on. You would go for the day, bring lunch, bring your mistress, probably make love, I don't know.

AR

Were there a lot of drugs involved in that scene, amphetamines for example, influencing artistic production? Did they contribute to the aesthetics of the time in any way?

DP

Everyone did them. I remember my aunt used to give my brothers bottles of a thousand when they were in college, because it would help them concentrate. It was all over the place. I would watch someone make a drawing all night then erase it. Not everybody was productive. Michael Smith, who was a theater critic for the *Village Voice*, covered a whole wall of his apartment with one-cent stamps of George Washington. Johnny Dodd made murals on the walls, American Indians, and the ceiling had angels, like the three worlds.

I wrote a lot while on amphetamines. Once, I wrote all night, and I looked down and the pill was still next to my typewriter. So I realized that the mind was what was doing it, not the pill. After a while I started putting methedrine in my coffee, and that finally burned out my stomach. And then Billy rescued my stomach by teaching me to cook macrobiotically. The people that managed not to destroy everything they made or not end up with a mess on their hands were people that were very focused and very creative. Everybody else was like, "Okay, what should we do with this now?" And they would wake up a few days later with this mess in their house and do it again. You had to really care about the idea of work.

AR

Can you tell me about your experience working with Jack Smith and the role you played in his film *Normal Love*, where you are listed in the credits as "Pregnant Cutie"?

DP

I was on that cake. It was filmed the night before Alexander was born, my third child. I think he probably would have come a couple of weeks later if I hadn't fallen off the cake so many times. The mummy would come out of the woods and we would all fall off the cake.

Jack was . . . well, there were the drugs, for one thing. There was a lot of stuff going on for Jack. His work never got to the stage. You can't see the work separate from the person; it's all one thing. I had a lot of fun, and not just being there in the film. Up there at Wynn's, I wished I had had a camera real bad, just to photograph the various people in various situations in a costume, sewing a costume, or stark raving naked 'cause it was summer and easy. It was just a beautiful scene, with a lot of beautiful

people in it. Making films with Jack was lots of fun. He made you do the same thing over and over: fall off the cake a thousand times.

AR

It sounds like many friendships arose from these artistic collaborations.

DP

For a lot of us in New York, the friendship was based on the work. You didn't really ask questions or care about the rest of anybody's life, so long as you cared about what they were making. Our discussions were always about each other's work.

AR

In 1964, *Flaming Creatures*, Jean Genet's *Un Chant d'amour*, and a short film by Andy Warhol titled *Andy Warhol Films Jack Smith Filming Normal Love* were screened at your Poets Theater and raided by the police. Can you talk about this?

DP

We had a theater, the New York Poets Theater. A lot went through there, not only the plays we were doing but also one night a week there was music, one night there were movies, etc. Alan Marlowe had found the space, a small theater on St. Marks Place off of Third Avenue.

[Di Prima reads from *Spring and Autumn Annals*]

Last night I went with Alan to look at our new theater. Red walls, red satin curtains, a theater made by someone who loves old theaters. The wrought-iron work on the seats, something you should see, you would delight in it. The silence of space of even a small theater at night. The spaces, you fill them somehow, your strident demanding voice, your habit of moving incessantly, talking incessantly, the way you would have tried out the stage, all your advices, mostly unsought and unheeded. What a dancer needs spelled out again and again. That bag of rags that we threw scornfully out not even looking into it for schmattas. The hundreds and hundreds of theaters we worked in together, in Off-Broadway galleries always cold. Joanna always having hysterics on that black stage—that was Joanna Bishop, the Merce Cunningham dancer—about the cold and her hepatitis, the fights you and Alan had in the back of that house. Black walls, no heat, ever, in the radiators. John Wieners arriving, shy, to see his play. You and I playing *Discontent of the Russian Prince* together.

This was a play I wrote for him and me. It wasn't about anything, it was about getting up in the morning. It's the only play of mine that had a plot and the plot was getting up in the morning.

We rented it for a four-month season, February to May. I was there with Jonas Mekas [who had co-organized the screening] when we showed the Genet film. Jonas and I were arguing which one of us should get busted that night. "No! No! Take me!" "No! No! Take me!" So I think they ended up taking him, and we wound up doing the case. My husband and I hired a lawyer that we didn't have to pay named Michael Standard, who was doing a lot of civil liberties stuff at that point.

In fact my father, who was a very unknown lawyer, worked with his law-school friend and so-called partner on research for the case. My "Uncle" Bill was part of a Tammany Hall gang—he's my godfather, literally—and I would ask him what to do in a situation and he would find out. He found out who the judge was and what the judge needed to hear so that it would be on the record in a certain way. Bill talked to the judge ahead of time, and he told me that there was a particular way that I was supposed to word things, and I memorized it.

AR

This wasn't the first time you were arrested on obscenity charges—

DP

No, the first time was in 1961. Me and LeRoi were arrested for two pieces in the ninth issue of *The Floating Bear*, a piece by Burroughs and a piece of his. Actually, Roi was taken down to jail, but I wasn't, because I wouldn't open my door. It was early in the morning and his wife opened the door, and they not only took Roi but they took all of his mailing lists and everything on top of his desk. I don't know if he ever got it all back.

By the time I figured out what was happening—because I never opened my door before noon, it was always going to be trouble in New York at that point—me and my little daughter went up the fire escape to Freddie Herko's apartment upstairs and stayed there while they knocked at my door. Then they went away, and I came back downstairs and got all dressed up so I would look good in court. Freddie came down with Jeannie, my daughter, and explained to her that mom has to go downtown and explain some stuff to some very stupid men who didn't understand something she had published. That was OK with Jeannie, so she went back upstairs with Freddie. That was the biggest trauma of her life when he killed himself. They were very tight.

AR

How did they even find out about the ninth issue of the *Bear*?

DP

The Floating Bear only went out to a mailing list; you couldn't buy it, you could only get it if we wanted you to. But one of the people we were sending it to was a black poet in a prison in New Jersey. The warden read the thing and thought, "Oh dear." The Burroughs piece had a supreme court of baboons who were all fucking Roosevelt in the butt or something like that, and the warden didn't like that for some strange reason. So they reported it to the FBI. It was a federal thing because it was the mail, blah, blah, blah.

AR

Let's talk about the World's Fair. Do you remember going to the World's Fair in New York?

DP

I don't think I went to it, though I do remember the preparation for it. We did a march from the Poets Theater to Lincoln Center. We protested the fact that the city had cleaned up the streets, taken all the beggars off the street, in preparation for the fair.

AR

How many people participated in the protest?

DP

Between fifty and two hundred; people would join in and walk away. We were dragging coffins all the way from downtown. We left all this garbage, coffins and things, right in front of Lincoln Center for them to deal with. We extinguished a lot of lit candles in the fountain. There is a photo of Alan Marlowe taken by Peter Moore, where he is wearing a sign that reads "New York is a Summer Police State."

AR

Did anyone try to stop you? Was this the only protest that you remember?

DP

As far as that cleanup goes, I helped organize a general strike. We did lots of protesting, but it was different each time. Organizing a general strike with The Living Theatre is a performance in itself.

AR

So in the sixties, there was definitely a sense of a police state? When did that end?

DP

You know, I don't know if it stopped or people just decided not to give a damn. As the acid thing and the psychedelic thing got bigger, people were just . . . I moved out here in 1967 and then I left the city for the country in 1970, because the FBI was coming to my door every night at dinnertime and banging at the door. Everybody at the dinner table was wanted for something: draft, or censorship in Detroit, or something else. The only one we could send to the door was one of the kids, and it was usually my daughter Jeannie, who by then was about thirteen. She would go to the door and say, "Nobody here wants to talk to the FBI." She would say this through the closed door until they went away. But that got kind of boring, so I moved to the countryside up north.

I don't think it stopped, really, until the mid-seventies. People finally gave up or lost interest or something. All of us, well, by then we figured we didn't have to be in one place. We were comfortable in a vast variety of situations, because that's one of the things that LSD allows you to do, makes you able to live in the countryside, makes you desire to get back to a root kind of mind. So you go anywhere, you do anything. Join any group of people and do it another way.

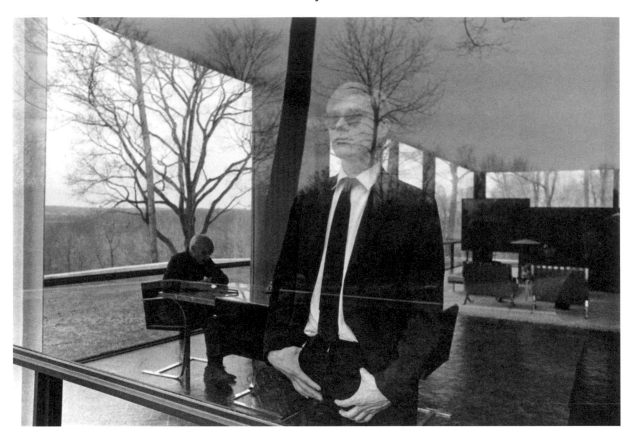

Here Warhol visits Philip
Johnson's Glass House where
the architect lived with David
Whitney, his long-time partner,
a curator and connector in his
own right and a close friend of
Warhol's. Constructed in 1949
in New Canaan, Connecticut,
the Glass House was designed
by Johnson as his own
residence. He also dotted the
grounds with architectural
experiments including "The
Bunker"—a private viewing
room in which artworks in his
collection, including several by
artists also on the New York
State Pavilion, were shown on
movable walls.

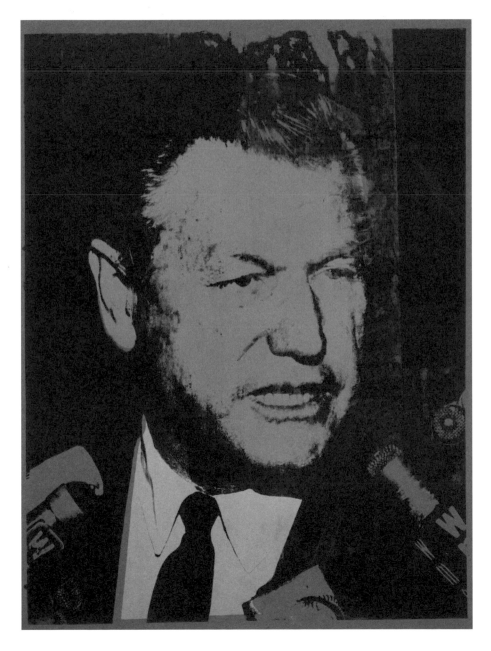

Although Philip Johnson named Nelson Rockefeller, moderate Republican governor of New York State from 1959 to 1973, as the source of the order to cover over Warhol's *Thirteen Most Wanted Men*, three years later the billionaire collector commissioned Warhol to make this portrait of himself and, in 1968, a multiple portrait of his second wife, Happy. It is unknown whether Warhol knew at the time about Rockefeller's role in the incident at the New York State Pavilion.

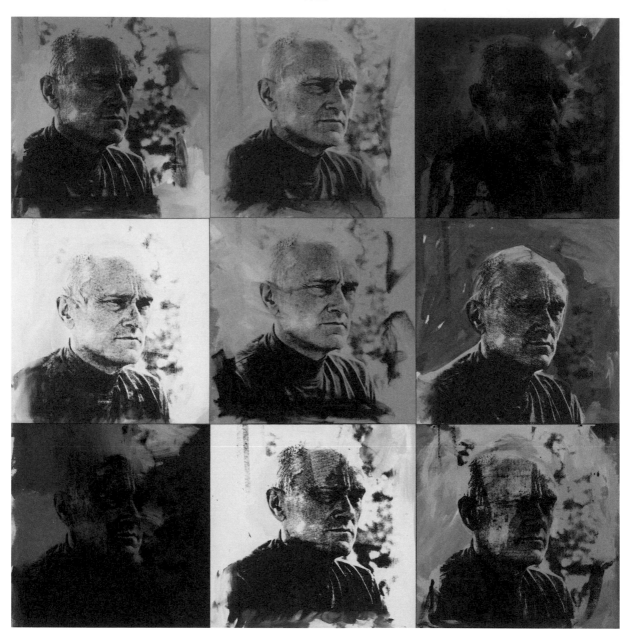

Warhol and Philip Johnson
remained associates until
Warhol's death in 1987. The
source for Warhol's 1972
portrait of Johnson is a
photograph of the architect
taken by Bruce Davidson
during the summer of 1964.

Biographies

Hilary Ballon is an architectural and urban historian at NYU. In 2012 she received the American Academy of Arts and Letters Award in Architecture. Her publications include *The Greatest Grid: The Master Plan of Manhattan 1811–2011* (2012), *Robert Moses and the Modern City* (2007), *New York's Pennsylvania Stations* (2002), *The Paris of Henri IV: Architecture and Urbanism* (1991), and *Louis Le Vau: Mazarin's Collège, Colbert's Revenge* (2001). She has curated several exhibitions on the urban development of New York, including exhibitions on Manhattan's grid on the bicentennial of its design and a reevaluation of Robert Moses's impact on New York City. In addition to her roles as University Professor and Professor of Urban Studies and Architecture at the Robert F. Wagner Graduate School of Public Service, Ballon is Deputy Vice Chancellor of NYU Abu Dhabi.

Nicholas Chambers is the Milton Fine Curator of Art at The Andy Warhol Museum, Pittsburgh and cocurator (with Larissa Harris) of "13 Most Wanted Men: *Andy Warhol and the 1964 World's Fair.*" He recently led the development of a new installation of The Warhol Museum's collection galleries, and he regularly consults on the development of Warhol exhibitions internationally. Chambers has also curated numerous solo exhibitions by contemporary artists including Genesis Breyer P-Orridge, Yasumasa Morimura, Spencer Finch, Pierre Bismuth, Katharina Grosse, and Santiago Sierra. He is currently developing a project with John Armleder and an exhibition analyzing the relationship between Warhol's work and the advertising industry.

Douglas Crimp is Fanny Knapp Allen Professor of Art History at the University of Rochester and the author of *On the Museum's Ruins* (1993), *Melancholia and Moralism: Essays on AIDS and Queer Politics* (2002), and *"Our Kind of Movie": The Films of Andy Warhol* (2012). Crimp was the curator of the "Pictures" exhibition at Artists Space in 1977 and an editor of *October* magazine from 1977 to 1990. With Lynne Cooke, he organized the exhibition "Mixed Use, Manhattan: Photography and Related Practices, 1970s to the Present" for the Reina Sofía in Madrid in the summer of 2010. He is currently completing a memoir of New York in the 1970s called *Before Pictures*.

Diane di Prima is a feminist poet, writer, editor, publisher, and teacher. She was a member of the emerging Beat movement of the 1950s, and coeditor, with LeRoi Jones, of the literary magazine *The Floating Bear* (1961–69). She cofounded the Poets Press and the New York Poets Theater, and founded Eidolon Editions and the Poets Institute. A follower of Buddhism, she is also cofounder of the San Francisco Institute of Magical and Healing Arts. Di Prima has published more than forty books, including the poetry collections *This Kind of Bird Flies Backwards* (1958) and *Pieces of a Song: Selected Poems* (2001), the short story collection *Dinners and Nightmares* (1960), the semi-autobiographical *Memoirs of a Beatnik* (1968), and the memoir *Recollections of My Life as a Woman: The New York Years* (2001). In 2009 di Prima was named Poet Laureate of San Francisco. She has been the recipient of the National Poetry Association's Lifetime Service Award, the Fred Cody Award for Lifetime Achievement, and an honorary doctorate from St. Lawrence University.

Richard ("Dick") Elman (1934–1997) was a novelist, poet, critic, and journalist. Elman published more than twenty books of fiction, nonfiction, and poetry, including *The Poorhouse State: The American Way of Life on Public Assistance* (1966), *Taxi Driver* (1976), and the comic novel *Tar Beach* (1991). He was Director of Public Affairs for WBAI-FM New York from 1961 to 1964, where he produced a number of radio documentaries. Elman taught at Bennington College Summer Writing Workshops in Vermont, as well as Columbia University, Hunter College, Sarah Lawrence College, the University of Pennsylvania, the University of Michigan at Ann Arbor, and Notre Dame University.

Tom Finkelpearl is Commissioner of the Department of Cultural Affairs of New York City. From 2002 to 2014, he was President and Executive Director of the Queens Museum. Prior to joining the Queens Museum, he spent twelve years at MoMA PS1, where he organized fifteen exhibitions in the 1980s, returning in 1999 as Deputy Director. He worked as Director of New York City's Percent for Art Program (1990–96), where he organized over 130 public art projects, and as Executive Director of Program at Skowhegan School of Painting and Sculpture (1996–1999). He is the author of *Dialogues in Public Art* (MIT Press, 2000) and *What We Made: Conversations on Art and Social Cooperation* (Duke University Press, 2013). He received a BA from Princeton University in 1979 and an MFA from Hunter College in 1983.

Albert Fisher is a National Emmy–winning television executive. He was involved in television for World's Fairs in Seattle, New York, and Montreal. Fisher was a Producer of the 1964 and 1965 opening-day network "specials" as well as Producer/Director of the official radio series for the 1964 New York World's Fair. He is currently in production on a PBS television special called *Remembering Tomorrow*, which celebrates New York's two World's Fairs. Fisher has garnered festival awards in Cannes, New York, London, Chicago, Barcelona, Locarno, and Edinburgh. He has also received the Columbia School of Journalism's Alfred I. DuPont Award; the Distinguished Service Award from the Caucus for Producers, Writers and Directors; and awards from

the American Bar Association and the International Film and Television Festival. He was cited for his work in the entertainment industry by the United States Congress.

Brian L. Frye is an Assistant Professor of Law at the University of Kentucky College of Law. His legal scholarship focuses on issues affecting artists and arts organizations, and his critical writing on film and art has appeared in *October*, *The New Republic*, *Film Comment*, *Cineaste*, *Senses of Cinema*, and *Incite!*, among other journals. In 2013, Frye coproduced the documentary film *Our Nixon*. His short films have appeared in the Whitney Biennial 2002 and the New York Film Festival and are in the permanent collection of the Whitney Museum of American Art. He is currently working on *The Winds & the Waves*, a documentary history of the representation of the gay rights movement, and *Andy & Julia*, a narrative feature about one day in the life of Andy Warhol and his mother Julia Warhola.

John Giorno is a poet, visual artist, writer, and performer. Giorno graduated from Columbia University in 1958 and was the "star" of Warhol's film *Sleep*. He has collaborated with William Burroughs, John Ashbery, Ted Berrigan, Patti Smith, Laurie Anderson, Philip Glass, Robert Rauschenberg, and Robert Mapplethorpe, and in the 2000s with Rirkrit Tiravanija, Pierre Huyghe, Elizabeth Peyton, and Ugo Rondinone, who is his partner. He is the author of ten books, including *You Got to Burn to Shine* (1994), *Cancer in my Left Ball* (1973), *Grasping at Emptiness* (1985), *Suicide Sutra* (1973), and *Subduing Demons in America* (2008), and has produced fifty-nine LPs, CDs, cassettes, and DVDs for Giorno Poetry Systems, an artist collective and record label he founded in 1965. He founded the AIDS Treatment Project and has been active in the development of Tibetan Buddhism in the West.

Anthony E. Grudin is Assistant Professor of Art History at the University of Vermont. He has two forthcoming books on Warhol. His essays have appeared in *Warhol: Headlines* (National Gallery, 2011), *October*, and *Oxford Art Journal*. He is coeditor with Jonathan Flatley of a special Warhol issue of *Criticism*, and is cocurating an exhibition on the Pictures Generation with DJ Hellerman.

Larissa Harris is Curator at the Queens Museum and cocurator (with Nicholas Chambers) of "13 Most Wanted Men: *Andy Warhol and the 1964 World's Fair*." At the Queens Museum she has organized a variety of exhibitions, such as *Red Lines Housing Crisis Learning Center* with Damon Rich and the Center for Urban Pedagogy (CUP) (2009); the first US museum show of Korean artist Sung Hwan Kim (2011); QM's biennial, "Queens International 2012"; a retrospective and new projects with the performance

group Los Angeles Poverty Department (LAPD) (2014); and a major new work with Mexican artist Pedro Reyes, *The People's United Nations (pUN)* (2013–14). In addition, she helped organize a studio and artist services program at the Queens Museum, and an artist residency in Corona, Queens.

Dr. Felicia Kornbluh is Associate Professor of History at the University of Vermont, where she directs the Gender, Sexuality, and Women's Studies Program. She is the author of *The Battle for Welfare Rights: Poverty and Politics in Modern America* (University of Pennsylvania Press, 2007). Kornbluh has written for journals and other publications including *Feminist Studies*, the *Journal of American History*, *The Nation*, the *Women's Review of Books*, and the *Los Angeles Times* op-ed page. She holds a PhD in history from Princeton University and a BA from Harvard-Radcliffe. A native of New York City, she began her scholarly career at Hunter College High School in Manhattan. Kornbluh is currently writing about the African American, women's, LGBT, and disability rights movements in a book entitled *Constant Craving: Economic Justice in Modern America*. She is also writing, with Audra Jennings, *Rethinking the Disability Rights Movement*, which will be published in 2016 by Routledge.

Gerard Malanga is an American poet, photographer, filmmaker, curator, and archivist. He is the author of a dozen books of poetry spanning a thirty-five-year period. His work has appeared in *Poetry*, *Paris Review*, *Partisan Review*, and the *New Yorker*. Malanga worked closely with Andy Warhol during the mid-'60s. Malanga's other works include *The Angus MacLise Checklist* (1981), *Scopophilia: The Love of Looking* (1985), *Up-Tight: The Velvet Underground Story* (1983, coauthored by Victor Bockris), *Tomboy & Other Tales* (Bottle of Smoke Press, 2014), *Malanga Chasing Vallejo, César Vallejo Selected Poems* (Three Rooms Press, 2014), *Three Diamonds* (1991), *Mythologies of the Heart* (1996), four books of photography, and two spoken-word audio compilations.

Jonas Mekas was born in Lithuania in a farming village. After WWII, liberated from a German forced-labor camp, in 1949 he landed in New York, where he began to film. In 1954, together with his brother Adolfas, he began publishing *Film Culture* magazine. In 1958, he started the Movie Journal column in the *Village Voice*. In the following years, he established the Film-Makers' Cinematheque and the Film-Makers' Cooperative, and helped to create Anthology Film Archives. He has published a dozen volumes of poetry and prose. His films, art, and installations have been shown at the Venice Biennale, Documenta, Museum Ludwig, the Centre Pompidou, and the Serpentine Gallery, among other museums and institutions. His film work include

such titles as *The Brig* (1964), *Walden* (1968), *Reminiscences of a Journey to Lithuania* (1971), *Lost Lost Lost* (1976), *As I Was Moving Ahead Occasionally I Saw Brief Glimpses of Beauty* (2001), and most recently, *Outtakes from the Life of a Happy Man* (2012).

Timothy Mennel is Senior Editor at the University of Chicago Press, where he acquires titles primarily in American and urban history. He has held editorial positions at the American Planning Association, Random House, The Andy Warhol Foundation for the Visual Arts, and *Artforum*, and he has been a consultant to the Rockefeller Foundation, the Municipal Art Society of New York, and the Museum of the City of New York. He coedited *Reconsidering Jane Jacobs* (2011), which included his essay on Jacobs and Andy Warhol, and *Block by Block: Jane Jacobs and the Future of New York* (2009). His 2007 dissertation in geography at the University of Minnesota was a novel that reconsidered the life and import of Robert Moses.

Richard Meyer is Robert and Ruth Halperin Professor in Art History at Stanford University. He is the author of *Outlaw Representation: Censorship and Homosexuality in Twentieth-Century American Art* (Oxford University Press), which was awarded the Charles Eldredge Prize for Outstanding Scholarship from the Smithsonian American Art Museum. In 2013, he published *What Was Contemporary Art?* (MIT Press), a history of the idea of contemporary art in early twentieth-century America, and *Art & Queer Culture* (Phaidon), a survey coedited with Catherine Lord on visual art and nonnormative sexuality from the late nineteenth century to the present. In 2011–12, Meyer guest-curated the exhibition "Naked Hollywood: Weegee in Los Angeles" at the Museum of Contemporary Art in Los Angeles.

Billy Name (William Linich) is a photographer, filmmaker, and lighting designer. Name lived and worked at Andy Warhol's Factory from 1964 to 1970, where he was responsible for silvering the space and acting as Warhol's archivist and photographer. He began his career as a lighting designer in the theater in 1960, illuminating the likes of dancers Lucinda Childs, Yvonne Rainer, Merce Cunningham, and Freddie Herko at spaces such as Judson Memorial Church, New York Poets Theater, and The Living Theatre. Name taught himself the technical aspects of photography after receiving Warhol's Honeywell Pentax camera as a gift. His brief romance and subsequent friendship with Warhol led to collaboration on Warhol's films, paintings, and sculpture. A comprehensive collection of Name's photographs will be published in a two-volume edition by Reel Art Press in late 2014.

Brian Purnell teaches Africana Studies and History at Bowdoin College. He is the author of *Fighting Jim Crow in the County of Kings: The Congress of Racial Equality in Brooklyn* (University Press of Kentucky, 2013). He lives in Brunswick, Maine, with his wife Leana and their four children, Isabella, Gabriel, Lillian, and Emilia.

Anastasia Rygle is an independent curator and writer based in New York City. Before joining the *13 Most Wanted Men* exhibition team, she worked at numerous institutions including The Andy Warhol Museum, the Carnegie Museum of Art, the Württembergischer Kunstverein Stuttgart, and the Dia Foundation for the Arts. She completed a master's degree at the Center for Curatorial Studies, Bard College, with a thesis on "Ray Johnson: The Dover Street Years, 1953–1960." Additionally, at Bard, she organized an exhibition of the same title that featured over sixty rarely seen early works by Johnson. Rygle is currently at work on a series of essays that consider the artistic output of artists who lived in the area known as Coenties Slip in Lower Manhattan in the 1950s. She is also working on a two-volume edition of Billy Name's photographs with Dagon James, as well as preparing a manuscript on the subject of Ray Johnson for publication.

Eric Shiner is the Director of The Andy Warhol Museum, located in Pittsburgh, PA. In 2012, Shiner organized "Factory Direct: Pittsburgh," showcasing the work of fourteen established contemporary artists invited to participate in residencies in Pittsburgh-based factories, as well as "Andy Warhol: 15 Minutes Eternal," the largest traveling exhibition of Warhol artwork in Asia. Shiner curated the 2013 Armory Focus: USA at the Armory Show, which presented a broad picture of the country's contemporary cultural practice. Shiner is a scholar of contemporary Japanese art and a leading authority on Andy Warhol. He received a bachelor's degree in philosophy in the history of art and architecture and Japanese language and literature from the University of Pittsburgh Honors College in 1994, a master's degree in art history from Osaka University in 2001, and a master's in art history from Yale in 2003.

Richard Norton Smith, a 1975 graduate of Harvard College, is author or coauthor of eleven books, among them a Pulitzer-finalist biography of Thomas E. Dewey, and biographies of George Washington, Herbert Hoover, and Chicago Tribune publisher Robert R. McCormick. He has served as a Capitol Hill and White House speechwriter, and Director of five presidential libraries—Hoover, Eisenhower, Reagan, Ford, and the Abraham Lincoln Library and Museum in Springfield, Illinois. Smith is a frequent guest on C-SPAN, the PBS NewsHour, and ABC News, and

contributor to publications such as *Time*, *Life*, and the *New York Times*. He is currently a Scholar in Residence at George Mason University, and his book *On His Own Terms: A Life of Nelson Rockefeller, a biography of the former New York Governor and Vice President*, was recently published by Random House.

Dr. Lori C. Walters is a Research Assistant Professor with a joint appointment with the Institute for Simulation & Training and Department of History at the University of Central Florida. She has served as the Principal Investigator on grants funded by the National Science Foundation, the National Endowment for the Humanities, and the State of Florida. Her research focuses on how digital environments can enhance interdisciplinary learning for elementary and middle-school children. Her most recent project addresses the 1964–65 New York World's Fair, *ChronoLeap: The Great World's Fair Adventure* (ongoing). Dr. Walters has also worked to gather oral histories of individuals who worked at Cape Canaveral in the 1950s and '60s.

Mark Wigley is an architectural historian, theorist, and critic, and most recently Dean of Columbia University's Graduate School of Architecture (2004–2014). Wigley cocurated, with Philip Johnson, the 1988 exhibition "Deconstructivist Architecture" at the Museum of Modern Art. He has also curated exhibitions at the Witte de With in Rotterdam, the Drawing Center in New York, and the CCA in Montreal. He is a founder of *Volume Magazine*, and his publications include *The Activist Drawing: Retracing Situationist Architectures from Constant's New Babylon to Beyond* (coedited with Cather de Zegher, 2001), *Constant's New Babylon: The Hyper-Architecture of Desire* (1998), *White Walls, Designer Dresses: The Fashioning of Modern Architecture* (1995), and *The Architecture of Deconstruction: Derrida's Haunt* (1993).

Photo Captions

p 8
Patrick A. Burns
Thirteen Most Wanted Men *by Andy Warhol on Facade of New York State Pavilion Theaterama*, 1964
Digital print
© The New York Times/Redux

pp 15 – 18
"The Thirteen Most Wanted," Police Department, City of New York, 1962
Printed ink on coated paper
Collection of The Andy Warhol Museum, Pittsburgh; Founding Collection, Contribution The Andy Warhol Foundation for the Visual Arts, Inc.

p 19
Andy Warhol
Ethel Scull, 1963
Photo-booth photographs
7 7/8 × 1 5/8 in. (20 × 4.1 cm.)
Collection of The Andy Warhol Museum, Pittsburgh; Founding Collection, Contribution The Andy Warhol Foundation for the Visual Arts, Inc.

p 20
Andy Warhol
Little Electric Chair, 1964-1965
Silk-screen ink on linen
22 × 27¾ in. (55.9 × 70.5 cm.)
Collection of The Andy Warhol Museum, Pittsburgh; Founding Collection, Contribution The Andy Warhol Foundation for the Visual Arts, Inc.

pp 21 and 22
Andy Warhol
Most Wanted Man No. 1, John M., 1964
Silk-screen ink on linen
48 × 40 in. (122 × 101.5 cm)
Collection of Herbert F. Johnson Museum of Art, Cornell University. Acquired with funds provided by the National Endowment for the Arts, and through the generosity of individual donors.

p 29
Billy Name
Interior of the Factory with Most Wanted Men *and Box Sculptures*, 1964
Archival pigment print
Courtesy of Billy Name and Dagon James
© Billy Name

p 30
Billy Name
Andy Warhol on his Desk, 1964
Archival pigment print
Courtesy of Billy Name and Dagon James
© Billy Name

pp 31 and 32
Andy Warhol
Most Wanted Man No. 2, John Victor G., 1964
Silk-screen ink on linen
48 ½ × 37 1/8 in. (123.2 × 94.3 cm.) and 48 5/8 × 38 1/2 in. (123.5 × 97.8 cm.)
Collection of The Andy Warhol Museum, Pittsburgh; Founding Collection, Contribution Dia Center for the Arts

p 39
Letter (from Billy Name to Andy Warhol), ca 1965, pen on paper
Collection of The Andy Warhol Museum, Pittsburgh; Founding Collection, Contribution The Andy Warhol Foundation for the Visual Arts, Inc.

pp 40 and 41
Andy Warhol
Thirteen Most Beautiful Boys (41 *Screen Tests*), 1964–1966
Collection of The Andy Warhol Museum, Pittsburgh; Founding Collection, Contribution The Andy Warhol Foundation for the Visual Arts, Inc.
© The Andy Warhol Museum, Pittsburgh, PA, a museum of Carnegie Institute. All rights reserved

Row 1 (L to R)
Screen Test: Steve Balkin [ST14], 1964
16mm film, black and white, silent, 4.4 min. @ 16fps, 3.9 min. @ 18fps

Screen Test: Gregory Battcock [ST18], 1964
16mm film, black and white, silent, 4.5 min. @ 16fps, 4 min. @18fps

Screen Test: DeVerne Bookwalter [ST27], 1964
16mm film, black and white, silent, 4.5 min. @ 16fps, 4 min. @18fps

Screen Test: Boy [ST31], 1964
16mm film, black and white, silent, 4.5 min. @ 16fps, 4 min. @18fps

Screen Test: Walter Burn [ST35], 1964
16mm film, black and white, silent, 4.4 min. @ 16fps, 3.9 min. @18fps

Screen Test: Lawrence Casey [ST48], 1964
16mm film, black and white, silent, 4.5 min. @ 16fps, 4 min. @18fps

Row 2
Screen Test: James Claire [ST54], 1966
16mm film, black and white, silent, 4.5 min. @ 16fps, 4 min. @18fps

Screen Test: Roderick Clayton [ST57], 1966
16mm film, black and white, silent, 4.6 min. @ 16fps, 4.1 min. @18fps

Screen Test: Rufus Collins [ST61], 1964
16mm film, black and white, silent, 4.3 min. @ 16fps, 3.9 min. @18fps

Screen Test: Walter Dainwood [ST65], 1964
16mm film, black and white, silent, 4.4 min. @ 16fps, 3.9 min. @18fps

Screen Test: Walter Dainwood [ST66], 1964
16mm film, black and white, silent, 4.4 min. @ 16fps, 3.9 min. @18fps

Screen Test: Denis Deegan [ST73], 1964
16mm film, black and white, silent, 4.6 min. @ 16fps, 4.1 min. @18fps

Row 3

Screen Test: Kelly Edey [ST89], 1964
16mm film, black and white, silent, 4.5
min. @ 16fps, 4 min. @18fps

Screen Test: Kelly Edey [ST90], 1964
16mm film, black and white, silent, 4.7
min. @ 16fps, 4.2 min. @18fps

Screen Test: John Giorno [ST116], 1964
16mm film, black and white, silent, 4.4
min. @ 16 fps, 3.9 min. @18 fps

Screen Test: John Giorno [ST117], 1964
16mm film, black and white, silent, 4.4
min. @ 16 fps, 3.9 min. @18 fps

Screen Test: David Hallacy [ST126], 1964
16mm film, black and white, silent, 4.4
min. @ 16 fps, 3.9 min. @18 fps

Screen Test: David Hallacy [ST127], 1964
16mm film, black and white, silent, 4.5
min. @ 16 fps, 4 min. @18 fps

Row 4

Screen Test: Helmut [ST136], 1964
16mm film, black and white, silent, 4.4
min. @ 16 fps, 3.9 min. @18 fps

Screen Test: Freddy Herko [ST137], 1964
16mm film, black and white, silent, 4.6
min. @ 16 fps, 4.1 min. @18 fps

Screen Test: Dennis Hopper [ST153], 1964
16mm film, black and white, silent, 4.5
min. @ 16 fps, 4 min. @18fps

Screen Test: Dennis Hopper [ST154], 1964
16mm film, black and white, silent, 4.4
min. @ 16 fps, 3.9min. @18 fps

Screen Test: Peter Hujar [ST157], 1964
16mm film, black and white, silent, 4.4
min. @ 16 fps, 3.9 min. @18 fps

Screen Test: Kenneth King [ST179], 1964
16mm film, black and white, silent, 4.4
min. @ 16 fps, 3.9 min. @18 fps

Row 5

Screen Test: Kenneth King [ST180], 1964
16mm film, black and white, silent, 3.9
min. @ 16 fps, 3.5 min. @18 fps

Screen Test: Howard Kraushar [ST186],
1964
16mm film, black and white, silent, 4.6
min. @ 16 fps, 4.1 min. @18 fps

Screen Test: Larry Latreille [ST191], 1965
16mm film, black and white, silent, 4.5
min. @ 16 fps, 4 min. @18 fps

Screen Test: Joe LaSueur [ST192], 1964
16mm film, black and white, silent, 4.5
min. @ 16 fps, 4 min. @18 fps
Film still courtesy The Andy Warhol Film
Project, Whitney Museum of American Art

Screen Test: Billy Linich [ST194], 1964
16mm film, black and white, silent, 4.4
min. @ 16 fps, 3.9 min. @18 fps

Screen Test: Gerard Malanga [ST198],
1964
16mm film, black and white, silent, 4.6
min. @ 16 fps, 4.1 min. @18 fps

Row 6

Screen Test: Richard Markowitz [ST204],
1964
16mm film, black and white, silent, 4.4
min. @ 16 fps, 3.9 min. @18 fps

Screen Test: Richard Markowitz [ST205],
1964
16mm film, black and white, silent, 4.5
min. @ 16 fps, 4 min. @18 fps

Screen Test: Taylor Mead [ST209], 1964
16mm film, black and white, silent, 4.4
min. @ 16 fps, 3.9 min. @18 fps

Screen Test: Francois de Menil [ST212],
1965
16mm film, black and white, silent, 4.5
min. @ 16 fps, 4 min. @18 fps

Screen Test: Sophronus Mundy [ST227],
1964
16mm film, black and white, silent, 4.1
min. @ 16 fps, 3.7 min. @18 fps

Screen Test: John Palmer [ST254], 1964
16mm film, black and white, silent, 4.5
min. @ 16 fps, 4 min. @18 fps

Row 7

Screen Test: Robert Pincus-Witten [ST258],
1964
16mm film, black and white, silent, 4.5
min. @ 16 fps, 3.9 min. @18 fps

Screen Test: Bruce Rudow [ST287], 1964
16mm film, black and white, silent, 4.2
min. @ 16 fps, 3.7 min. @18 fps

Screen Test: Star of the Bed [ST327], 1964
16mm film, black and white, silent, 4.4
min. @ 16 fps, 3.9 min. @18 fps

Screen Test: Steve Stone [ST330], 1964
16mm film, black and white, silent, 4.4
min. @ 16 fps, 3.9 min. @18 fps

Screen Test: Paul Thek [ST337], 1964
16mm film, black and white, silent, 4.4
min. @ 16 fps, 3.9 min. @18 fps

Screen Test: Tony Towle [ST342], 1964
16mm film, black and white, silent, 4.4
min. @ 16 fps, 3.9 min. @18 fps

Callie Angell, *Andy Warhol Screen Tests:
The Films of Andy Warhol Catalogue
Raisonné* (New York: Abrams, 2006),
244–245.

p 42
Andy Warhol
Most Wanted Man No. 3, Ellis Ruez B.,
1964
Silk-screen ink on linen
48 × 40 in. (122 × 101.5 cm)
Mugrabi Collection

p 45
Harper's Bazaar (February 1964)
Pictured: Philip Johnson and the 1964
World's Fair New York State Pavilion artists,
with fashion models
Printed ink on coated paper
10 × 14 in. (24.5 × 35.5 cm)
Collection of the Queens Museum, New
York
Photograph by David Montgomery for
Harper's Bazaar

p 46
Andy Warhol
Most Wanted Man No. 4, Redmond C.,
1964
Silk-screen ink on linen
48 × 38 3/4 in.
The Doris and Donald Fisher Collection,
San Francisco
Photograph by Ian Reeves

p 56
*Telegram (Western Union Telegram from
Philip Johnson to Andy Warhol, dated
March 4, 1964),* 1964
Typewritten ink on preprinted form
5 1/2 × 8 1/2 in. (14 × 21.6 cm.)
Collection of The Andy Warhol Museum,
Pittsburgh; Founding Collection,
Contribution The Andy Warhol
Foundation for the Visual Arts, Inc.

p 57
*Newspaper clipping ("Some Not-So-Fair
Faces; Mural is Something Yegg-stra,"
New York Journal-American, April 15,
1964),* 1964
Printed ink on newsprint
Overall: 13 1/4 ×5 1/4 in. (33.7 × 13.3 cm.)
Collection of The Andy Warhol Museum,
Pittsburgh; Founding Collection,
Contribution The Andy Warhol
Foundation for the Visual Arts, Inc.

p 58
Andy Warhol
*Correspondence (from Andrew Warhol
to New York State Department of Public
Works, April 17, 1964),* 1964
Carbon on onionskin paper
Overall: 11 × 8 1/2 in. (27.9 × 21.6 cm.)
Collection of The Andy Warhol Museum,
Pittsburgh; Founding Collection,
Contribution The Andy Warhol
Foundation for the Visual Arts, Inc.

pp 59 and 60
Andy Warhol
*Most Wanted Man No. 5, Arthur Alvin
M.,* 1964
Silk-screen ink on linen
47 1/2 × 38 7/8 in. each
Brant Foundation, Greenwich, CT

p 69
*Newspaper clipping ("Fair's 'Most
Wanted' Mural Becomes 'Least
Desirable'" by Mel Juffe, New York
Journal-American, Saturday, April 18,
1964),* 1964
Printed ink on paper
Overall: 21 1/2 × 14 5/8 in. (54.6 ×
37.2 cm.)

Collection of The Andy Warhol Museum,
Pittsburgh; Founding Collection,
Contribution The Andy Warhol
Foundation for the Visual Arts, Inc.

p 70
Unknown Photographer
*View of A Windy Summer Day by Peter
Agostini and a Silvered-over Andy Warhol
Mural on the New York State Pavilion,*
1964
Digital print
Courtesy of Bill Cotter (worldsfairphotos.
com)

pp 71 and 72
Andy Warhol
*Most Wanted Man No. 6, Thomas Francis
C.,* 1964
Silk-screen ink on linen
48 × 78 in. (121.92 × 198.12 cm)
The Eli and Edythe L. Broad Collection,
Los Angeles
Photograph by Douglas M. Parker Studio,
Los Angeles

p 77
Billy Name
*Andy Warhol at the World's Fair in Bell
Telephone Booth,* 1964
Archival pigment print
Courtesy of Billy Name and Dagon James
© Billy Name

p 77
Billy Name
*Andy Warhol in Snack Bar at the World's
Fair,* 1964
Archival pigment print
Courtesy of Billy Name and Dagon James
© Billy Name

p 78
Andy Warhol
*The American Man (Portrait of Watson
Powell),* 1964
Silk-screen ink on linen
Collection of The Andy Warhol Museum,
Pittsburgh; Founding Collection,
Contribution Dia Center for the Arts.
1997.1.6a; 1997.1.6b
1998.1.43; 1998.1.46

pp 79 and 80
Andy Warhol
Most Wanted Man No. 7, Salvatore V.,
1964
Silk-screen ink on linen
47 3/4 × 38 3/4 in. each (121 × 98.5 cm)
Museum Ludwig, Cologne/Donation
Ludwig

p 86
Mark Lancaster
*Interior of the Factory with Robert Moses
Panels,* 1964
Digital print
Courtesy of Mark Lancaster
© Mark Lancaster

p 87
Andy Warhol
Empire, 1964
16mm film transferred to DVD, black and

white, silent, 8 hrs.
Collection of The Andy Warhol Museum, Pittsburgh; Founding Collection, Contribution The Andy Warhol Foundation for the Visual Arts, Inc.

p 88
Andy Warhol
Most Wanted Man No. 8, Andrew F., 1964
Silk-screen ink on linen
48 × 38 7/8 in. (122 × 98.5 cm)
Private collection

p 92
Photocopy ("Silver Square 'So Nothing' at Fair It Satisfies Warhol," New York World-Telegram, July 6, 1965), 2014
World's Fair Archives, New York Public Library, New York

p 93
Andre Morain
Andy Warhol Exhibition Installation, Ileana Sonnabend Gallery in Paris, France, May 1967, 1967
Gelatin silver print
Leo Castelli Gallery Records, Archives of American Art, Smithsonian Institution, Washington DC

p 94
Andy Warhol
Most Wanted Man No. 9, John S., 1964
Silk-screen ink on linen
48 × 38 7/8 in. (122 × 98.5 cm)
Private collection

p 102
Van Williams
New York State Pavilion from the 1964 World's Fair (Night View), 1964
Digital print
Collection of the Queens Museum, New York
© Van Williams

p 103
Jerry Kean
New York State Pavilion from the 1964 World's Fair (Overview of Central Pavilion), 1964
Digital print
Collection of the Queens Museum, New York
© Jerry Kean

p 104
Ticket for New York State Pavilion feature film at the Theaterama, New York State Pavilion at the 1964 World's Fair, 1964
Printed ink on paper
Collection of the Queens Museum, New York

Pamphlet on the New York State Pavilion (The New York State Exhibit: "The State Fair of the Future"), 1963–64
Ink on colored paper
11 × 8 1/2 in. (28 × 22 cm)
Collection of the Queens Museum

pp 105 and 106
Art in America (August 1964)
Pictured: Philip Johnson's introduction

and reproductions of the New York State Pavilion art installation photographed by Eric Pollitzer
Printed ink on coated paper
10 × 14 in. (24.5 × 35.5 cm)
Collection of the Queens Museum, New York
Originally published in *Art in America* August, 1964, pp 112–27.
Courtesy BMP Media Holdings, Inc.

pp 107 and 108
Andy Warhol
Most Wanted Man No. 10, Louis M., 1963
Silk-screen ink on linen
47 3/4 × 38 3/4 in. each (121 × 98.5 cm)
Collection of the Städtisches Museum Abteiberg, Mönchengladbach
Photograph by Achim Kukulies

p 114
Mosaic depicting Robert Moses by Andy Warhol, located in passarelle entry to Flushing Meadows Corona Park, Queens, NY. Installed 1994-1996.
Photograph by Daniel Morris for the Queens Museum.

pp 115 and 116
Andy Warhol
Most Wanted Man No. 11, John Joseph H., 1964
Silk-screen ink on linen
48 × 38 7/8 in. (122 × 98.5 cm) and 48 1/4 × 40 in. each (122.5 × 101.5 cm)
Collection of Museum für Moderne Kunst, Frankfurt; Former collection of Karl Stroeher, Darmstadt
Photograph by Axel Schneider, Frankfurt am Main

p 120
Peter Moore
March for Freedom of Expression, New York, Alan Marlowe with Sign, 1964
Vintage gelatin silver print
Courtesy of Paula Cooper Gallery, New York
© Barbara Moore/Licensed by VAGA, NY

pp 121 and 122
Andy Warhol
Most Wanted Man No. 12, Frank B., 1964
Silk-screen ink on linen
48 × 39 in. (121.9 × 99.1 cm.) each
Collection of The Andy Warhol Museum, Pittsburgh; Founding Collection, Contribution The Andy Warhol Foundation for the Visual Arts, Inc.

p 128
Bob Adelman
CORE (Congress for Racial Equality) Protestors at the Unisphere at the 1964 New York World's Fair, 1964
Gelatin silver print
Courtesy of Bob Adelman
© Bob Adelman

pp 129 and 130
Andy Warhol
Most Wanted Man No. 13, Joseph F., 1964
Silk-screen ink on linen
48 × 39 3/4 in. (122 × 101 cm) each
Private collection

p 136
David McCabe
Andy Warhol at the Window of the Glass House with Philip Johnson, 1965
Gelatin silver print
Courtesy of David McCabe
© David McCabe

p 137
Andy Warhol
Nelson Rockefeller, 1967
Silk-screen ink on linen
75 × 65 in. (190.5 × 165 cm) Collection of The Andy Warhol Museum, Pittsburgh; Founding Collection, Contribution The Andy Warhol Foundation for the Visual Arts, Inc.

p 138
Andy Warhol
Portrait of Philip Johnson, 1972
Silk-screen ink on linen
96 × 96 in. (244 × 244 cm)
Philip Johnson Glass House Collection

Individual works of art appearing in this book may be protected by copyright in the United States of America or elsewhere, and may not be reproduced in any form without permission of the rights holders. In reproducing images in this publication, the Queens Museum has obtained the permission of rights holders whenever possible.

**Some Not-So-Fair Faces:
Mural Is Something Yegg-stra**

Unabashedly adorning the New York State Pavilion at the World's Fair today—resplendent in all their scars, cauliflower ears and other appurtenances of their trade—are the faces of the city's 13 Most Wanted Criminals.

They peer out from an immense canvas to the Pavillion's outer wall on the Fairgrounds. If they survive the weather and the expected howl of protest, they will be viewed by the international exhibition's 90 million visitors.

DESIGNER DELIGHTED
The fugitives themselves might not be happy about their star billing, but the pavilion's designer, Philip Johnson, is delighted.

"There are 10 quite different murals on the pavilion and this is one of the best," he declared today.

As it is, things could have been worse. The mural could have shown a giant pickle.

OFFICIAL "SHOTS"
"I had thought about doing a great big Heinz pickle," confided contemporary artist Andrew Warhol, commissioned by Mr. Johnson, who was charged with responsibility of setting art to harmonize with his design of the $5 million pavilion.

Mr. Warhol quickly settled on his "13 Most Wanted" idea instead.

The display consists of an arrangements [sic] of Police Department "mug shots" both full-face and profile, complete with Criminal Identification Bureau number plates pinned to the suspects' coats or slung around their necks.

On the propriety of the theme to a pavilion designed to project the Empire State's

image to the world, Mr. Johnson shrugged:
"The picture is a comment on the socio-logical factor in American life."

GIVEN FREE HAND
The 20 × 20-foot mural, blasted by one Fair employee as "the worst thing I've seen at the Fair" is mounted on the masonite facade of the pavilion. It is fully visible to persons walking toward the exhibit.

"Andy chose to do the painting," Mr. Johnson explained. "I didn't tell him not to. He was given a free hand."

Mr. Warhol, described in a brochure to be distributed at the pavilion as "well known for his paintings of repeated Cambell's Soup Cans, dollar bills and photographs of Marilyn Monroe," explained:

"I was first contacted by Mr. Johnson about six months ago. The whole thing cost about $4,000. That's all they gave me to do it.

"It took one day. I got the pictures from a book the police put out. It's called, 'The 13 Most Wanted Men.' It just had something to do with New York, and I was paid just enough to have it silk screened. I didn't make any money on it."

UNCERTAIN ON COST
Mr. Johnson was uncertain about the cost of the art work, recalling:

"I don't think we paid for the painting. We gave permission and some money, I don't know how much, for the materials.

"This is an exhibit. The money wasn't what the open market would bring.

"Andy was chosen with the advice of most museum directors as representative of the middle generation of American artists.

"He's one of the leading pop artists—though I don't like the term."

The Pavilion's brochure explains more specifically that "the repeated images form a field, a rectangle nearly coextensive with that of the canvas." It adds hopefully:

"Many artists have been against commerce and industry and society in general. This attitude seems too simple now, even naive. Warhol and many contemporary artists are interested in society as it is."

Frederic B. Vogel, director of special events of the New York State Commission on the World's Fair and the man who supposedly had final say on the mural was not immediately available for comment.

A sampling of public opinion, however, produced instant and conflicting reaction to the controversial mural.

"Frankly, I consider it out of place at the Fair," said J. Louis Battari, of 317 40th st., Lindenhurst, L.I. "The Fair's a place for beauty, progress and enjoyment, not a backdrop for criminal billboards."

William Rupp, of 60–88 Putnam Ave., Brooklyn, a State Park policeman, not only approved of the mural, but suggested an addition.

"Why not have these persons depicted on the mural?" he said. "They should put Rocky on top to lead the way!"

Mary Ann Selak, of 555 County Line Rd., Amityville, L.I., took an esthetic viewpoint:

"I think a painting with all those criminals will spoil some of the fun of the Fair. It should come down."

Said Morris Haynes, a shipping clerk of

111-51 167th st., Jamaica, Queens:

"Such a mural has no place at the Fair. It would be appropriate in police stations and post offices, but not at a World's Fair where people go to relax and have fun."

Joe Cohen, a merchant of 81–45 168th st., Jamaica, Queens said:

"Thugs at the Fair? Nobody wants to see their distasteful pictures. Why not concentrate on beauty instead of criminals and crime?"

Arnold Whitridge, member of the City Art Commission and a trustee of the Metropolitan Museum of Art, had this to say from the viewpoint of an art connoisseur:

"The city commission has nothing to do with art at the World's Fair. I haven't seen the mural but, from what I'm told, it doesn't sound like a good idea to me. I don't know who's in charge out there."

Walter Arm, deputy commissioner of the Police Department's Bureau of Community Relations said he didn't have any idea how Mr. Warhol got hold of the pamphlet used as a working plan for the work of art.

Transferred to the mural by silkscreen process from the pamphlet issued in February, 1962 are "mug shots" of John "Chappie" Mazziotta, sought in the 1952 murder of Brooklyn pants salesman Arnold Schuster, who tipped police on bank robber Willie "The Actor" Sutton.

Also, John Victor Guisto, sought in the murder of an International Garment Workers Union organizer; Ellis Ruiz "The Professor" Baez, wanted in the hammer-knife slaying of a 14-year-old girl; Redmond "Minnie" Cribben, wanted for a tavern murder and a bank robbery; Arthur Alvin "Skin" Mills, a veteran safecracker and burglar.

Also, Thomas Francis "Duke" Connelly, bank robber; Salvatore Vitale, confidence man; Andrew Ferraiola, wanted in a dice game holdup murder; John Strzelecki, grand larceny suspect; Louis Joseph Musto, wanted for a baseball bat assault; John Joseph Henehan Jr., a liquor store holdup suspect; Frank "Tanky" Bellone, wanted for murder; and Joseph Fungone, wanted for robbery.

Fair's 'Most Wanted' Mural Becomes 'Least Desirable'

The Police Dep't, it appears, is not the only group which looks with disfavor on the 13 rough-looking citizens it classifies as its "most Wanted Criminals."

Andrew Warhol, the "pop" artist whose mural of this not-so-social cast of characters was to adorn the exterior of the New York Pavilion of the World's Fair, decided yesterday he doesn't care about "the boys" either.

Mr. Warhol yesterday told Philip Johnson, designer of the exhibit, he did not feel his work achieved the effect he had in mind, and asked that be removed so he could replace it with another painting.

OWN DECISION

Mr. Johnson said the decision to take down the controversial mural, which disturbed the art world, when it was brought to light last week, was strictly the artist's.

"He thought we hung it wrong," said Mr. Johnson. "He didn't like it the moment he saw it. And since he was willing to do another

piece, I didn't think we had a right to hold him to this one.

"I like it. Most people did," continued Mr. Johnson. "There have been some complaints by people who didn't like the subject matter. But that had nothing to do with the art."

Asked if there had been any complaints from World's Fair officials and if a new painting would be ready in time for Wednesday's opening, Mr. Johnson replied.

"There is no question about official complaints from any Fair authorities. And if there were, we would not do anything about it.

"Mr. Warhol works very fast and I'm sure he'll have a replacement ready in a few days. There won't be anything up there until he gets another work done."

'WORST OF ALL'

The 20 × 20 foot mural was described as "a comment on the sociological factor in American life" by one critic, and classified as "the worst thing I've seen here," by a Fair employee.

What will Mr. Warhol's replacement be? That's the question being debated around the city's art circles today.

The artist has done huge pickles, as well as cans of soup and dollar bills.

Exhibition Checklist

Paintings

Andy Warhol
Pittsburgh, 1928–New York, 1987
Most Wanted Man No. 1, John M., 1964
Silk-screen ink on linen
Collection of Herbert F. Johnson Museum of Art, Cornell University. Acquired with funds provided by the National Endowment for the Arts, and through the generosity of individual donors.

Andy Warhol
Most Wanted Man No. 2, John Victor G., 1964
Silk-screen ink on linen
Collection of The Andy Warhol Museum, Pittsburgh; Founding Collection, Contribution Dia Center for the Arts 2002.4.4a-b

Andy Warhol
Most Wanted Man No. 3, Ellis Ruez B., 1964
Silk-screen ink on linen
Mugrabi Collection

Andy Warhol
Most Wanted Man No. 4, Redmond C., 1964
Silk-screen ink on linen
The Doris and Donald Fisher Collection, San Francisco

Andy Warhol
Most Wanted Man No. 6, Thomas Francis C., 1964
Silk-screen ink on linen
The Eli and Edythe L. Broad Collection, Los Angeles

Andy Warhol
Most Wanted Man No. 7, Salvatore V., 1964
Silk-screen ink on linen
Museum Ludwig, Cologne/Donation Ludwig

Andy Warhol
Most Wanted Man No. 10, Louis M., 1964
Silk-screen ink on linen
Collection of the Städtisches Museum Abteiberg, Mönchengladbach

Andy Warhol
Most Wanted Man No. 11, John Joseph H., 1964
Silk-screen ink on linen
Collection of Museum für Moderne Kunst, Frankfurt; Former collection of Karl Stroeher, Darmstadt

Andy Warhol
Most Wanted Man No. 12, Frank B., 1964
Silk-screen ink on linen
Collection of The Andy Warhol Museum, Pittsburgh; Founding Collection, Contribution The Andy Warhol Foundation for the Visual Arts, Inc. 1998.1.139 and 1998.1.140

Andy Warhol
Flowers, 1964
Silk-screen ink on linen
Collection of The Andy Warhol Museum, Pittsburgh; Founding Collection, Contribution The Andy Warhol Foundation for the Visual Arts, Inc. 1998.1.26

Andy Warhol
Jackie, 1964
Silk-screen ink on linen
Collection of The Andy Warhol Museum, Pittsburgh; Founding Collection, Contribution The Andy Warhol Foundation for the Visual Arts, Inc. 1998.1.90

Andy Warhol
Jackie, 1964
Silk-screen ink on linen
Collection of The Andy Warhol Museum, Pittsburgh; Founding Collection, Contribution The Andy Warhol Foundation for the Visual Arts, Inc. 1998.1.96

Andy Warhol
Jackie, 1964
Silk-screen ink on linen
Collection of The Andy Warhol Museum, Pittsburgh; Founding Collection, Contribution The Andy Warhol Foundation for the Visual Arts, Inc. 1998.1.111

Andy Warhol
Jackie, 1964
Silk-screen ink on linen
Collection of The Andy Warhol Museum, Pittsburgh; Founding Collection, Contribution The Andy Warhol Foundation for the Visual Arts, Inc. 1998.1.125

Andy Warhol
The American Man (Portrait of Watson Powell), 1964
Silk-screen ink on linen
Collection of The Andy Warhol Museum, Pittsburgh; Founding Collection, Contribution Dia Center for the Arts. 1997.1.6a

Andy Warhol
The American Man (Portrait of Watson Powell), 1964
Silk-screen ink on linen
Collection of The Andy Warhol Museum, Pittsburgh; Founding Collection, Contribution Dia Center for the Arts. 1997.1.6b

Andy Warhol
The American Man (Portrait of Watson Powell), 1964
Silk-screen ink on linen
Collection of The Andy Warhol Museum, Pittsburgh; Founding Collection, Contribution The Andy Warhol Foundation for the Visual Arts, Inc. 1998.1.43

Andy Warhol
The American Man (Portrait of Watson Powell), 1964
Silk-screen ink on linen
Collection of The Andy Warhol Museum, Pittsburgh; Founding Collection, Contribution The Andy Warhol Foundation for the Visual Arts, Inc. 1998.1.46

Andy Warhol
Little Electric Chair, 1964–1965
Silk-screen ink on linen
Collection of The Andy Warhol Museum, Pittsburgh; Founding Collection, Contribution The Andy Warhol Foundation for the Visual Arts, Inc. 1998.1.12

Andy Warhol
Nelson Rockefeller, 1967
Silk-screen ink on linen
Collection of The Andy Warhol Museum, Pittsburgh; Founding Collection, Contribution The Andy Warhol Foundation for the Visual Arts, Inc. 1998.1.152

Andy Warhol
Happy Rockefeller, 1968
Silk-screen ink on linen
Collection of The Andy Warhol Museum, Pittsburgh; Founding Collection, Contribution The Andy Warhol Foundation for the Visual Arts, Inc. 1998.1.144

Andy Warhol
Happy Rockefeller, 1968
Silk-screen ink on linen
Collection of The Andy Warhol Museum, Pittsburgh; Founding Collection, Contribution The Andy Warhol Foundation for the Visual Arts, Inc. 1998.1.145

Andy Warhol
Happy Rockefeller, 1968
Silk-screen ink on linen
Collection of The Andy Warhol Museum,
Pittsburgh; Founding Collection,
Contribution The Andy Warhol
Foundation for the Visual Arts, Inc.
1998.1.146

Andy Warhol
Happy Rockefeller, 1968
Silk-screen ink on linen
Collection of The Andy Warhol Museum,
Pittsburgh; Founding Collection,
Contribution The Andy Warhol
Foundation for the Visual Arts, Inc.
1998.1.147

Andy Warhol
Happy Rockefeller, 1968
Silk-screen ink on linen
Collection of The Andy Warhol Museum,
Pittsburgh; Founding Collection,
Contribution The Andy Warhol
Foundation for the Visual Arts, Inc.
1998.1.148

Photo-booth photographs

Andy Warhol
Ethel Scull, 1963
Facsimile of an original photo-booth
photograph
Collection of The Andy Warhol Museum,
Pittsburgh; Founding Collection,
Contribution The Andy Warhol
Foundation for the Visual Arts, Inc.
1998.1.2794

Andy Warhol
Ethel Scull, 1963
Facsimile of an original photo-booth
photograph
Collection of The Andy Warhol Museum,
Pittsburgh; Founding Collection,
Contribution The Andy Warhol
Foundation for the Visual Arts, Inc.
1998.1.2796

Andy Warhol
John Giorno, ca. 1963
Facsimile of an original photo-booth
photograph
Overall: 7 7/8 × 1 5/8 in. (20 × 4.1 cm.)
Collection of The Andy Warhol Museum,
Pittsburgh; Founding Collection,
Contribution The Andy Warhol
Foundation for the Visual Arts, Inc.
1998.1.2815

Andy Warhol
Self-Portrait (Being Punched), 1963–1964
Facsimile of an original photo-booth
photograph
Collection of The Andy Warhol Museum,
Pittsburgh; Founding Collection,
Contribution The Andy Warhol
Foundation for the Visual Arts, Inc.
1998.1.2744

Andy Warhol
Taylor Mead, 1963–1964
Facsimile of an original photo-booth
photograph

Collection of The Andy Warhol Museum,
Pittsburgh; Founding Collection,
Contribution The Andy Warhol
Foundation for the Visual Arts, Inc.
1998.1.2805

Andy Warhol
Self-Portrait (Tuxedo), 1964
Facsimile of an original photo-booth
photograph
Collection of The Andy Warhol Museum,
Pittsburgh; Founding Collection,
Contribution The Andy Warhol
Foundation for the Visual Arts, Inc.
TC21.73.195

Collages

Andy Warhol
*Collage ("The Dogs' Attack is Negroes'
Reward," from Life Magazine, May 17,
1963)*, 1963
Newsprint clipping, graphite, tape, and
gouache on heavyweight paper
Collection of The Andy Warhol Museum,
Pittsburgh; Founding Collection,
Contribution The Andy Warhol
Foundation for the Visual Arts, Inc.
1998.3.4438

Sculptures

*Traveling Scale Model of the 1964 World's
Fair*, 1961
Lester & Associates, Nyack, NY
Mixed media
Collection of the Queens Museum, New
York

Andy Warhol
Brillo Soap Pads Box, 1964
Silk-screen ink and house paint on
plywood
Collection of The Andy Warhol Museum,
Pittsburgh; Founding Collection,
Contribution The Andy Warhol
Foundation for the Visual Arts, Inc.
1998.1.708

Andy Warhol
Campbell's Tomato Juice Box, 1964
Silk-screen ink and house paint on
plywood
Collection of The Andy Warhol Museum,
Pittsburgh; Founding Collection,
Contribution The Andy Warhol
Foundation for the Visual Arts, Inc.
1998.1.767

Andy Warhol
Del Monte Peach Halves Box, 1964
Silk-screen ink and house paint on
plywood
Collection of The Andy Warhol Museum,
Pittsburgh; Founding Collection,
Contribution The Andy Warhol
Foundation for the Visual Arts, Inc.
1998.1.773

Andy Warhol
Heinz Tomato Ketchup Box, 1964
Silk-screen ink and house paint on
plywood
Collection of The Andy Warhol Museum,

Pittsburgh; Founding Collection,
Contribution The Andy Warhol
Foundation for the Visual Arts, Inc.
1998.1.742

Film

Andy Warhol
Eat, 1964
16mm film transferred to DVD, black and
white, silent, 45 min.
Collection of The Andy Warhol Museum,
Pittsburgh; Founding Collection,
Contribution The Andy Warhol
Foundation for the Visual Arts, Inc.

Andy Warhol
Empire, 1964
16mm film transferred to DVD, black and
white, silent, 8 hrs.
Collection of The Andy Warhol Museum,
Pittsburgh; Founding Collection,
Contribution The Andy Warhol
Foundation for the Visual Arts, Inc.

Andy Warhol
Thirteen Most Beautiful Boys, 1964–1966
16mm film transferred to DVD, black
and white, silent, approx. 3 min. each (41
Screen Tests)

Jonas Mekas
Semeiskiai, Lithuania, 1922
Award Presentation to Andy Warhol, 1964
16 mm film transferred to DVD, black and
white, sound, 12 min.
Courtesy of Electronic Arts Intermix

Marie Menken
New York, 1909–1970
Andy Warhol, 1965
16 mm film transferred to DVD, color,
silent, 18 min.
Courtesy of Electronic Arts Intermix

Photographs

Bob Adelman
New York, 1931
*CORE (Congress for Racial Equality)
Protestors at the Unisphere at the 1964
New York World's Fair*, 1964, reprint 2014
Gelatin silver print
Courtesy of Bob Adelman

Bob Adelman
Andy Warhol at Leo Castelli Gallery, 1965,
reprint 2014
Black and white photograph
Courtesy of Bob Adelman

Bob Adelman
*Andy Warhol with Most Wanted Men
Painting at Leo Castelli Gallery*, 1965,
reprint 2014
Black and white photograph
Courtesy of Bob Adelman

Bob Adelman
*Bibbe Hansen and Andy Warhol at Leo
Castelli Gallery*, 1965, reprint 2014
Gelatin silver print
Courtesy of Bob Adelman

Bob Adelman
*Bibbe Hansen, Chuck Wein, Gerard
Malanga, and Andy Warhol*, 1965, reprint
2014
Black and white photograph
Courtesy of Bob Adelman

Mario de Biasi
Belluno, Italy, 1923–Milan, 2013
Andy Warhol in His Studio, 1964, reprint
2014
Digital print
Getty Images

Mario de Biasi
Andy Warhol in His Studio, 1964, reprint
2014
Digital print
Getty Images

Mario de Biasi
Andy Warhol with Campbell's Boxes,
1964, reprint 2014
Digital print
Getty Images

Mario de Biasi
Andy Warhol with Detergent Boxes, 1964,
reprint 2014
Digital print
Getty Images

Rudy Burckhardt
Basel, Switzerland, 1914–New York, 1999
Eat *Filmstrip Still by Andy Warhol*, 1964
Gelatin silver print
Leo Castelli Gallery Records, Archives of
American Art, Smithsonian Institution

Bruce Davidson
Oak Park, IL, 1933
Philip Johnson, 1964
Gelatin silver print
Collection of The Andy Warhol Museum,
Pittsburgh; Founding Collection,
Contribution The Andy Warhol
Foundation for the Visual Arts, Inc.
TC21.14

Jerry Kean
Toledo, Ohio, 1937
*New York State Pavilion from the 1964
World's Fair (Overview of Central Pavilion)*,
1964, reprint 2014
Digital print
Collection of the Queens Museum, New
York

William John Kennedy
Glen Cove, NY, 1930
Andy Warhol Looking Through American
Man, 1964, reprint 2014
Gelatin silver fiber print
Courtesy of KIWI Arts Group

Mark Lancaster
Holmfirth, United Kingdom, 1938
*Interior of the Factory with Robert Moses
Panels*, 1964, reprint 2014
Digital print
Courtesy of Mark Lancaster

Mark Lancaster
Robert Moses Panels at the Factory, 1964,

reprint 2014
Digital print
Courtesy of Mark Lancaster

David McCabe
Leicester, United Kingdom, 1940
David Whitney (at Henry Geldzahler's Apartment), 1964, reprint 2014
Gelatin silver print
Courtesy of David McCabe

David McCabe
Andy, David Whitney, Philip Johnson, Dr. John Dalton, and Architect Robert Stern, 1965, reprint 2014
Gelatin silver print
Courtesy of David McCabe

David McCabe
Andy Warhol at the Window of the Glass House with Philip Johnson, 1965, reprint 2014
Gelatin silver print
Courtesy of David McCabe

Fred W. McDarrah
New York, 1926–2007
Pop Artists Assemble at Factory Party: Tom Wesselmann, Roy Lichtenstein, James Rosenquist, Andy Warhol, Claes Oldenberg, April 21, 1964, 1964
Vintage gelatin silver print
Courtesy of Steven Kasher Gallery, New York and the Estate of Fred W. McDarrah

Peter Moore
New York, 1932–1993
March for Freedom of Expression, New York, Alan Marlowe with Sign, 1964
Vintage gelatin silver print
Courtesy of Paula Cooper Gallery, New York

Peter Moore
March for Freedom of Expression, New York, Protesters Carry the Coffin, 1964
Vintage gelatin silver print
Courtesy of Paula Cooper Gallery, New York

Peter Moore
March for Freedom of Expression, New York, Protesters in a Line, 1964
Vintage gelatin silver print
Courtesy of Paula Cooper Gallery, New York

Peter Moore
March for Freedom of Expression, New York, Taylor Mead, 1964
Vintage gelatin silver print
Courtesy of Paula Cooper Gallery, New York

Peter Moore
Photograph of the Door of the Poets Theater after It Was Shut Down by the NYPD, 1964, 1964
Vintage gelatin silver print
Courtesy of Paula Cooper Gallery, New York

Andre Morain
Andy Warhol Exhibition Installation,

Ileana Sonnabend Gallery in Paris, France, May 1967, 1967
Vintage gelatin silver print
Leo Castelli Gallery Records, Archives of American Art, Smithsonian Institution, Washington, DC

Ugo Mulas
Pozzolengo, Italy, 1927–Milan, 1973
Andy Warhol and Henry Geldzahler at the Factory, 1964
Vintage gelatin silver print
Leo Castelli Gallery Records, Archives of American Art, Smithsonian Institution, Washington, DC

Ugo Mulas
Andy Warhol with Jonas Mekas, 1964
Vintage gelatin silver print
Leo Castelli Gallery Records, Archives of American Art, Smithsonian Institution, Washington, DC

Ugo Mulas
Philip Fagan, New York, 1964, reprint 2014
Gelatin silver print
Courtesy Ugo Mulas Archive, Galleria Lia Rumma, Milano/Napoli

Ugo Mulas
Police at Factory Party, April 21, 1964, 1964, reprint 2014
Gelatin silver print
Courtesy the Estate of Ugo Mulas and MiCucci Gallery

Billy Name
William Linich, Poughkeepsie, 1940
Andy Warhol on his Desk, 1964, reprint 2014
Archival pigment print
Courtesy of Billy Name and Dagon James

Billy Name
Andy Warhol at World's Fair in Bell Telephone Booth, 1964, reprint 2014
Archival pigment print
Courtesy of Billy Name and Dagon James

Billy Name
Andy Warhol in Snack Bar at the World's Fair, 1964, reprint 2014
Archival pigment print
Courtesy of Billy Name and Dagon James

Billy Name
Andy Warhol Silver Factory (Warhol Sitting in front of Foil Wall), 1964, reprint 2014
Archival pigment print
Courtesy of Billy Name and Dagon James

Billy Name
Campbell's Tomato Juice Box *Sculptures on the Floor of the Factory*, 1964, reprint 2014
Archival pigment print
Courtesy of Billy Name and Dagon James

Billy Name
Exterior of the 47th Street Factory, 1964, reprint 2014
Archival pigment print
Courtesy of Billy Name and Dagon James

Billy Name
Heinz, Brillo, Mott's *and* Kellogg's Box *Sculptures at the Stable Gallery*, 1964, reprint 2014
Archival pigment print
Courtesy of Billy Name and Dagon James

Billy Name
Interior of the Factory with Most Wanted Men *and* Box Sculptures, 1964, reprint 2014
Archival pigment print
Courtesy of Billy Name and Dagon James

Billy Name
Night View of Brass Rail Restaurant at the World's Fair, 1964
Archival pigment print
Courtesy of Billy Name and Dagon James

Harry Shunk and János [Jean] Kender
Robert Moses Panel by Andy Warhol, 1964
Gelatin silver print
Print courtesy: Leo Castelli Gallery Records, Archives of American Art, Smithsonian Institution, Washington DC
Image Courtesy: The Shunk-Kender Photography Collection. Courtesy of The Roy Lichtenstein Foundation

Jim Strong
The Cliffhanger *by Robert Mallary on Facade of New York State Pavilion Theaterama*, 1964, reprint 1989
Gelatin silver print
Collection of the Queens Museum, New York

Jim Strong
World's Fair Mural *by James Rosenquist on Facade of New York State Pavilion Theaterama*, 1964, reprint 1989
Gelatin silver print
Collection of the Queens Museum, New York

Jim Strong
A Windy Summer Day *by Peter Agostini on Facade of New York State Pavilion Theaterama*, 1964, reprint 1989
Gelatin silver print
Collection of the Queens Museum, New York

Jim Strong
Prometheus *by Alexander Liberman on Facade of New York State Pavilion Theaterama*, 1964, reprint 1989
Gelatin silver print
Collection of the Queens Museum, New York

Jim Strong
Skyway *by Robert Rauschenberg on Facade of New York State Pavilion Theaterama*, 1964, reprint 1989
Gelatin silver print
Collection of the Queens Museum, New York

Jim Strong
EAT *by Robert Indiana on Facade of New York State Pavilion Theaterama*, 1964,

reprint 1989
Gelatin silver print
Collection of the Queens Museum, New York

Jim Strong
Two Curves *by Ellsworth Kelly on Facade of New York State Pavilion Theaterama*, 1964, reprint 1989
Gelatin silver print
Collection of the Queens Museum, New York

Jim Strong
Untitled *by John Chamberlain on Facade of New York State Pavilion Theaterama*, 1964, reprint 1989
Gelatin silver print
Collection of the Queens Museum, New York

Jim Strong
World's Fair Mural *by Roy Lichtenstein on facade of New York State Pavilion Theaterama*, 1964, reprint 1989
Gelatin silver print
Collection of the Queens Museum, New York

Thirteen Most Wanted Men *by Andy Warhol on Facade of New York State Pavilion Theaterama*, 1964, reprint 2014.
Digital print
Patrick A. Burns/New York Times/Redux

Van Williams
New York State Pavilion from the 1964 World's Fair (Night View), 1964, reprint 2014
Digital print
Collection of the Queens Museum, New York

Unknown Photographer
New York State Pavilion with Silvered-over Andy Warhol Mural behind Tree, 1964, reprint 2014
Digital print
Courtesy of Bill Cotter (worldsfairphotos.com)

Unknown Photographer
View of A Windy Summer Day *by Peter Agostini and a Silvered-over Andy Warhol Mural on the New York State Pavilion*, 1964, reprint 2014
Digital print
Courtesy of Bill Cotter (worldsfairphotos.com)

Archival material

Photograph (Source for Ambulance Disaster*)*, 1960
Vintage gelatin silver print
Collection of The Andy Warhol Museum, Pittsburgh; Founding Collection, Contribution The Andy Warhol Foundation for the Visual Arts, Inc. 1998.3.4418

FBI Wanted Poster (Kenneth Holleck Sharp), ca. 1961
Printed ink on cardboard

Collection of The Andy Warhol Museum, Pittsburgh; Founding Collection, Contribution The Andy Warhol Foundation for the Visual Arts, Inc. TC30.97

FBI Wanted Poster (William Terry Nichols), ca. 1961
Printed ink on cardboard
Collection of The Andy Warhol Museum, Pittsburgh; Founding Collection, Contribution The Andy Warhol Foundation for the Visual Arts, Inc. TC30.11

"The Thirteen Most Wanted," Police Department, City of New York, 1962
Printed ink on coated paper
Collection of The Andy Warhol Museum, Pittsburgh; Founding Collection, Contribution The Andy Warhol Foundation for the Visual Arts, Inc. TC92.10a

Invoice (from Aetna Silk Screen Products to Andy Warhol Enterprises, March 9, 1964), 1964
Printed and handwritten ink on preprinted paper form
Collection of The Andy Warhol Museum, Pittsburgh; Founding Collection, Contribution The Andy Warhol Foundation for the Visual Arts, Inc. T728

Film Culture Special Issue: American Directors, Part 2 (Summer 1963)
Printed ink on coated paper
Private Collection, New York

Pamphlet on the New York State Pavilion (The New York State Exhibit: "The State Fair of the Future"), 1963–64
Ink on colored paper
Collection of the Queens Museum

Harper's Bazaar (February 1964)
Printed ink on coated paper
Collection of Jay Reeg

Photocopy (Film-makers Cooperative: "To the Friends of the Cinema" March 1964), nd
Collection of Jonas Mekas

Photocopy (Record of Items Confiscated by Police and Bail Bond Slip; both: March 14, 1964), nd
Collection of Jonas Mekas

Newspaper clipping ("City Puts Bomb Under Off-beat Culture Scene" by Stephanie Gervis Harrington, Publication Unknown, March 26, 1964), 1964
Printed ink on newsprint pasted up on board
Collection of Jonas Mekas

Newspaper clipping (Film-Makers Cooperative Anti-Censorship Fund: "To Our Friends" April 8, 1964), 1964
Printed ink on newsprint pasted up on board
Collection of Jonas Mekas

Newspaper clipping ("Some Not-So-Fair Faces; Mural is Something Yegg-stra," New York Journal-American, April 15, 1964), 1964
Facsimile of original printed ink on newsprint
Collection of The Andy Warhol Museum, Pittsburgh; Founding Collection, Contribution The Andy Warhol Foundation for the Visual Arts, Inc. TC-17.43
TC-17.57.1a-b

Newspaper clipping ("Fair's 'Most Wanted' Mural Becomes 'Least Desirable'" by Mel Juffe, New York Journal-American, Saturday, April 18, 1964), 1964
Facsimile of original printed ink on paper
Collection of The Andy Warhol Museum, Pittsburgh; Founding Collection, Contribution The Andy Warhol Foundation for the Visual Arts, Inc. TC-17.144

"The Personality of the Artist" (Exhibition Announcement for Andy Warhol's Second Stable Gallery Exhibition, April 21st, 1964), 1964
Printed ink on coated paper
Private Collection, New York

Torchlight Parade (Promotional Flyer), 1964
Printed ink on colored paper
Collection of the Queens Museum, New York

Life Magazine (April 24, 1964)
Printed ink on coated paper
Collection of the Queens Museum, New York

Exhibition Announcement Robert Indiana / Stable Gallery, New York, May 12, 1964, 1964
Printed ink on paper
Collection of The Andy Warhol Museum, Pittsburgh; Founding Collection, Contribution The Andy Warhol Foundation for the Visual Arts, Inc. TC-2.27

Show Magazine, Vol. 4, no. 10 (November 1964), 1964
Printed ink on coated paper
Collection of The Andy Warhol Museum, Pittsburgh; Gift of Kyle Wright R2013.6

Show Magazine, Vol. 4, no. 10 (November 1964), 1964
Printed ink on coated paper
Collection of the Queens Museum, New York

Film schedule (Film-Makers' Cinematheque, November 30–December 21, 1964), 1964
Facsimile of original printed ink on paper
Collection of The Andy Warhol Museum, Pittsburgh; Founding Collection, Contribution The Andy Warhol Foundation for the Visual Arts, Inc. TC14.4

Newspaper clipping ("Silver Square 'So Nothing' at Fair, It Satisfies Warhol," New York World Telegram, July 6, 1965, p. 6), 1965
Photocopy of original printed ink on paper
World's Fair Archives, New York Public Library, New York

Philip Johnson: Architecture 1949–1965
Publication by Holt, Rinehart & Winston; First Edition (1966)
Collection of the Queens Museum, New York

Exhibition Pamphlet ("Andy Warhol: Dossier No. 2357, Thirteen Most Wanted Men"), April 1967
Printed ink on paper
Collection of The Andy Warhol Museum, Pittsburgh; Founding Collection, Contribution The Andy Warhol Foundation for the Visual Arts, Inc. 2001.8

Andy Warhol Stockholm Catalogue, 1970
Printed ink on paper
Collection of The Andy Warhol Museum, Pittsburgh; Gift of Kyle Wright 2012.10.27

Andy Warhol Stockholm Catalogue, 1970
Printed ink on paper
Collection of The Andy Warhol Museum, Pittsburgh; Gift of Kyle Wright 2012.10.28

Transcript of Unpublished Interview with Philip Johnson by Henry Geldzahler, 1982, p. 14, 1982
Facsimile of original printed ink on paper
Henry Geldzahler Papers, Beinecke Library, Yale University, New Haven

Correspondence

Typewritten Letter with Enclosure (from Thompson Starrett Construction Co. to Mr. Andrew Warhol, Dated February 1, 1963), 1963
Typewritten ink on paper
Collection of The Andy Warhol Museum, Pittsburgh; Founding Collection, Contribution The Andy Warhol Foundation for the Visual Arts, Inc. TC55.16.1a-TC55.16.2b

Amendments to State Architect's Standard Specifications. New York State Exhibit, New York World's Fair 1964–1965. December 26, 1962, 1962
Collection of The Andy Warhol Museum, Pittsburgh; Founding Collection, Contribution The Andy Warhol Foundation for the Visual Arts, Inc. TC55.16.1a-TC55.16.2b

Telegram (Western Union Telegram from Philip Johnson to Andy Warhol, Dated March 4, 1964), 1964
Facsimile of original typewritten ink on preprinted form
Collection of The Andy Warhol Museum, Pittsburgh; Founding Collection, Contribution The Andy Warhol

Foundation for the Visual Arts, Inc. T3036

Andy Warhol Correspondence (from Andrew Warhol to New York State Department of Public Works, April 17, 1964), 1964
Carbon on onionskin paper
Collection of The Andy Warhol Museum, Pittsburgh; Founding Collection, Contribution The Andy Warhol Foundation for the Visual Arts, Inc. 1998.3.4429

Typewritten Letter (Frank O'Hara to Larry Rivers, 18 April 1964), 1964
Typewritten ink on paper, 2 pages
Larry Rivers Papers, Collection of Fales Library, New York University

Andy Warhol Typewritten Letter (From Andy Warhol to Eleanor Ward, May 26, 1964), 1964
Typewritten ink on paper
Collection of The Andy Warhol Museum, Pittsburgh; Founding Collection, Contribution The Andy Warhol Foundation for the Visual Arts, Inc. TC-12.97.1-TC-12.97.3

Statement (From Stable Gallery to Andy Warhol, June 13, 1964), 1964
Printed and typewritten ink on paper
Collection of The Andy Warhol Museum, Pittsburgh; Founding Collection, Contribution The Andy Warhol Foundation for the Visual Arts, Inc. T726

Note on Architect's Graphboard, Handwritten in Black Felt-Tip by "Billy" re: Watson Powell Portrait, 1964
Felt-tip on paper
Collection of The Andy Warhol Museum, Pittsburgh; Founding Collection, Contribution The Andy Warhol Foundation for the Visual Arts, Inc. TC39.284

Billy Name Letter (from Billy Name to Andy Warhol), ca 1965
Felt-tip ink on Hi-Art Bristol graph board
Collection of The Andy Warhol Museum, Pittsburgh; Founding Collection, Contribution The Andy Warhol Foundation for the Visual Arts, Inc. TC5.60

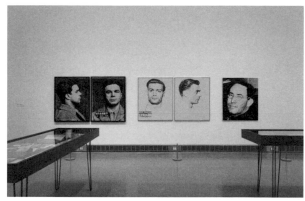

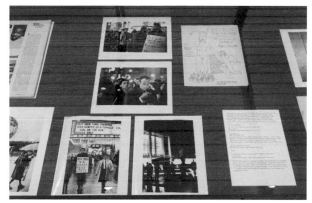

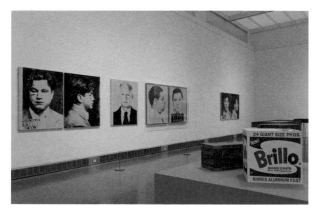

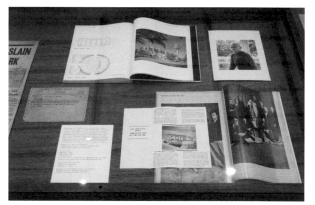

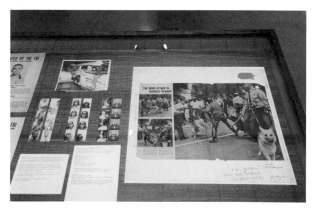

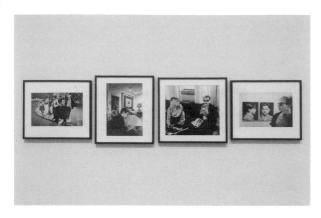

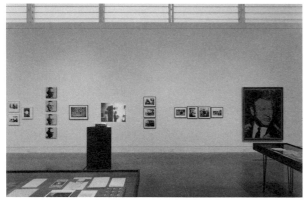
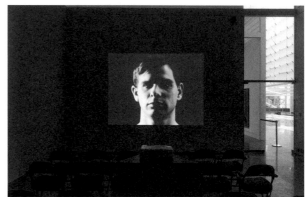
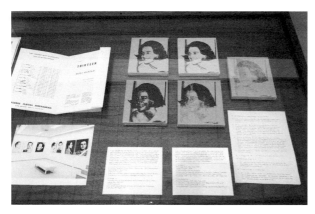
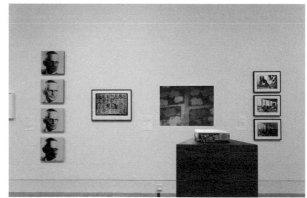
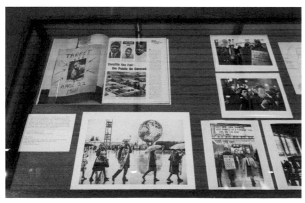
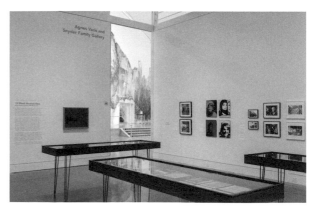

This book is published on the occasion of 13 Most Wanted Men: *Andy Warhol and the 1964 World's Fair*, an exhibition developed collaboratively by the Queens Museum and The Andy Warhol Museum, curated by Larissa Harris, Curator, Queens Museum; and Nicholas Chambers, The Milton Fine Curator of Art, The Andy Warhol Museum; with Anastasia Rygle, Project Assistant Curator; and Timothy Mennel, Curatorial Adviser.

April 27–September 7, 2014 at the Queens Museum, New York
September 27, 2014–January 5, 2015 at The Andy Warhol Museum, Pittsburgh

13 Most Wanted Men: *Andy Warhol and the 1964 World's Fair* exhibition and publication are supported by The Henry Luce Foundation, National Endowment for the Arts and Delta Air Lines. Additional support comes from the New York City Department of Cultural Affairs and New York State Council on the Arts with the support of Governor Andrew Cuomo and the New York State Legislature.

13 Most Wanted Men: *Andy Warhol and the 1964 World's Fair* contributors are Hilary Ballon, Nicholas Chambers, Douglas Crimp, Diane di Prima, Dick Elman, Tom Finkelpearl, Albert Fisher, Brian L. Frye, John Giorno, Anthony Grudin, Larissa Harris, Felicia Kornbluh, Gerard Malanga, Jonas Mekas, Timothy Mennel, Richard Meyer, Billy Name, Brian Purnell, Anastasia Rygle, Eric Shiner, Richard Norton Smith, Lori Walters, and Mark Wigley.

Edited by Larissa Harris & Media Farzin
Copyedited by Michael Andrews, Abraham Adams, and Ben Mercer
Designed by David Reinfurt & Lily Healey
ISBN: 1-929641-19-2
Printed in the United States of America
Printed by The Avery Group at Shapco Printing, Minneapolis

Published by the Queens Museum
New York City Building
Flushing Meadows Corona Park
Queens, NY 11368
T: 718 592 9700
www.queensmuseum.org

Cover:
Show Magazine Vol. 4, No. 10 (November 1964), Printed ink on paper, 13 × 10 3/8 in. (33 × 26.3 cm)
The Andy Warhol Museum, Pittsburgh Founding Collection, The Andy Warhol Foundation for the Visual Arts, Inc.

Warhol Superstar Jane Holzer is pictured on the cover of *Show* magazine in 1964 World's Fair souvenir sunglasses. A cover article titled "Underground Movies: How They're Made" is reworked to address Warhol in a hand-written note: "How you made me / Love, Jane." This image was chosen for its juxtaposition of World's Fair and underground culture that nods towards the incident at the heart of the book.

Back cover and p 3:
Excerpt from *POPism: The Warhol Sixties*, by Andy Warhol and Pat Hackett. © 1980 Andy Warhol. Reprinted by permission of Houghton Mifflin Harcourt Publishing Company. All Rights Reserved.